PAPER PLAY

GINGKO PRESS

PAPER PLAY

ISBN 978-1-58423-555-2

First Published in the United States of America by
Gingko Press by arrangement with
Sandu Publishing Co., Ltd.

Text edited by Gingko Press.

Gingko Press, Inc.
1321 Fifth Street
Berkeley, CA 94710 USA
Tel: (510) 898 1195
Fax: (510) 898 1196
Email: books@gingkopress.com
www.gingkopress.com

Copyright © 2014 by Sandu Publishing
First published in 2014 by Sandu Publishing

Sponsored by Design 360°
– Concept and Design Magazine

Edited and produced by
Sandu Publishing Co., Ltd.
Book design, concepts & art direction by
Sandu Publishing Co., Ltd.
Chief Editor: Wang Shaoqiang
sandu.publishing@gmail.com
www.sandupublishing.com

Printed and bound in China

Mademoiselle Maurice

Artist
Savoy — France

"Paper, where do you come from? Who are you?"

From the Latin *papyrus*, *papuros* in Greek, meaning "Egyptian reed." Paper is defined as: "Material appearing as thin and dry sheets mainly composed of fibers or pieces of fibers adhering to each other." Paper weighs less than 224 grams per square meter. Above this value it is considered cardboard.

Everyday and everywhere, paper is used as a medium. It passes from hand to hand, from eyes to eyes. We often touch it, almost always read it, but it is rarely contemplated. It remains a common object, which we do not always pay attention to in our daily lives. We have been using paper since ancient times and it has evolved and adapted to our needs. Its original components may vary, but we still use natural sources: flax, hemp, cotton, wood and even the droppings of herbivores. Some insects are amazing manufacturers and architects of paper, just think of the honeycomb nests created by bees.

The paper is foremost a writing medium, used as a tool for communication and to share knowledge. It may seem obvious in our daily lives, but paper contains numerous hidden treasures and beauty. Many artists do not see it as a simple object of consumption, but transform it into artistic compositions with the appreciation of each of its features.

Paper is a medium with nearly inexhaustible resources. It is one of the most modest materials, but one that can be shaped in the most complex of ways. The role of the artist is to make it sublime, as if he or she is orchestrating the movements and changes of a living element. Texture, weight and color give paper its first visible characteristics, but the artist can transform it and give it an unexpected personality, sometimes spectacular and sensational. Its lightness pleases, but its apparent fragility can also turn into an unexpected strength, resulting in a graphic character the artist has imagined and realized.

When I'm in front of a sheet of paper, its purity touches me. A single sheet is perfect, smooth, with impeccable edges. Paper may seem simple, but what you can create makes it excessively complex. Working with the material inspires something magical. Its transformation can be long and tedious with intricate steps or incredibly simple.

Paper can come in infinite shades. It may be soft, but its relief can be felt under our fingers, its delicacy reveals itself before our caresses and every type of paper has its own smell. It may curl sensually, or bend sharply. The single sheet can be transformed into different forms linked by folds with straight edges. Each fold that is brought to the paper stiffens it a little more. Yet one blade can cut it easily and every piece cut out from it makes it, on the contrary, a little more fragile.

An artist can use paper on large or small scales. Thousands of cuts can turn it into delicate lace, worthy of the most precious traditional lace, but a paper lace is more fragile and a small tension could pull it to pieces.

Carvings may remain abstract and graphic or may represent realistic and figurative compositions. Its expression surface may be a few square centimeters or on a gigantic scale. Paper can cover entire walls and be the medium of writing, painting or various designs. Paper is the privileged canvas for expression and transmission, used as a medium in the various techniques of creations, such as traditional writing, calligraphy, drawing, folding and painting but also unique ways of expression like Braille, where the paper is not read with the eyes, but felt with the sense of touch, thanks to a new dimension provided by hundreds of small raised dots.

Artists must be able to use all their senses to transform it, to understand it, to work with it. It is a poetic and sensitive approach, where emotion passes through the senses, either for the creator or for the spectator who appreciates the creation.

However, paper work also requires technique, logic or even mathematical calculation. Calculation of area and perimeter to transform a flat surface into a perfect geometric shape or pattern. Paper folding is an art, and the Japanese are masters. The art of 'Origami' (折り紙 from oru, fold, and kami paper, a technique brought back from China to Japan by Buddhist monks) is now an international and very popular art; it has even become the source of some legends and beliefs.

Paper also expresses itself through movement. The movement of paper is often slow, almost more mechanical than organic. Paper may be suspended, moving with the wind, twirling in the air, appearing to open or close depending how it has been worked, cut and folded.

The accumulation of paper is also changing. Many artists work with a multitude of different layers or elements – they overlap, line, stack, glue together, assemble, gather or spread. Paper, by accumulation, then receives a new strength and offers other possibilities, multiplying the options for creation.

Although a tiny flame can destroy it, its edge is so thin and flexible it can cut the skin of a finger. These numerous paradoxes fascinate us and make paper the unique material that it is. We are seduced by its infinite poetry, along with its modesty.

Finally, do not forget that its origin is humble and powerful. It is created from nature. It does not have inexhaustible resources, which is why more than ever paper should not only be admired and worked, but also respected.

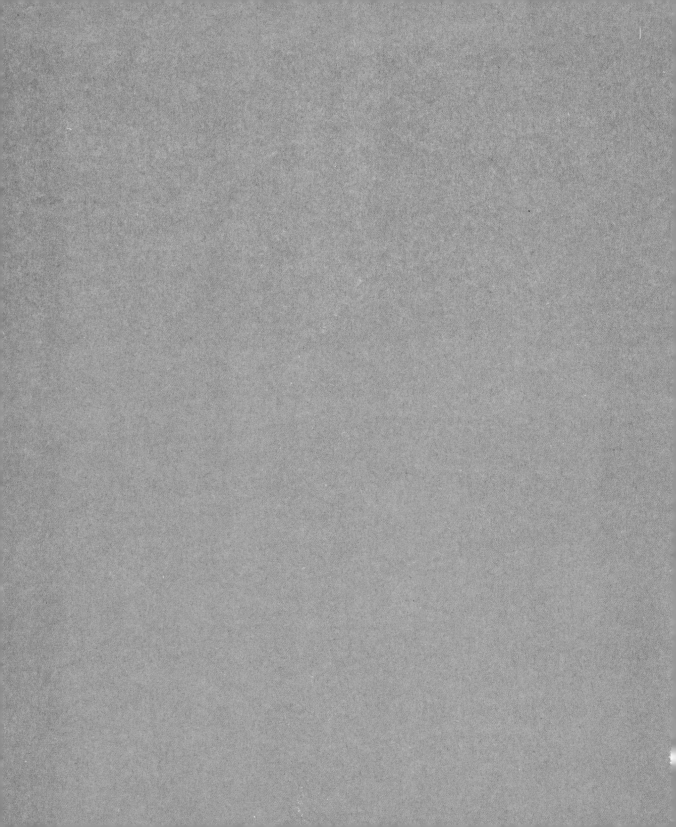

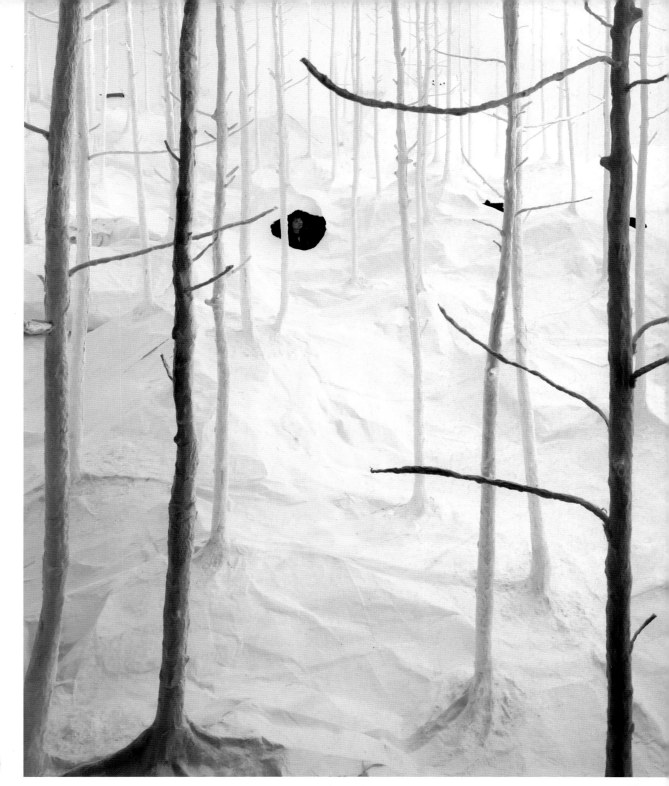

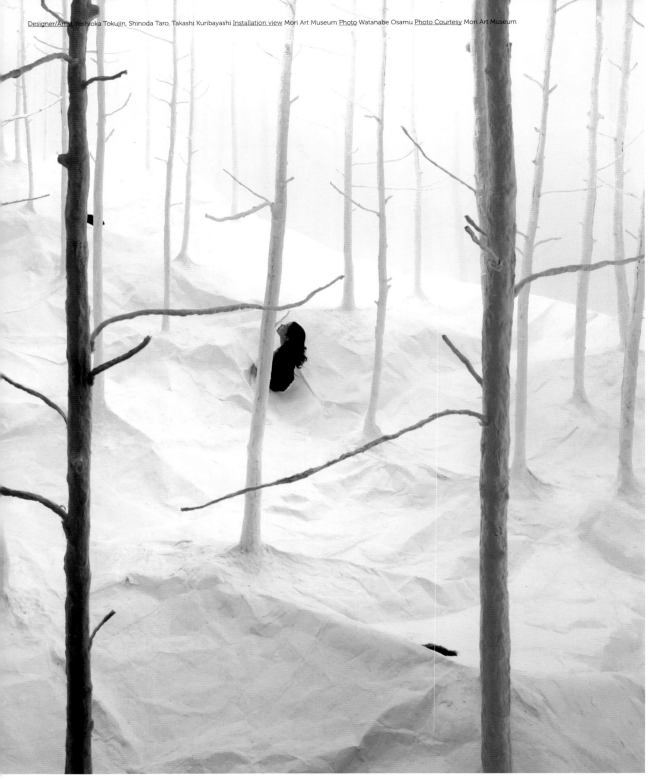

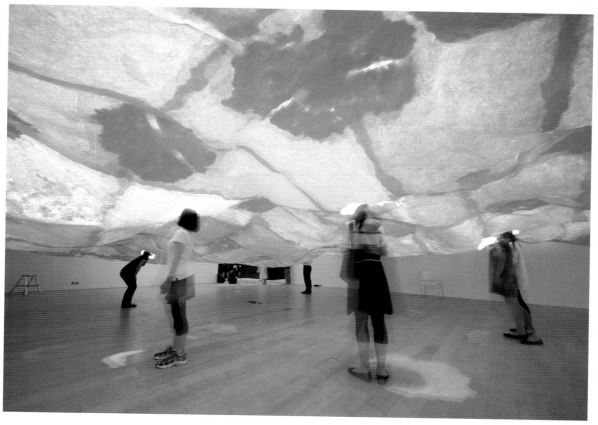

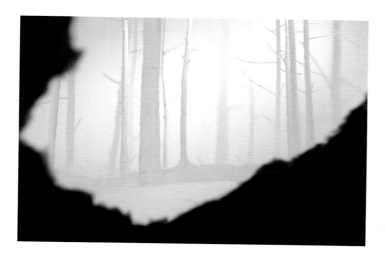

Sensing Nature

The white trees that appear to float in the
gallery space were molded by the artist from
Japanese larch trees in Yamagata, using Awa
washi (handmade paper). The washi, which
was made from natural materials such as kuzo
(a type of mulberry tree) and mitsumata (paper
bush), were molded into tree forms, becoming
a symbol of the ecology of our natural world.
People were able to view the installation by
peering out through a crevice in the 'forest
floor' and observing the world that lay above
the ground, observing the forest from an
insect's perspective.

Design Agency Art des Hauses Designer Anne Franke Photographer Prof. Frank Göldner (Hochschule Mannheim), Anne Franke

Blanc de Neige

Together with two partners, German communications designer Anne Franke runs the renowned design studio 'Art des Hauses' in Dortmund, Germany.

Her affinity and passion for paper led to the formation of her jewelry. Her work in design meant she dealt with paper distributors and different kinds of paper everyday — it was therefore only a matter of time until a new project with paper began and this culminated in her jewelry collection. Numerous experiments with different papers formed part of her creative process, which she called 'Blanc de Neige.'

Fine, sensual, uncoated paper is the base of the necklaces. Each individual leaf is created one at a time and then combined with a blend and arrangement of silver and stainless steel. When worn, the leaves move with the person — like leaves in the wind. The leaves are shades of white and designed in a light and simple way. Each leaf is hand embossed by Franke.

The designs vary in their form: either a few leaves strung together by an elegant chain, or hundreds of closely strung together leaves forming an opulent collar, resembling a Greek laurel wreath.

All necklaces are handmade and produced in limited editions. The pieces have been featured in many international magazines and professional design journals. Various exhibitions of the jewelry have been held at galleries in Germany, Austria, Australia and America.

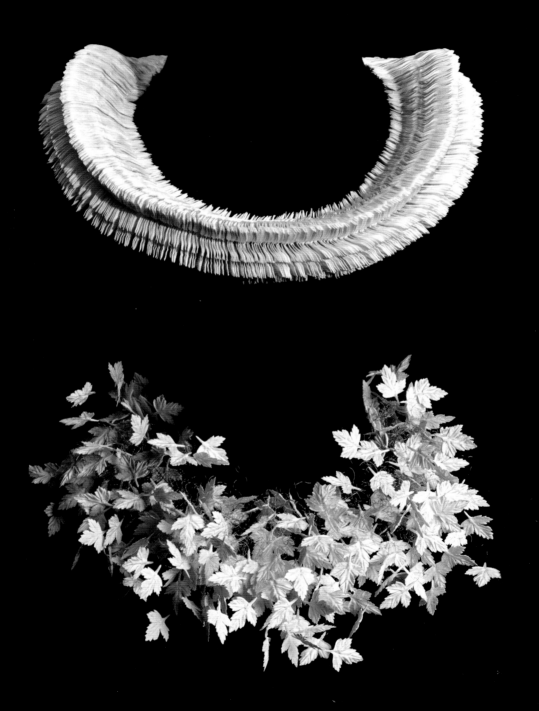

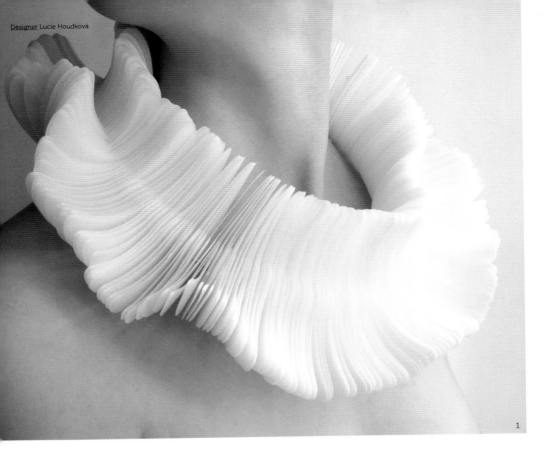

1

The Deep

1, 2 / necklace
3 / bracelet

Lucie Houdková's work is inspired
by ocean flora and fauna. The variety
and diversity of sea life inspired her
to create this collection titled 'The
Deep.' Her jewelry mainly reflects the
structures of sponge coral, whose
own natural 'design' impressed her
greatly. Houdková spent a great deal
of time conceiving an idea that would
best express the character of the
sponge coral and connect it with her
own imagination and intent.

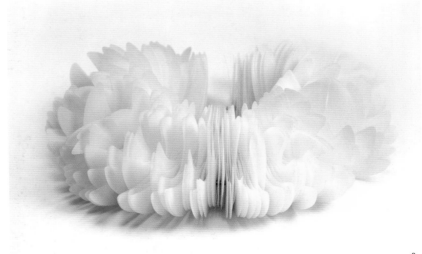

2

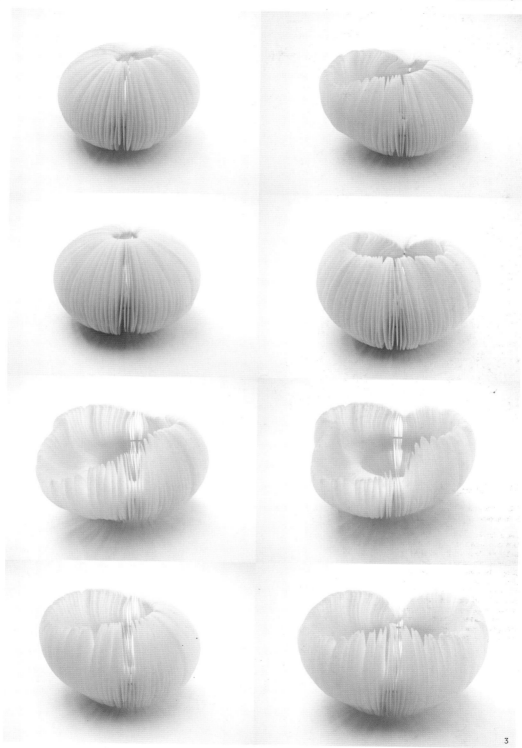

3

Artists Christine Kim, Marcin Kedzior Client Nuit Blanche Toronto 2013 Photographer Don Toye

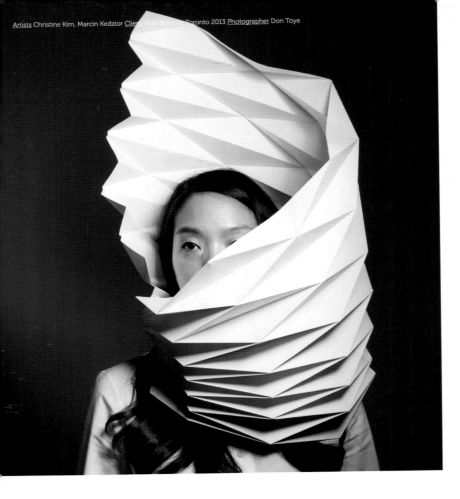

Paper Orbs

Pictured here are prototypes for Nuit Blanche Toronto, 2013. This project, entitled *Paper Orbs*, begins the night as a massive origami sculpture, which dissolves throughout the night into thousands of paper helmets worn by visitors as they parade down Toronto's historic processional route. The paper orbs disperse into scattered constellations that float on the street. Folded paper sculptures are mounted on top of sleepless bodies, which restlessly comb the street — little astronauts emerge, dragging their feet, laughing, staring into space, full of chatter, exclamations, silent meditations, unexpected gestures, with paper orbs bobbing up and down, surveying the scene.

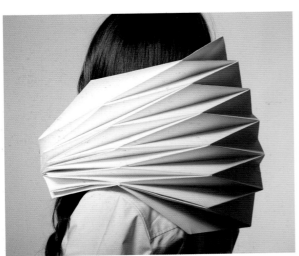
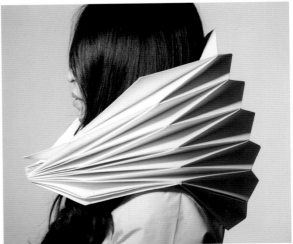

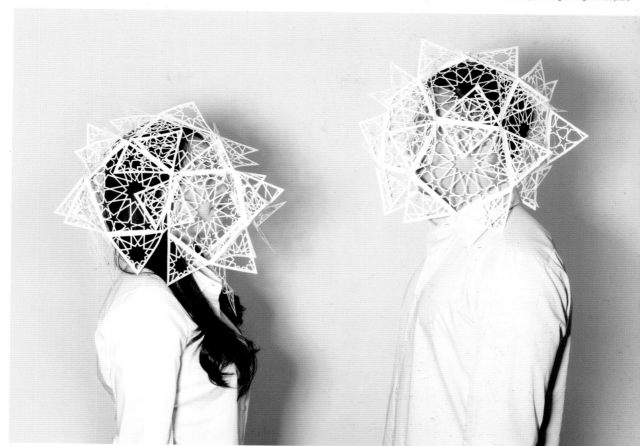

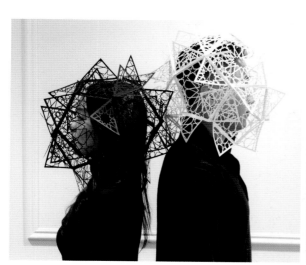

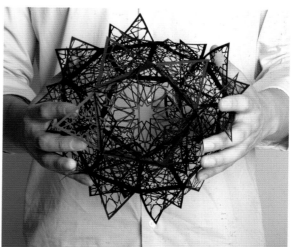

Designer Wirin Chaowana Client Art Thesis, Visual Communication Design, Silpakorn University, Thailand Photographer Waritsara Sakda

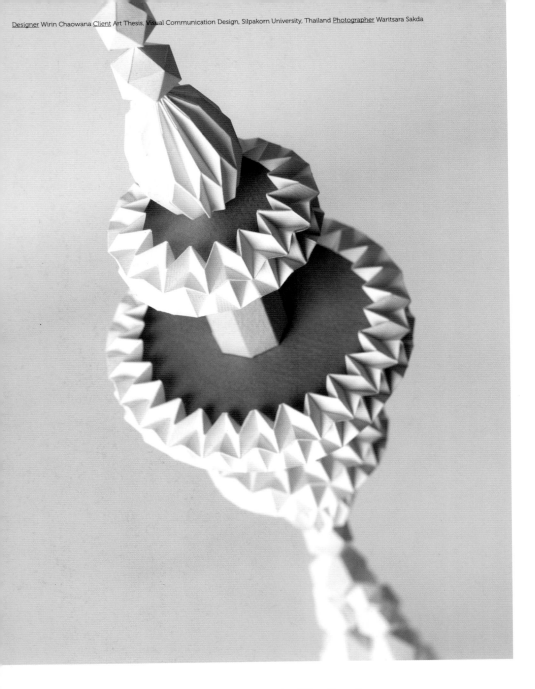

The Art of Flower Arrangements in Thailand

These paper designs were inspired by Thai fresh flower arrangements, one of the most valued and refined handicraft in the country. In the project, 'The Art of Flower Arrangements in Thailand,' there are three sets of paper craft designs: Malai (floral garlands), Phan Phum (floral arrangements on pedestal trays) and Khruang Khwaen (floral pendants). To present the beauty of the craft in innovative and interesting ways, while keeping the fine essence of traditional Thai flower arrangement, the fresh flowers are replaced by geometric forms and complex paper folding.

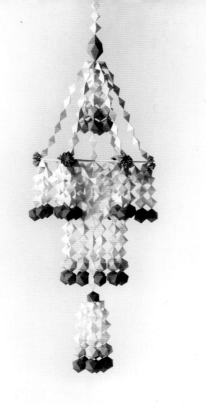

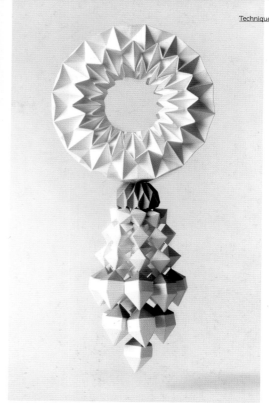

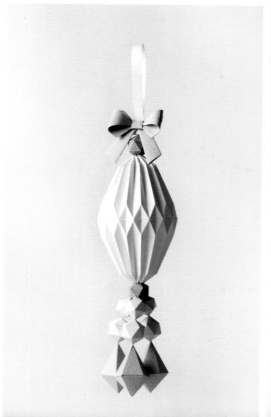

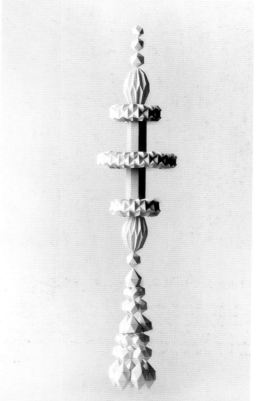

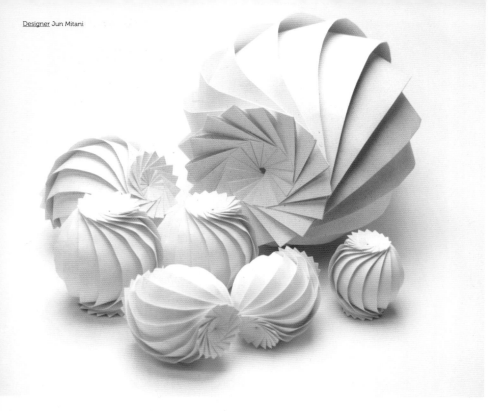

Spherical Origami

Spherical Origami is a series of paper artworks that are made by folding a single sheet of paper. Most of their forms are designed based on axisymmetrical geometry and reflections. Their sophisticated appearances were generated by a computer under the geometrical constraints that the shapes had to be reconstructible from a single sheet of paper without tears and wrinkles. As a result of precise calculations and computational simulations, unique and curved origami works came into the world. Jun Mitani, a computer scientist, developed several dedicated software programs. The software helped him to explore 3D shapes, which satisfy geometrical constraints. The unfolded patterns were automatically calculated and the folding lines were scored on a sheet by a cutting machine. The scored sheets were then folded by hand.

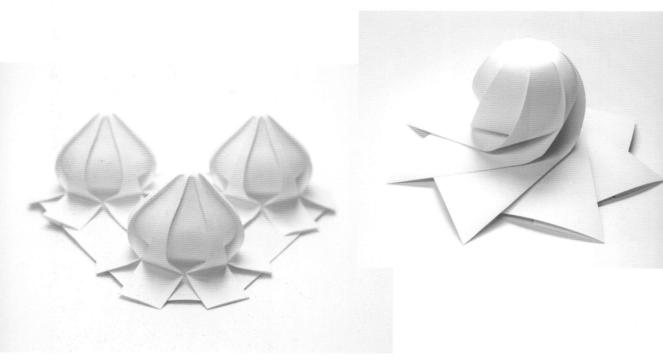

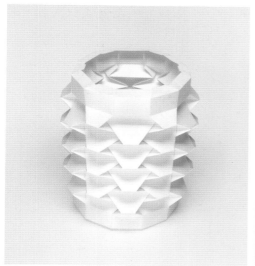
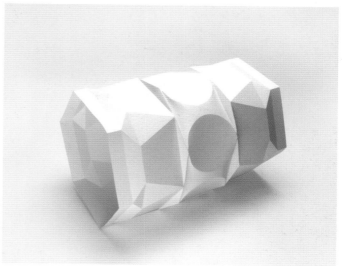

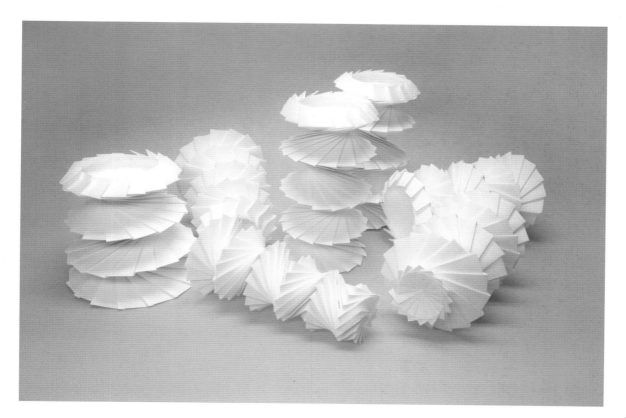

Artist Charlotte McGowan-Griffin Photographer Patricia Sevilla Ciordia Technique Cut paper

Brainstorming III

Part of an ongoing series that explores hidden patterns in nature, these use a traditional reductive technique — the positive 'cut-out' is defined by the negative areas and vice-versa.

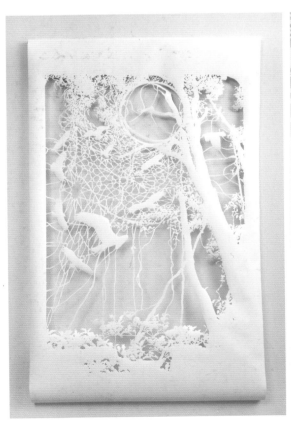

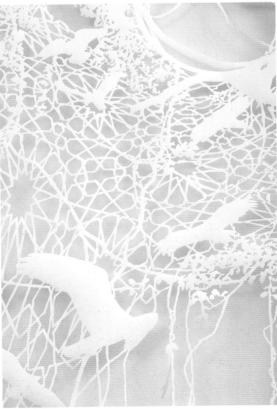

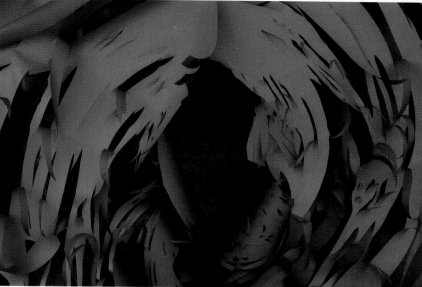

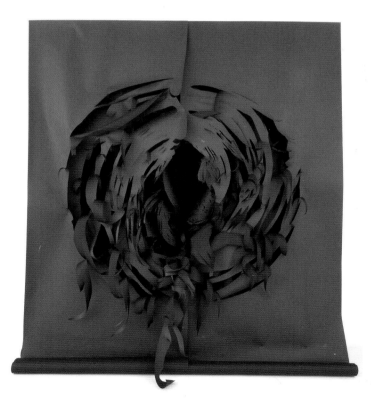

The Origin of the World

This work comprises 14 large sheets of black drawing paper layered and cut to create a deep 'black hole.' The artist's layered relief works demonstrate the sculptural qualities, dynamism and volume that paper is capable of. All the cut elements remain in the work, thus she named this technique 'cutting in,' as opposed to the more traditional method of 'cutting out', seen in works such as 'Brainstorming III' and 'Metamorphoses.'

Designer/ Artist Géraldine Gonzalez Photographer Géraldine Gonzalez

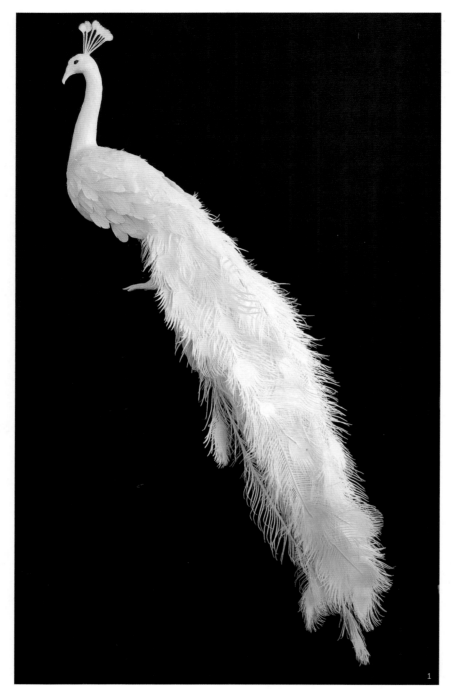

1

Enchanting Crystal Paper Sculpture

1 / Le Paon blanc
2 / Medusas

Géraldine Gonzalez's visions and dreams, combined with nature and surrealist situations, are always the inspiration for her sculptures. She enjoys working with transparency and light, which for her, seems to be a poetic universe. *Le Paon blanc* was created for a French luxury brand, while *Medusas* was based on a dream she once had. When the project was realized, it was well received by the public and became part of a number of exhibitions and private collections.

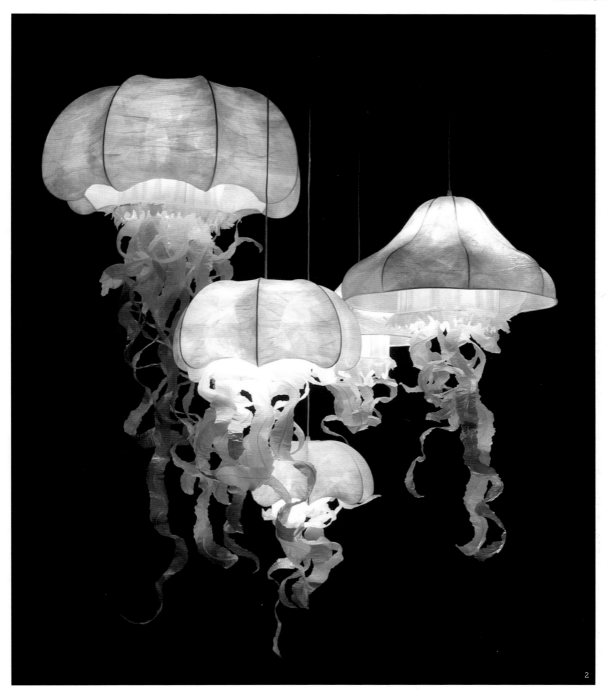

2

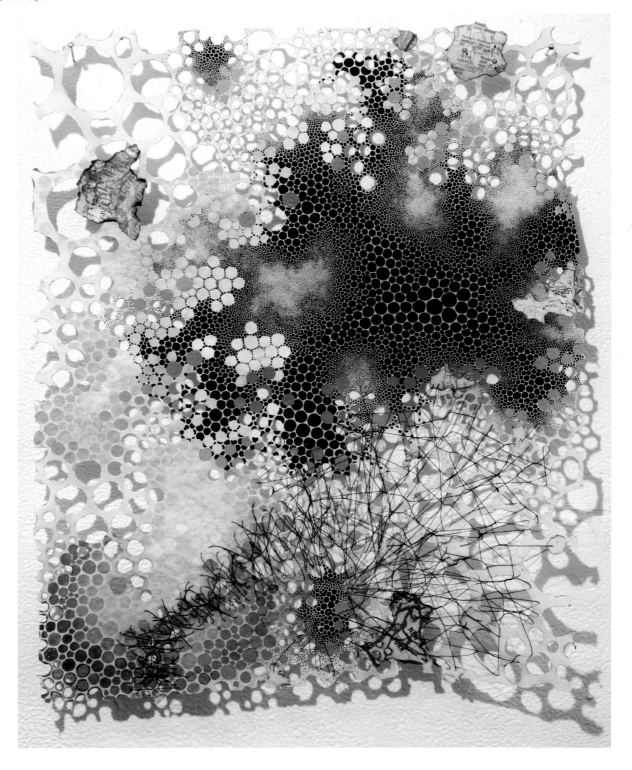

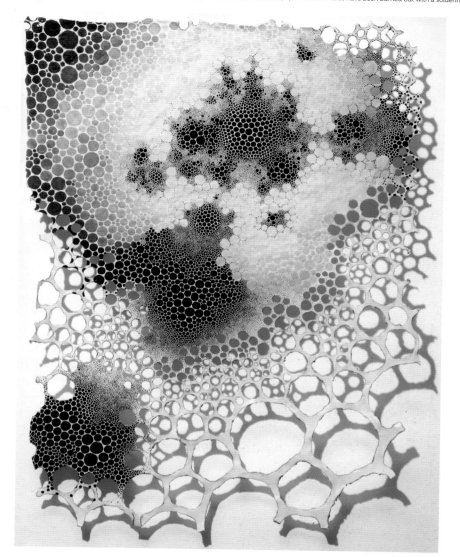

Integrations

1 / Morass
2 / Esthesia

Zen Buddhism, Japanese aesthetics and Psychology inspire Karen Margolis' art. Her imagery is based on the Enso, the Japanese term for circle, a sacred symbol in Zen, embodying infinity and perfection. Attracted by its mystical aspects and its paradox of imperfection, she reinterprets the vocabulary of the Enso in both positive and negative space. Margolis' process involves two distinctly opposing procedures: burning holes in material and constructing discrete components into compositions. Within this tension between destruction and formation she connects micro to macro and body to mind.

The Enso has been integrated with neuroscience in order for Margolis to create a "physical presence for the patterns of my emotions." She has translated meticulously gathered data of her internal monologues into color-coded dots that evoke interplay between neurotransmitters and chemicals in the brain. The colors are coordinated to a flow chart she developed that categorizes and assigns a Pantone reproducible color to each emotion. Margolis' coded language further incorporates linear elements of thread and dislocated map fragments, which vie with her fields of molecular color, shadows and space, to capture moments, frozen in time.

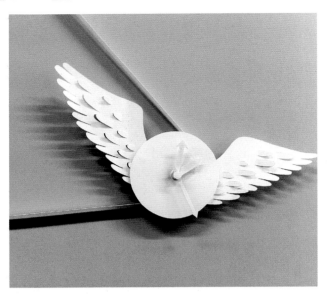

Clockwork

In 2011, a piece of art about our notions of time was commissioned from Mathilde Nivet by Hermès. She wanted to create something both funny, elegant and surprising, so she imagined a little winged clock animated by a gigantic mechanism. The clockwork actually moved and made a 'tick-tock' sound. She had been longing for an opportunity to experiment with paper in movement and after a period of time spent researching, she finally managed to create a motorized system that allowed the wheels to turn. Because the piece is large (165x100 cm), it produces a striking effect, while at the same time it is both fragile and mechanical. Hermès exhibited the clock at several events around the world, starting with an elegant diner in Paris where the guests were welcomed by the ticking of the clock.

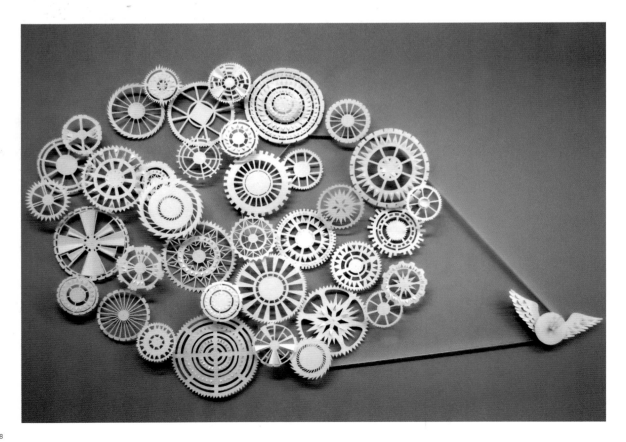

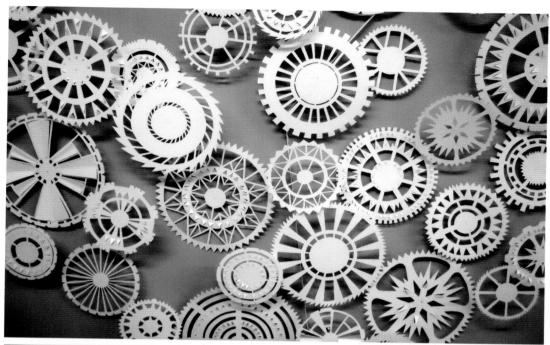

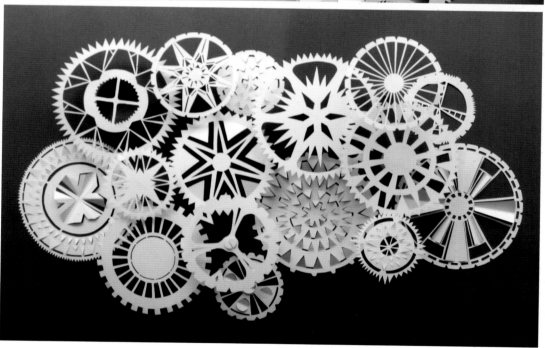

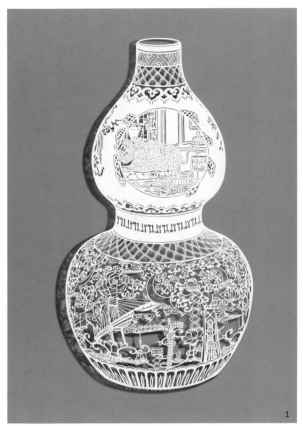

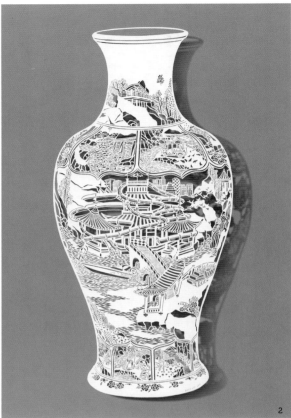

The Environmental Impact of Urbanism

1 / Hulu Vase — Polar Bears
2 / Vase — Re[creation]

'Hulu Vase — Polar Bears' is a piece from Bovey Lee's vase series that consists of dual narratives — depicting endangered species in domestic settings and man-made structures in nature. On the top half of the vase, she placed a mother polar bear and her cub in a living room, resting indoor comfortably on an ornate lounger and out of their natural habitat. On the bottom half of the vase and equally out of place, power towers, industrial cranes, bridges, airplanes, boats and barges, overrun patterns of flowers, leaves, birds, clouds and water. Together the two narratives evoke the peculiarity of our fraught relationship with wild life and natural landscape.

Vase — Re[creation]

'Vase — Re[creation]' depicts multiple fantastical environments where nature is peppered with leisurely human activities and man-made structures. Whether it is an observation deck for a viaduct connecting mountains, an elaborate water park coiling traditional pagodas, a camping site or playground, nature, history and tradition are mere vehicles that serve our need for consumption and entertainment. Collectively, these environments demonstrate the extent of man tapping, altering and interrupting every natural resource there is for recreational purposes.

Artist Charlotte McGowan-Griffin Photographer Patricia Sevilla Ciordia Technique Watermark on handmade paper

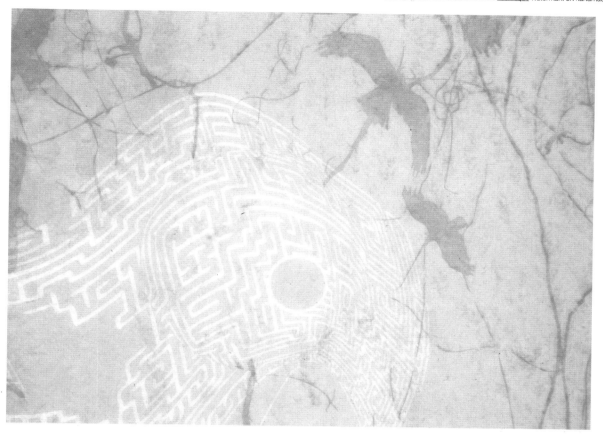

Substantial Forms

A limited edition work developed in collaboration with Berlin master papermaker Gangolf Ulbricht. What appears as a plain sheet of paper comes alive when light is applied to its surface. Watermarks, invented in the 13th century as a papermaker's 'signature,' are usually small symbols or initials in the corner of a piece of paper. However here, they cover the entire sheet to reveal a ghostly image through the elemental interaction of pulp, water and light.

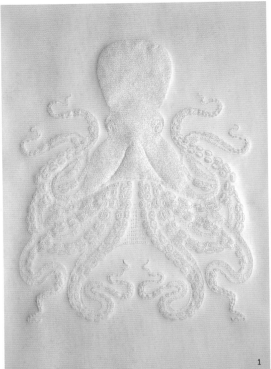

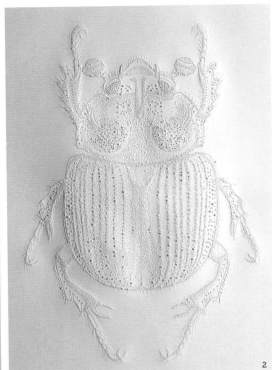

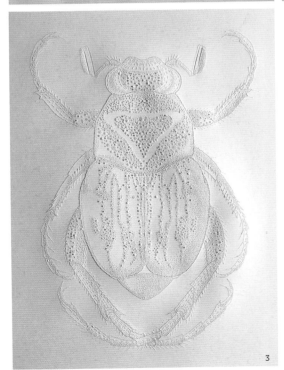

Natural World

1 / Octopus
2,3 / Scarab
4 / Lobster

In 2007, Pascale Malilo began making a series of 'drawings' that evokes the inventory of a natural history museum. She applies a kind of 'picotage' technique in her works. These 'drawings' are crafted by punching out little holes with a fine needle, creating outlines and patterns. Others series such as 'zoological' and 'botanical' were created with unusual techniques: gold leaf, wood glue or walnut stain.

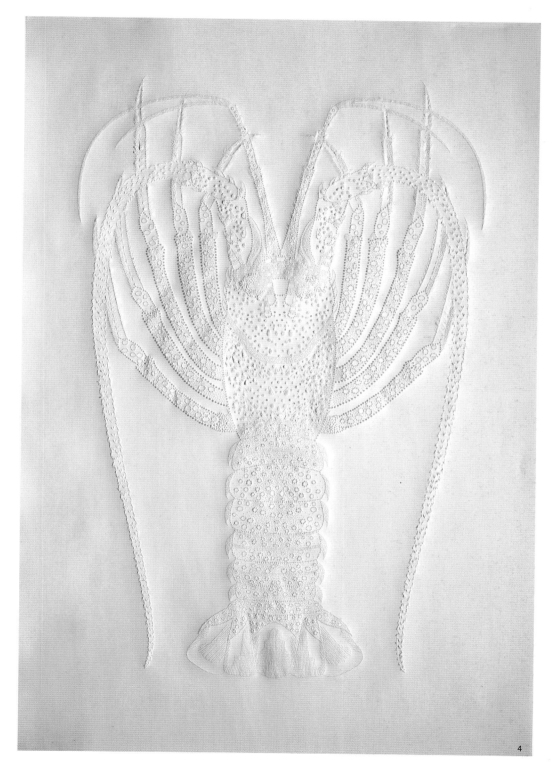

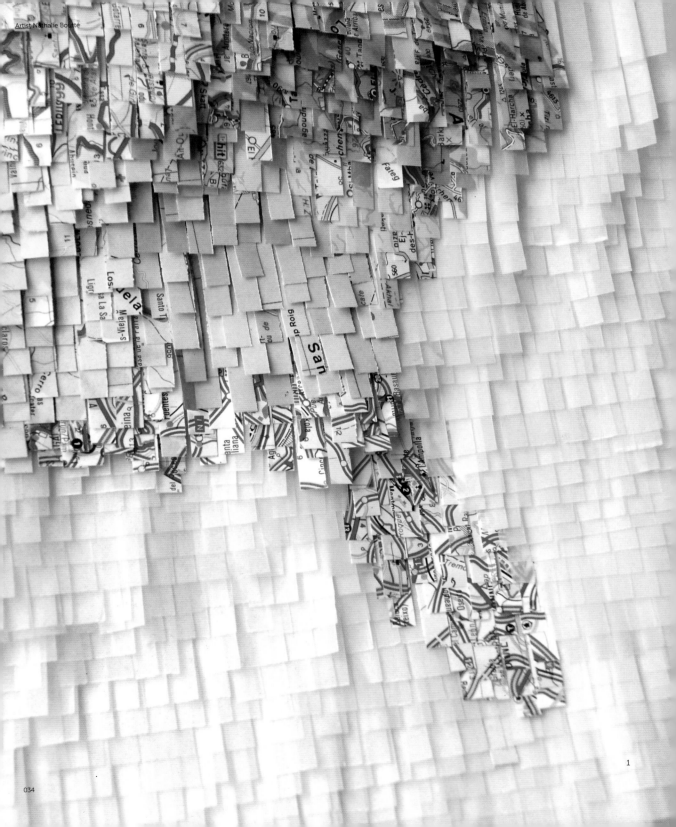

1

Strips Creation

1 / Work in progress (detail)
2 / Epicentre, 102 x 136 cm
3 / A mari usque ad mare, 84 x 140 cm
4 / Pangée, 67 x 148 cm
5,6 / Le passage (1) (detail), 116 x 66.5 cm
7 / Memories (detail), 73 x 100 cm
8,9 / Couturier Ballo (3), 102 x 53 cm
10 / Le petit chaperon rouge, 140 x 104 cm
11 / La disparition, 84 x 85 cm

Nathalie Boutté explores the limits of paper as
both material for her creations and as a carrier
for her works. She cuts strips of paper into
different widths and lengths, which she then
assembles to form figurative or abstract works.
With the development of IT, we are moving away
from printed media. With digital media we tend
to forget the simple pleasure of leafing through
a book. We have foregone road maps for GPS
systems. Nathalie cuts the paper not to weaken
it but to restore its primal energy. It is reborn
in the form of a coat and becomes animal. In
a world that goes faster and faster, she works
slowly. Nathalie takes the time to conceptualize
and realize every work. Each of them contains a
part of history or is part of her story, helping us
remember.

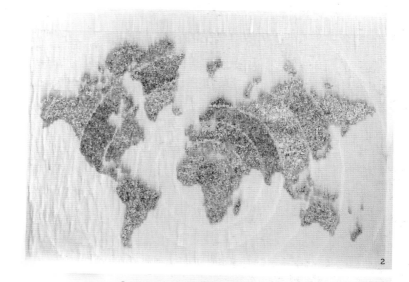

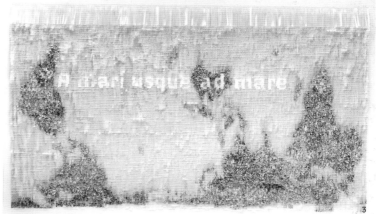

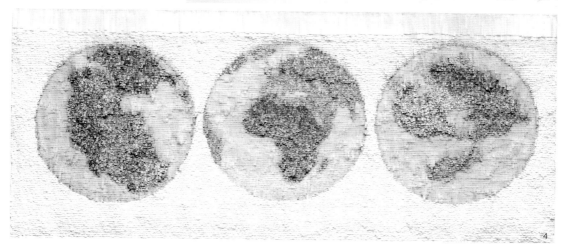

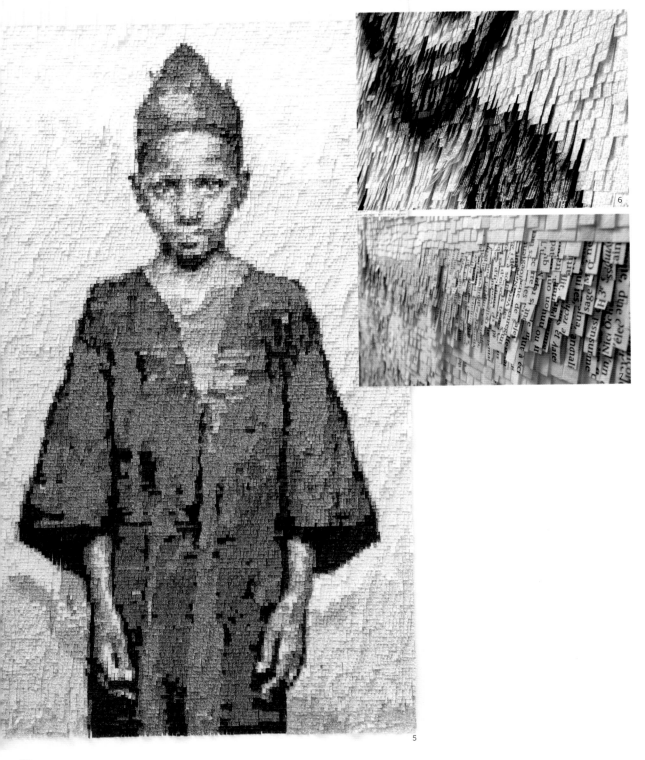

5

6

7

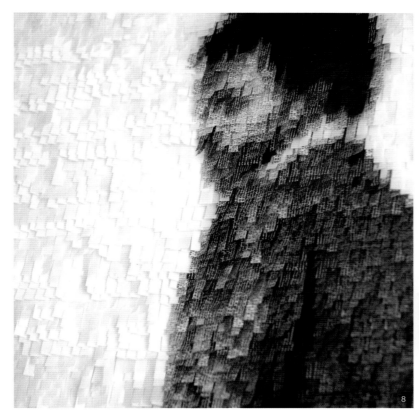

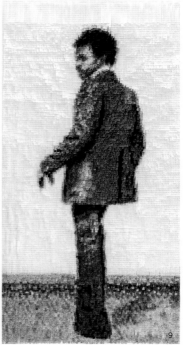

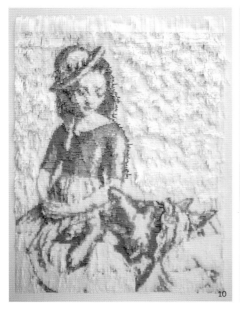

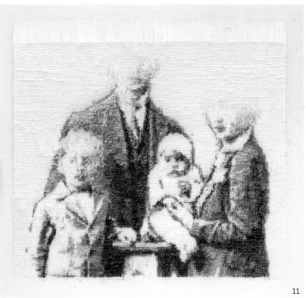

Footprint of Cities

1 / Coventry
2 / Moscow 1812
3 / London 1666
4 / Portland
5 / London 1940-1-4
6 / London 1940-1 Bloomsbury

There is a beauty in the contained history of existing forms and an innate beauty in the cartographic pattern or footprint of the city. The artist's sculptures use this structure and add a social and historical commentary, one that reflects the individuality and evolution of each city. He typically selects a pivotal period in the history of a given city and then finds texts that are specific to the time and place. The work is created by hand, each piece being carefully cut and formed from paper and he uses a map from a particular time period to build the sculpture. Many of the sculptures deal with cities at their most turbulent periods. They are works that attest to the underlying fragility of the urban organism and the transformations wrought by nature, politics and history.

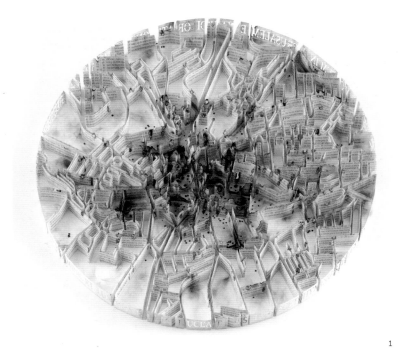

1

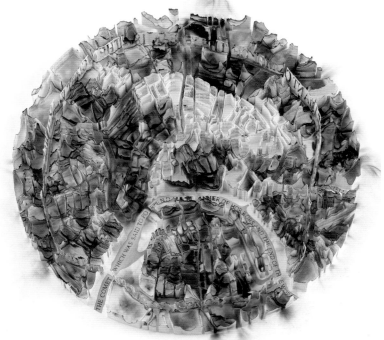

2

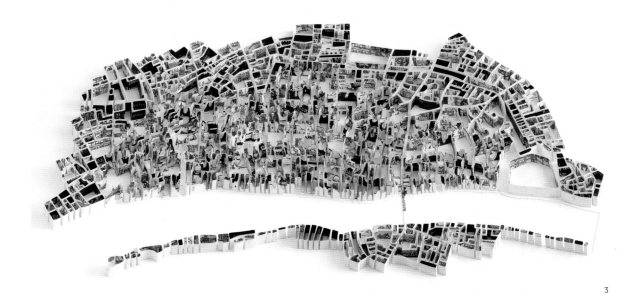

3

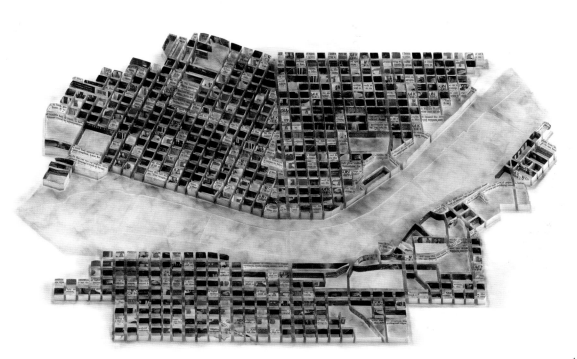

4

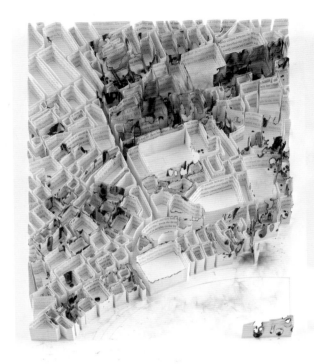
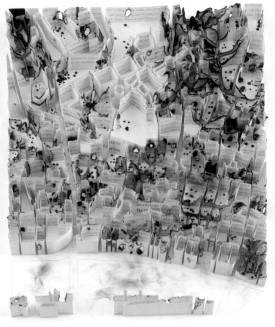
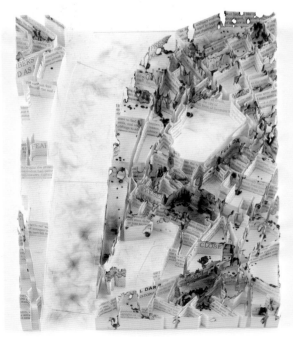
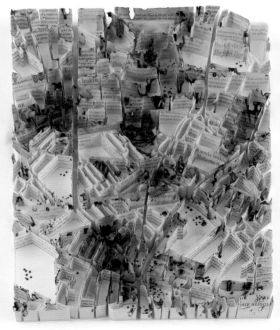

5

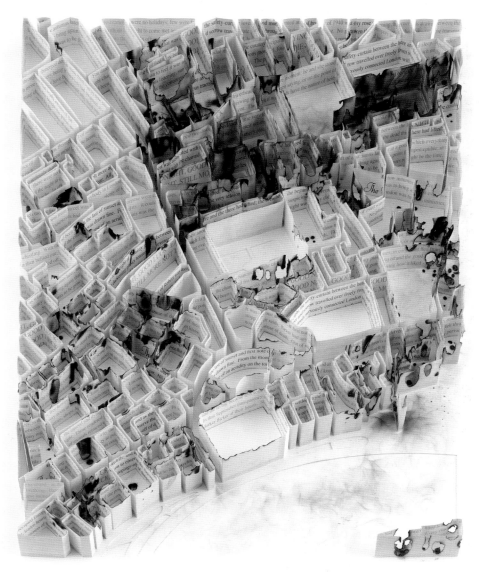

Metamorphoses

For these works, artist Charlotte McGowan applied shellac (a natural varnish produced by the lac beetle), to intricately cut paper. Here, Charlotte again picked up on the motif of the labyrinth and the theme of hidden patterns in nature.

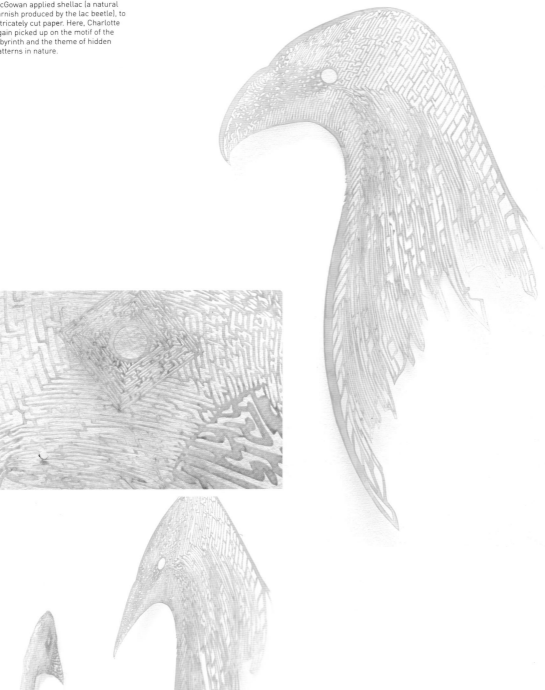

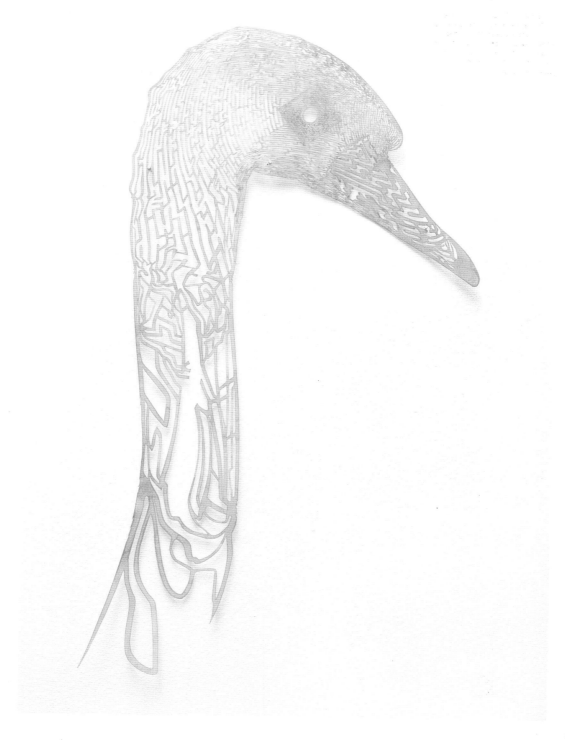

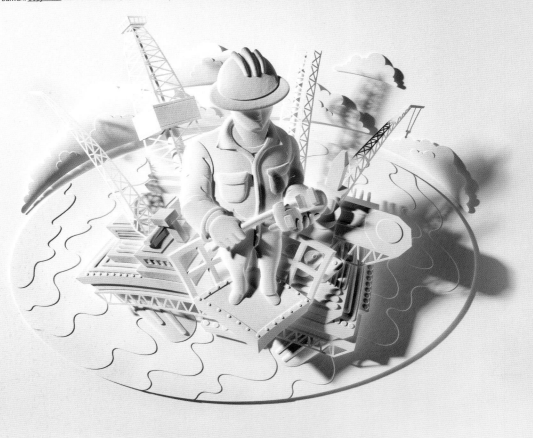

451° A Bulwark Film

Paper sculptor Jeff Nishinaka spent eight months creating a work of art — and then burned it to ashes. The film that documents this process was made as a reminder that, in the face of fire, life is as fragile as paper. For 451° that is the reason for everything they do — from training and technical support programs, to developing new FR (Fire Retardant) garments and seeking out better FR fabrics.

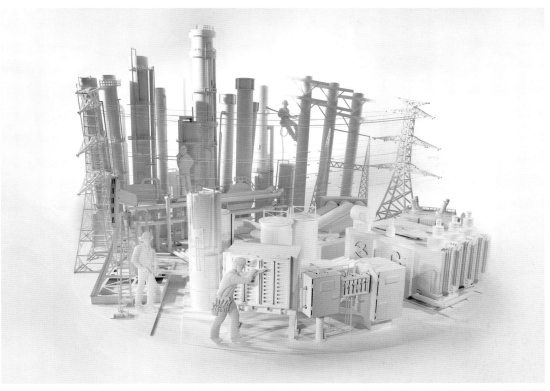

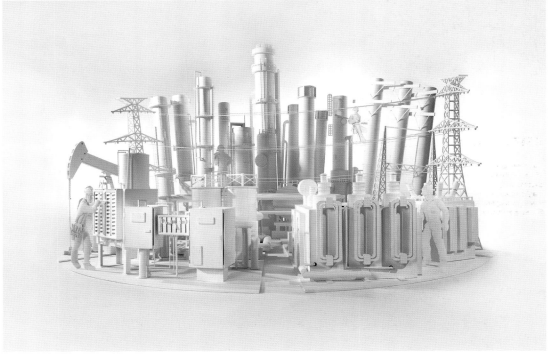

Designer Fideli Sundqvist Client Malmstenbutiken Photographer Helena Karlsson

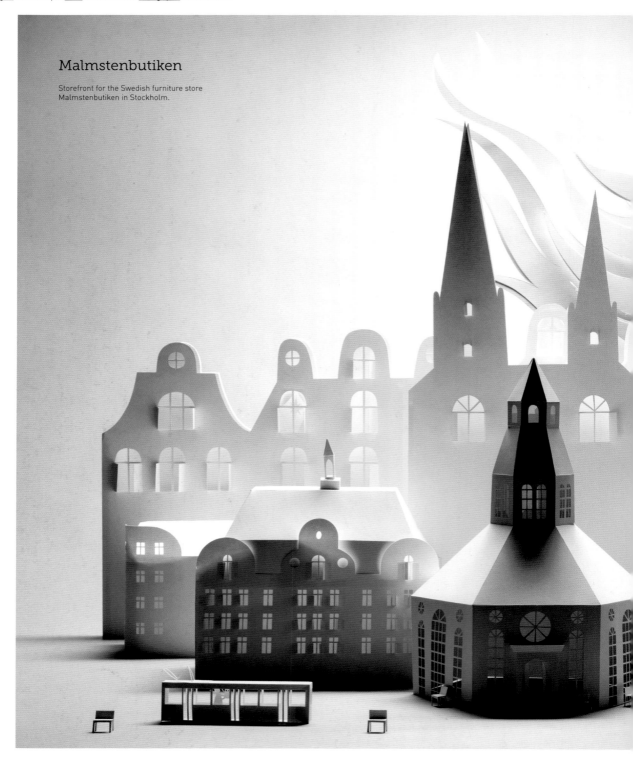

Malmstenbutiken

Storefront for the Swedish furniture store
Malmstenbutiken in Stockholm.

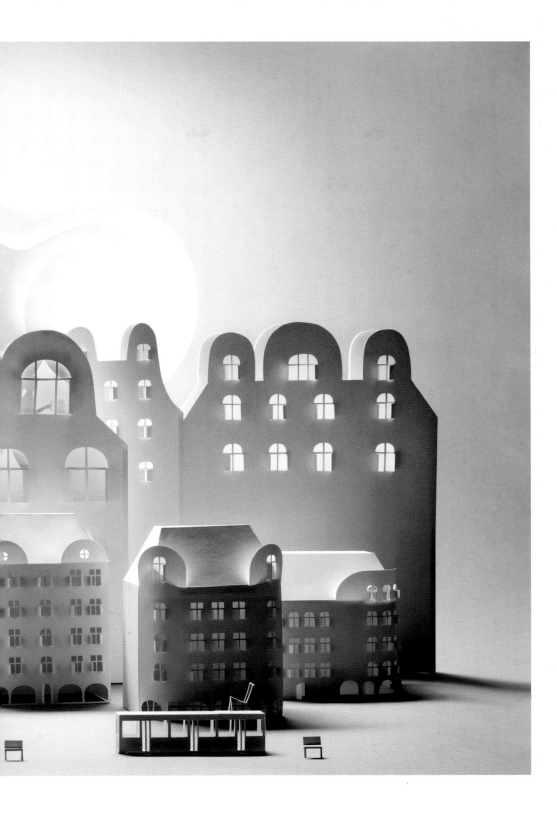

1. ABCs Book

Paper sculpture
representing the letter 'S'
for an ABC book featuring
26 artists from Bernstein
& Andriulli, New York. 'S'
stands for 'social' and today,
broadcasting now falls on
the audience. Successful
work, if embraced by the
public, will naturally be
amplified by those who
consume it.

2. Creativity

Cover for Spirituality &
Health Magazine

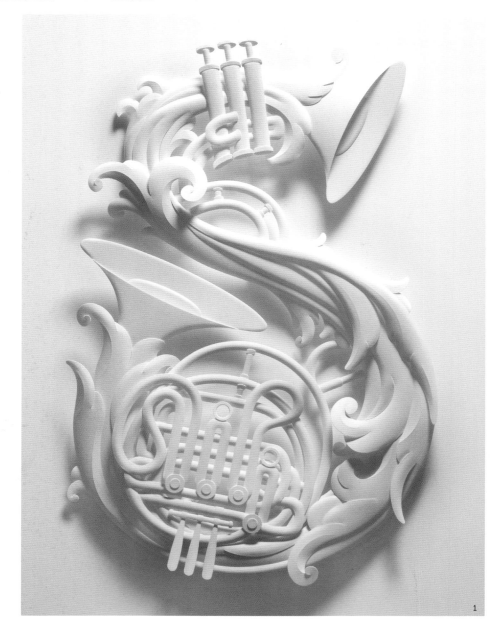

1

Artist Jeff Nishinaka Client Spirituality & Health Magazine Art Director Sandra Salamony Photographer Ed Ikuta

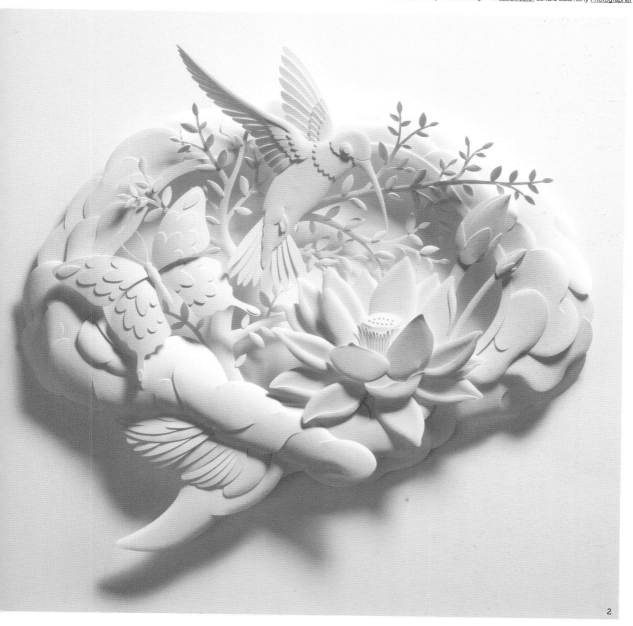

2

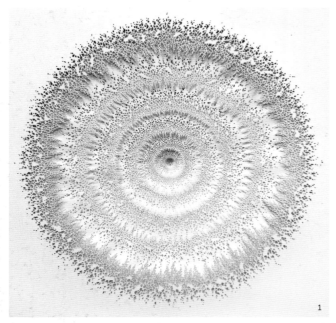

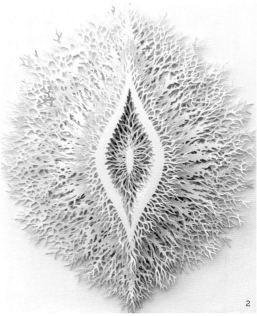

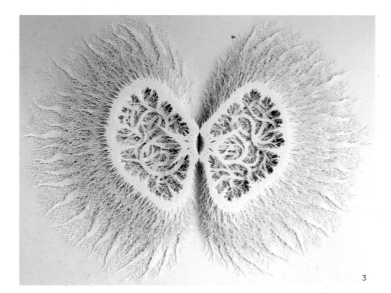

Redesigning Nature in Paper

1 / Clone (74x74cm, lasercut paper)
2 / Seed (50x40cm, lasercut paper, one of ten)
3 / Kernel (137x107cm, handcut paper)
4 / Kernel Detail 1
5 / Kernel Detail 2

The focus of Rogan Brown's artistic practice is an exploration of the relationship between the imagination and nature; that is, how the artistic imagination engages with and responds to the natural world. We can perhaps identify two broad artistic approaches to nature: on the one hand the 'Romantic' and on the other the 'Scientific.' Rogan's work draws on both of these approaches. Each piece starts with detailed observational drawings and precision of the paper cutting method, these, combined with construction of the three dimensional objects, brings to mind scientific model making and illustration.

Each piece is immensely time-consuming and labor intensive and grows organically rather than by precise design. One layer succeeds another until a kind of autonomy is reached and the piece itself begins to dictate its own development. Living through this process, which sometimes lasts for months, for Rogan, is the artwork, not the finished object itself, which is a kind of ghostly fossilized vestige of all the time, labor and imaginative energy that went into the piece.

Rogan's ultimate goal is to communicate his slow and sometimes frustrating, but always joyous, communion with nature; both in the external world of vegetation and minerals and internal, in the world of the imagination. He hopes to represent the startling detail, complexity and intricacy of natural forms and, by using paper, highlight their fragility and delicacy. Ultimately, he aims to recapture that moment of awe and wonder we had as children when we looked through a microscope for the first time.

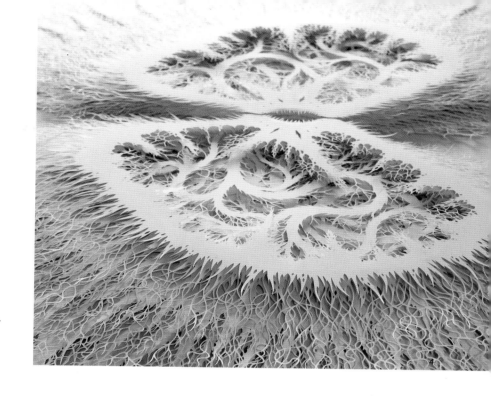

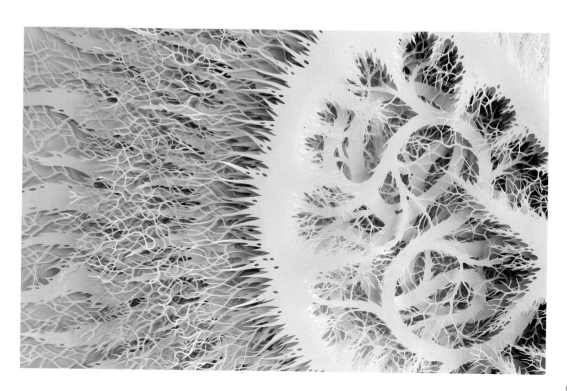

1

Cut-out Objects

1 / Thesaurus (21 x 15 x 19 cm.)
2 / Sand Clock I (20 x 24 x 20 cm.)
3 / Clock I (21 x 22 x 22 cm.)
4 / Sun Clock I (18 x 21 x 18 cm.)

Pablo Lehmann likes to transcribe texts and cut book pages in order to reconstruct them, creating different net forms. Cutting papers for him is always a way of writing, of creating spaces and transfiguring texts into single objects. Each page, each disjointed book, enables him to argue a personal point of view, but above all it is a place where the reader is committed to invent new paths of comprehension from each cut text. In this sense, words are not just vehicles of meaning but also shapes — mysterious webs that everyone can interpret and read using their most intimate code, their most secret desires.

2

3

4

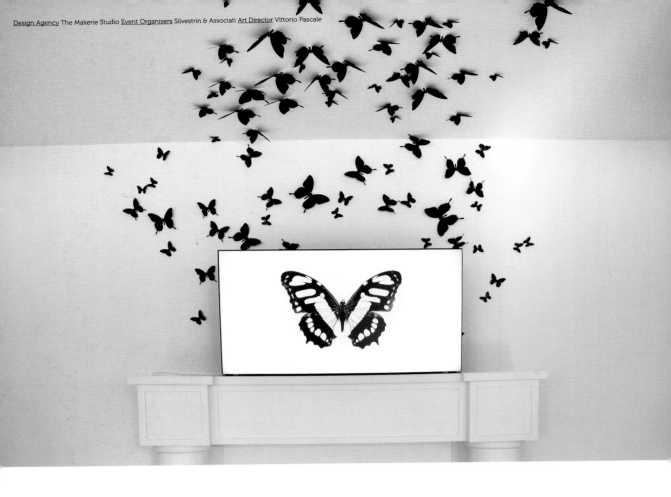

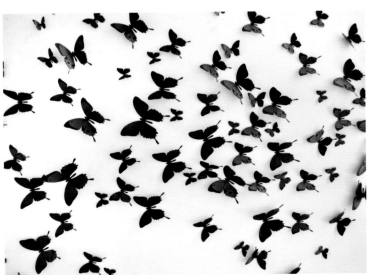

Mambrini Show — Milan Fashion Week

Three hundred iridescent black paper butterflies were made for Mambrini's evening show at Milan Fashion Week Spring 2013. The butterflies were placed on the walls, columns and ceiling of the showroom to complement Mambrini's new collection and videos.

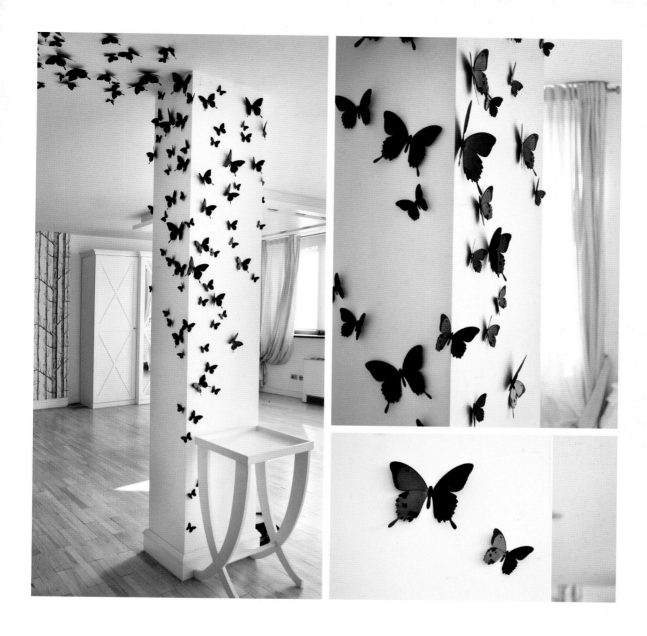

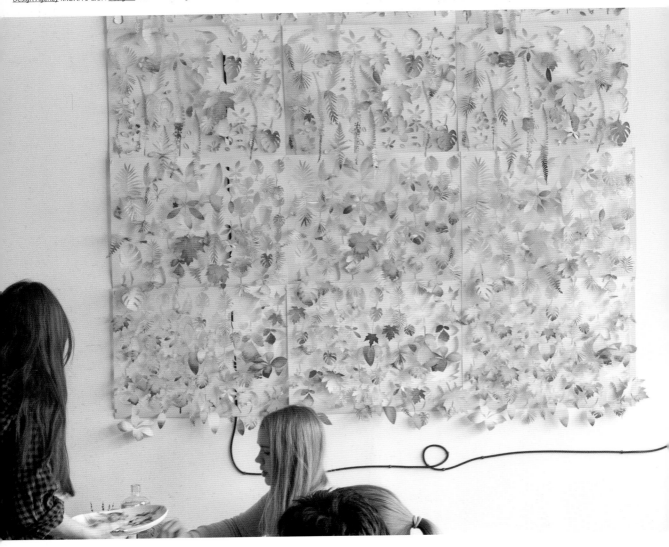

3D WALLPAPER

Inspired by gently falling autumn leaves, KRONA & LION turned to a combination of low and high-tech contemporary craft techniques to create a three-dimensional wallpaper in celebration of their signature material — paper. Delicate floral motifs cascade from the wall, pushing the limit of surface and pattern, allowing for the emergence of new objects, not visible upon first glance.

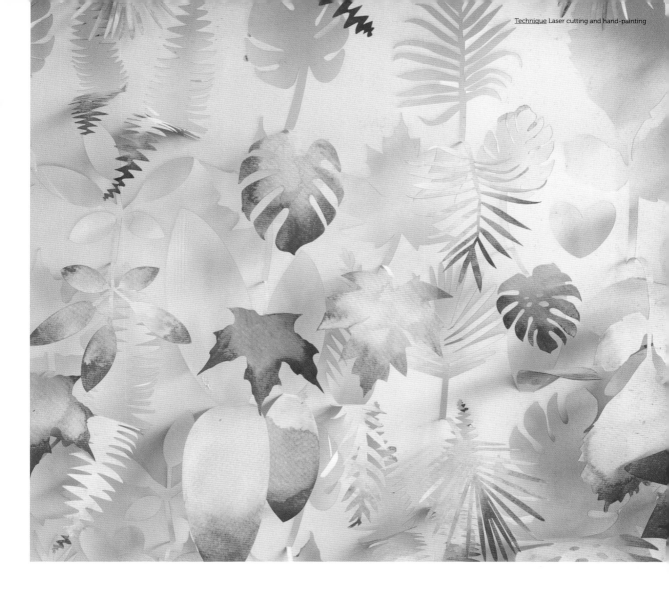

A Miniature World

1 / did you feel something
2 / it was an improvement
3 / it's worth it this time
4 / I think I missed that part
5 / Is it May Already

The way a painter takes to canvas, paints and a brush, Cybèle Young's medium of choice is Japanese paper. It possesses qualities of strength and sensitivity, beauty and subtlety. It challenges and inspires, while being patient and understanding. Working with paper, Cybèle employs printmaking and sculpture in her work, often unifying both processes. She pays attention to the minute — creating a world within a world, remaking the large into the small in order to grow larger anew. She creates art as a way of building a personal dictionary. Responding to her surroundings, she ends up creating a sculptural journal in miniature from the world in which she immerses herself. Using an inventory from everyday life, she creates 'words' that compose sentences and form stories. Engaging with abstract and familiar motifs, Cybèle juxtaposes sculptures to create a sense of dialogue or play between them. She compiles these in various permutations to create communities that interact and form new relationships — much like the small, seemingly insignificant moments in our everyday lives that come together to create unexpected outcomes.

1

2

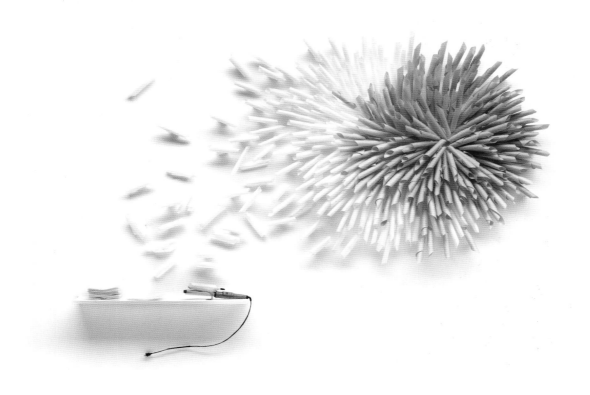

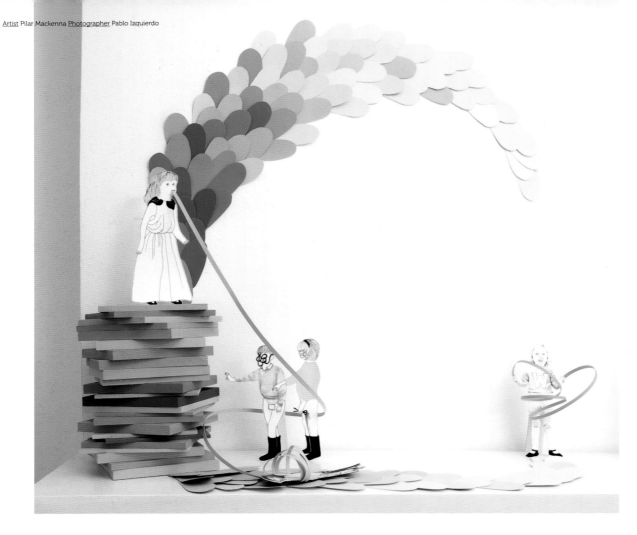

Mary Bell

Mary Bell was Pilar Mackenna's solo exhibition at MORO gallery in 2010. This installation plays with the deception of beauty. Delicate lines and colors transfer the friendly appearance of fairy tale into horror scenes that wrap you up and turn you around.

Regardless of the media, Pilar's purpose is to create relations and scenes with characters that combine irony with terror. She means to disturb our normal perception of these things and create hallucinating landscapes and fairy tale images using decontextualization as a common resource.

In Mary Bell, she employs misrepresentation and censure of children's fairy tales. The information contained in these stories has been distorted because of translations and the urge to moralize and rationalize their contents; we are therefore victims of censure ourselves. Her intention, when she creates, is to reinterpret and manipulate didactics, showing the latent contents hidden behind the apparent sweetness of children's tales.

The refined aesthetic of the artist, with its delicate colors and ingenious play with volume, returns to us a more tolerable horror. With her play on the deception of beauty, the elegance of her materials and the way they are presented, Mackenna makes us forget her intention is to horrify us.

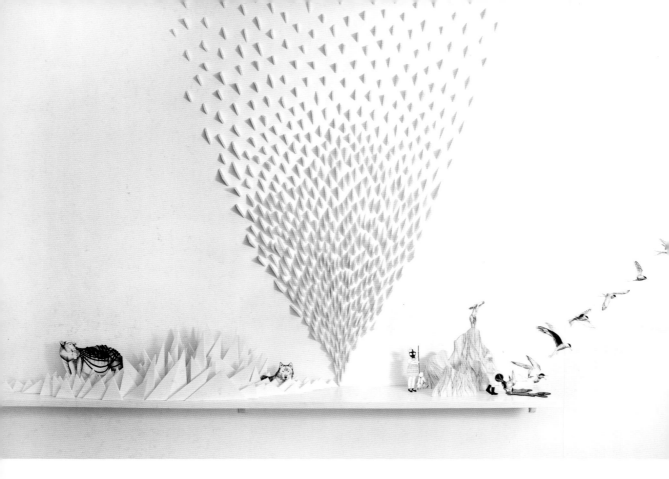

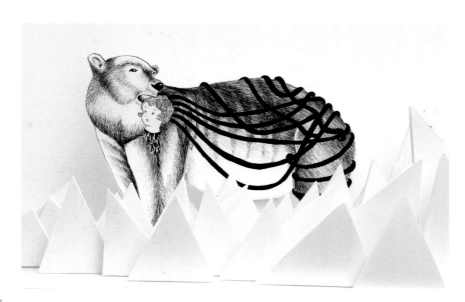

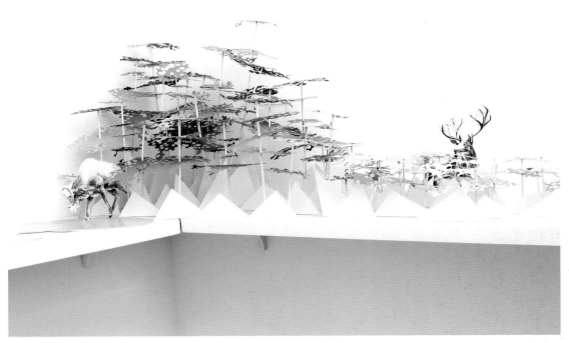

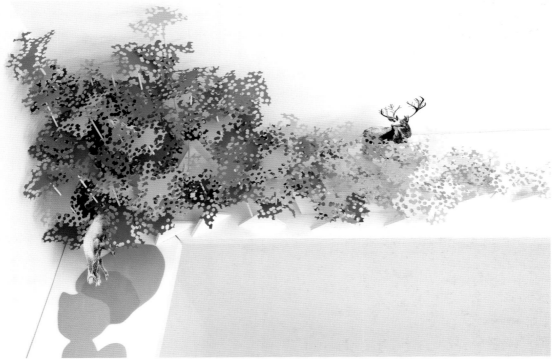

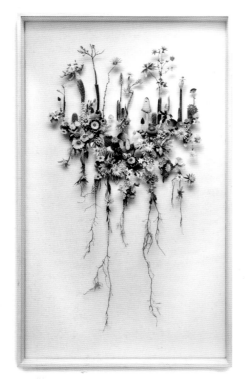
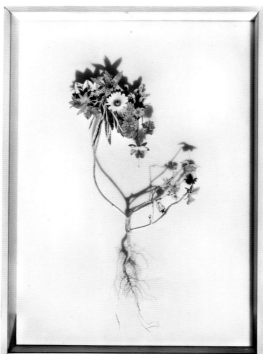
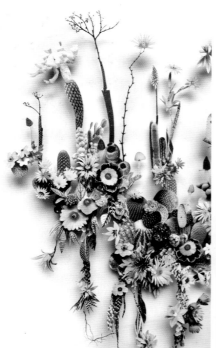
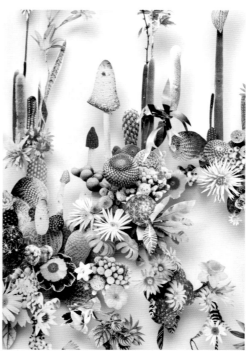

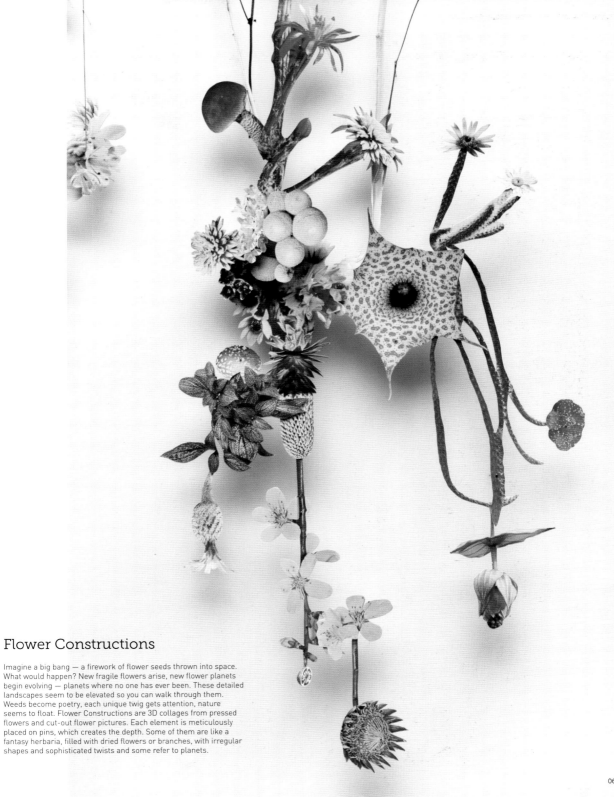

Flower Constructions

Imagine a big bang — a firework of flower seeds thrown into space.
What would happen? New fragile flowers arise, new flower planets
begin evolving — planets where no one has ever been. These detailed
landscapes seem to be elevated so you can walk through them.
Weeds become poetry, each unique twig gets attention, nature
seems to float. Flower Constructions are 3D collages from pressed
flowers and cut-out flower pictures. Each element is meticulously
placed on pins, which creates the depth. Some of them are like a
fantasy herbaria, filled with dried flowers or branches, with irregular
shapes and sophisticated twists and some refer to planets.

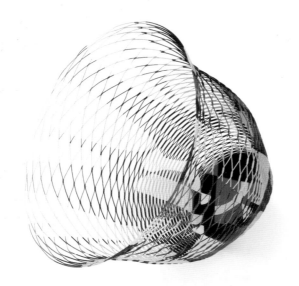

Airvase

1,2,3 / party
4 / garden
5 / sky

This is a paper bowl that envelops air. It is possible to create various shapes by pulling it in different directions. The paper is thin and light, but when expanded it is rigid and strong enough to stand alone. The charming textile patterns come from the fashion brand minä perhonen. With its designs inspired by observations of society and poetic sentiments for the natural world, minä perhonen creates a wide variety of original textile designs, including woven fabrics, prints and embroidery. In 2006, minä perhonen was awarded the grand prize at the 'Mainichi Fashion Grand Prix.' Its design fields now include lifestyle design like furniture and ceramics and uniforms for the TOKYO SKYTREE®. Pictured are the three series of airvase 'garden,' 'party' and 'sky.'

'garden' series: transports you to a fresh field of wild flowers swaying in the breeze.

'party' series: enhances the joy of gathering with friends through a fascinating collection of motifs.

'sky' series: evokes beautiful melodies of the sky with migratory birds in flight and the rhythmical sound of raindrops.

1

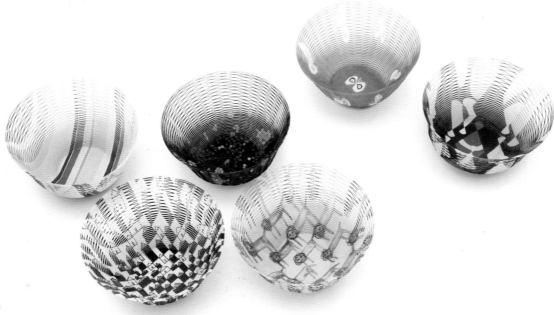

2

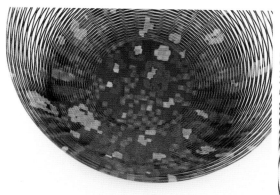

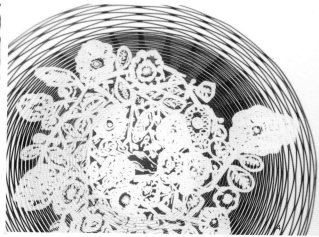

3

4

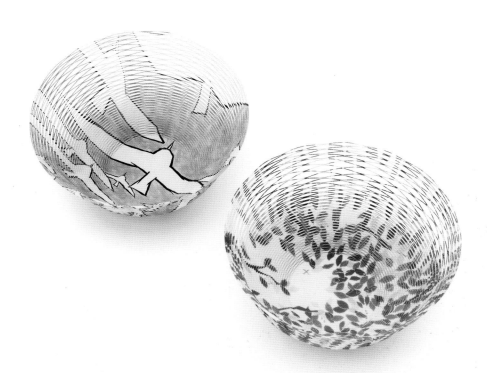

5

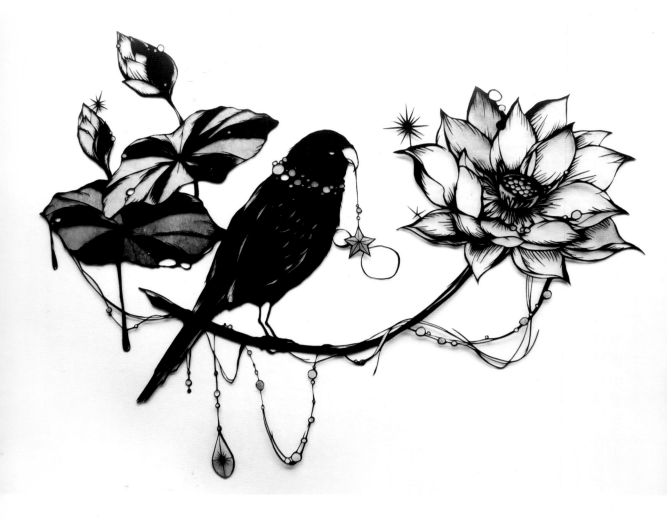

Rei-Getsu (Icy moon)

Designer Ohashi Shinobu imagined a bird and a lotus and assumed a water drop from that lotus became a piece of jewelry.

Capture Ideas in Paper

1 / Old Person of Bree
2 / Deep Blue
3 / Whale-Spirit

Sarah Dennis's work combines traditional scherenschnitte (paper cutting) with collage that is inspired by her interest in nature, classic children's stories, poems and plays. She has always been fascinated with the beauty of oriental artwork. Her grandfather collected Japanese artwork and books in which she took great interest and spent hours and hours studying as a child. It was when she discovered Chinese folk art that she found paper art and was truly amazed by the intricacy and detail of this work. She began to experiment with how to capture ideas in paper. Fascinated by the shadows that different forms take, she felt it important to explore how she could add height to the artwork and incorporate the play of natural light within each piece. To create shadows, she hand cut each layer with a craft knife and float mounted each piece with acid free pads. The shadow behind the paper graciously changes with the ambient light in the environment to create a sense of movement, which is a recurring theme within her work. She seeks to capture a fluidity of nature and a moment of narrative, which is entangled within layers of the paper.

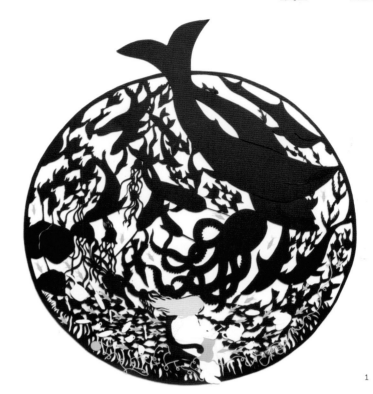

1

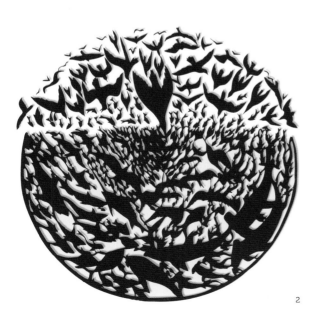

2

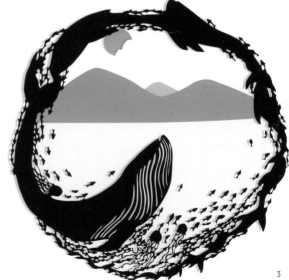

3

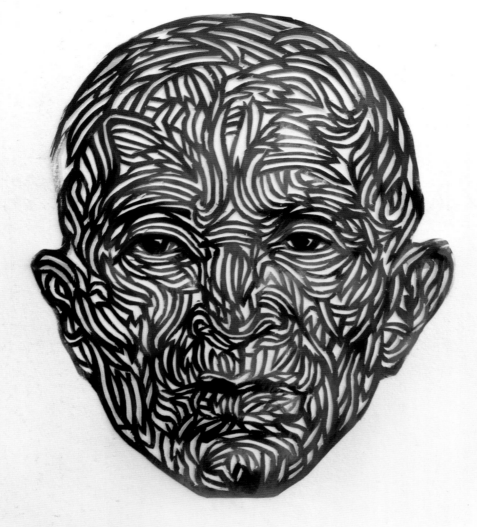

A reconstruction of traditions

1

1 / Portrait of Briek Schotte
2 / Portrait of Roel Arkenstein
3 / Portrait of "Think"
4 / Portrait of Theo Wesselo
5 / Portrait of Marco

The works of Kuin Heuff are painted and cut portraits on paper. Kuin paints a full portrait in acrylics after she puts the knife into the work. She works from the layers of paint and brush strokes to transform the painted portraits into a lace-like structure of dazzling patterns and lines.

In 2007, she began working with paper cutting as a direct result from research of the physical painted portrait, where she examined the paintings like studying the anatomy of the body in the dissecting room.

Besides this direct motive, the research started 15 years earlier. In 1993, Kuin Heuff started painting portraits in an ongoing process of painting and repainting, to create a portrait. Constructing by destruction. In the following years, she combined painting portraits with various disciplines of art such as installation, fashion, moving pictures and performing arts. She exchanges the typical creative process of combination by the construction of images through the destruction of them.

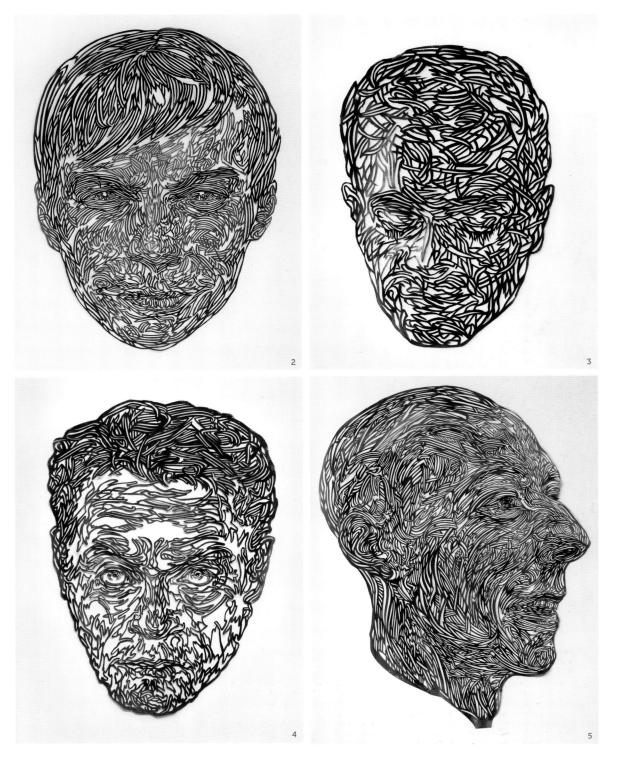

2

3

4

5

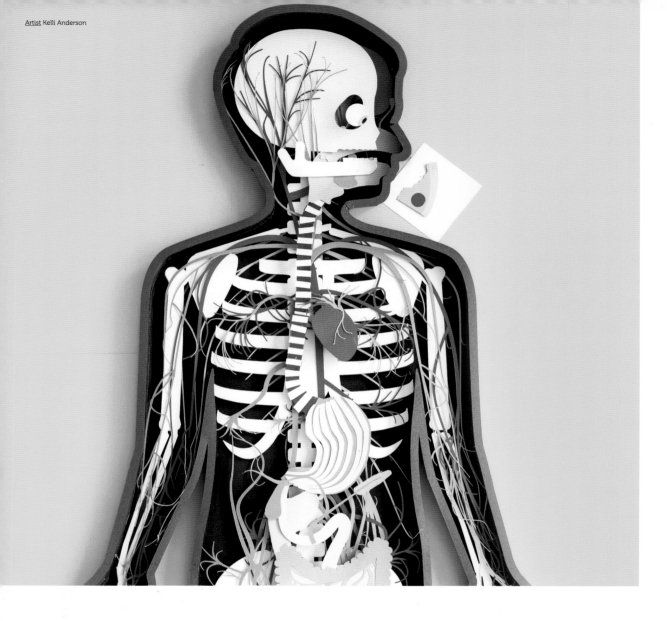

The Human Body

Longtime friends of artist Kelli Anderson recently started a company called Tinybop, which creates system-thinking apps for children. Kelli designed and illustrated 200 or so images of bones, veins, nerves, teeth, guts and chewed-up-food, of which the illustrations are comprised. Anything that a real body does, this body does — it eats, digests, pumps blood, gets sick, burps, runs in place, you name it — all at multiple zoom levels with a realistic variety of responses to the users interaction. This stop-motion app-demo for Tinybop's The Human Body is made entirely out of paper (including the sounds). It shows children how the body's systems function by layering them into place like an old-fashioned biology textbook come to life. Raul and Youngna conducted the biology research with an attention to detail tantamount to at least a semester of medical school, consulted with doctors and sent hundreds of images of each organ to Kelli, which Kelli interpreted in this not-quite-textbook style.

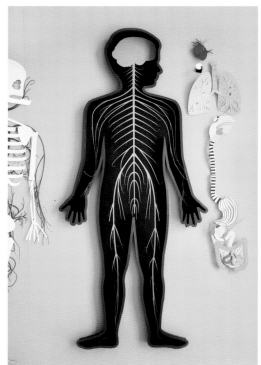
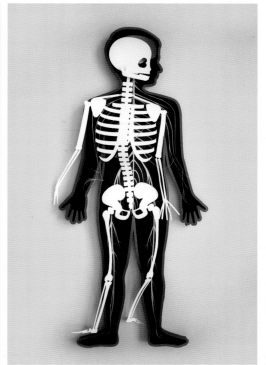
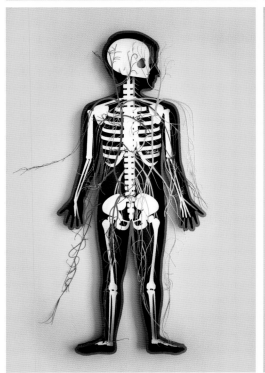
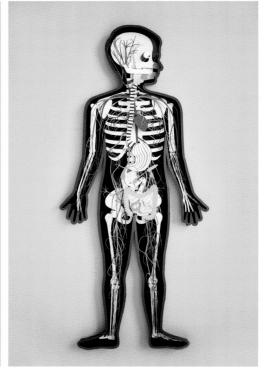

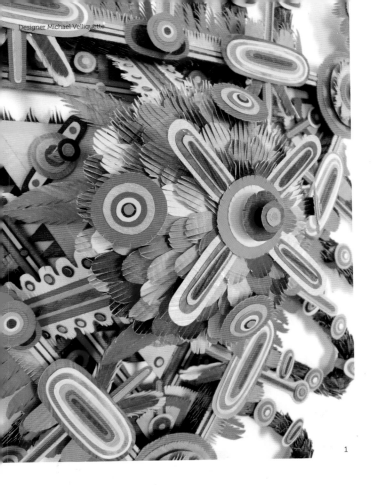

Paper Constructions

1 / Meat Eater
2 / Happy Tower
3 / Power Structure II

These works represent a recent selection of Michael Velliquette's sculptural and pictorial cut paper constructions. The three-dimensional sculptural works embody an array of pan-cultural design and art historical influences, while being simultaneously suggestive of powerful ritualistic ciphers.

The low-relief paper pictures are also a recurring format for Velliquette. Drawn from the worlds of dreams, myths and inner reflection, Velliquette's paper vignettes illustrate enigmatic musings about consciousness, otherness and the self. Central to Velliquette's work is the intrinsic drive of 'making' for its own sake. This results tangibly in a dizzying abundance of colors, shapes, tones, patterns and textures. Such aesthetic traits could also be found in devotional ornamentation, or, what Velliquette describes as "our natural human impulse for razzle-dazzle."

1

2

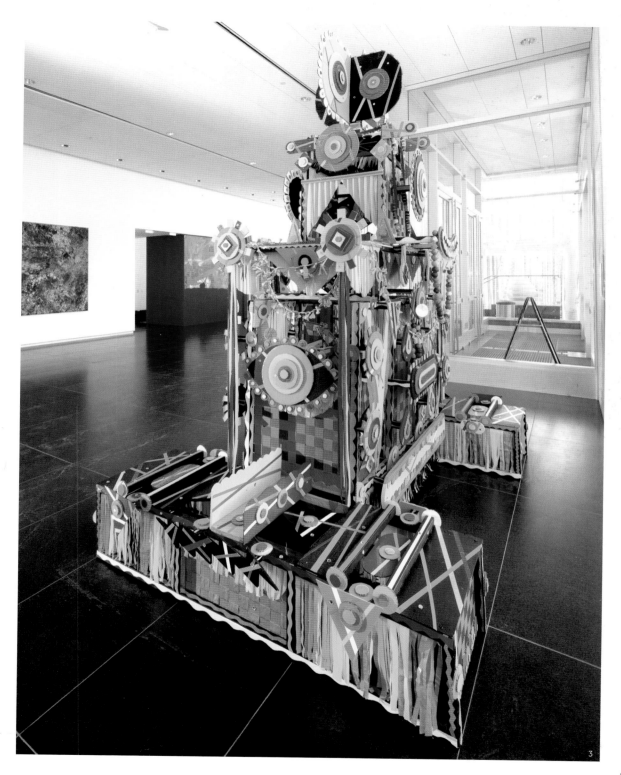

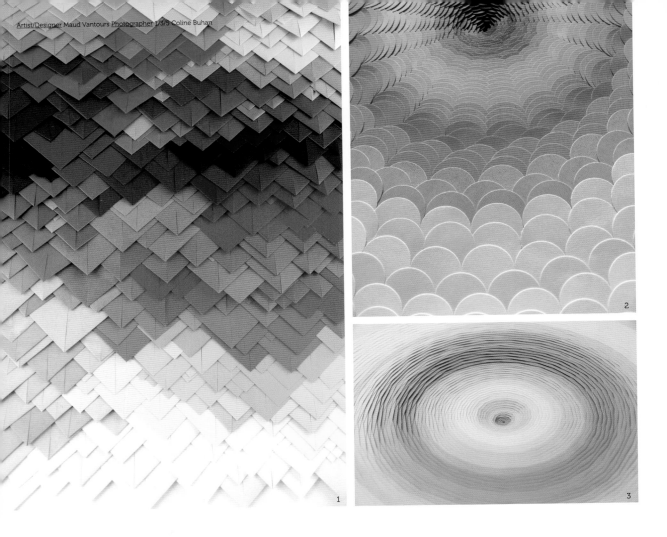

Multicolored Landscapes

1 / Envelopes
2 / Spiral detail
3 / Spiral
4 / Landscapes
5 / Montagne Satomicsoda

Color, material and patterns place an important role in Maud Vantours' work, like paper, which became her favorite material. She sculpts it in 3D layer after layer, by superimposing paper and colors to create inspired patterns in volume. Maud's work transcends a simple material and transforms it into a work of art. Her design creations are original graphics of multicolored and dreamlike landscapes. Her works mixing art and design have been shown in galleries and international exhibitions. Maud has also charmed and worked with major luxury brands including Guerlain, Tag Heuer, YSL, Lancôme and large retailers.

4

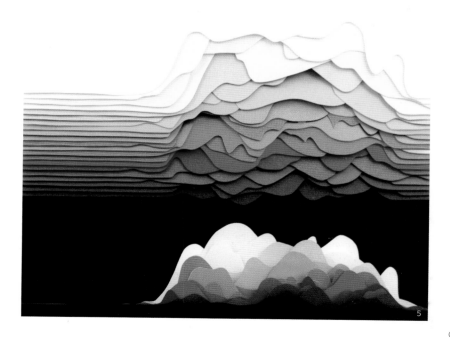

5

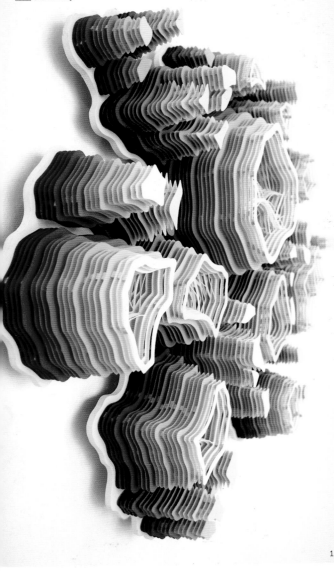

1

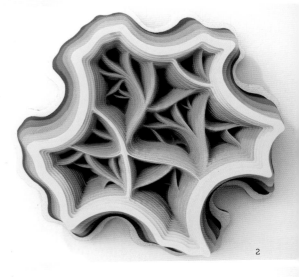

2

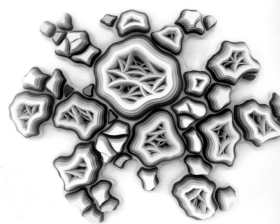

3

Wonders in Tragic Circumstances

1 / Patiflasmic Necrodiddlitis Detail
2 / Hugg-a-Diddle Workup Movement #2
3 / Patiflasmic Necrodiddlitis
4 / Hugg-a-Diddle Workup Movement #7 Detail
5 / Hugg-a-Diddle Workup Movement #7
6 / Patiflasmic Plasmatic Gestation Movement #1

In February of 2013, both of Charles' parents lost their battles with cancer. It was a devastating moment in his life and he stopped making work for a period time. He faught to find meaning in what he was doing, but he was lost in his grief. Over time Charles put all of that into his current body of work. His paper towers now represent cancer cell growth and how this continual growth expands, taking over everything it touches. Injected with bright neons and blown out colors, they take on the notion of radiation and chemo treatments and what that might do to the sinewy understructure of the human body. They are not meant to be a macabre reflection on a terrible disease, but a reflection on life and the wonder that can be found in the most tragic of circumstances.

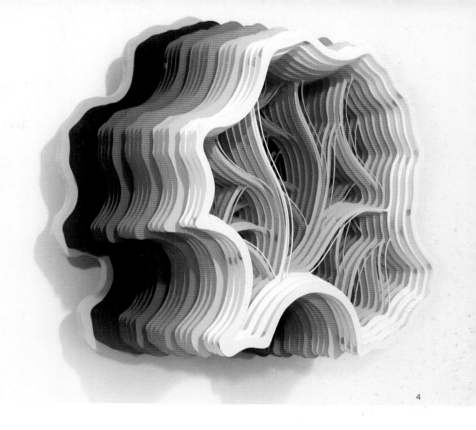

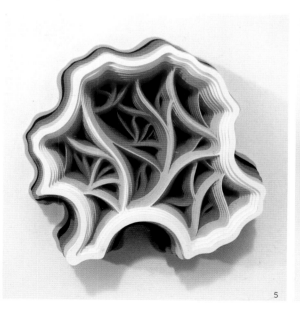

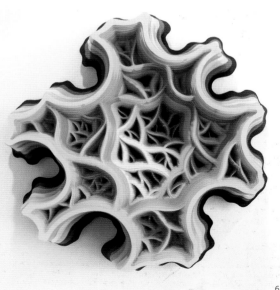

4

5

6

Designer Adriane Colburn Photographer Etienne Frossnard

Hyperspectral Spell

This piece is derived from a series of photographs Adriane Colburn took in the Peruvian Amazon along the Madre de Dios and Manu River, in French Guyana and in the tropical forests of Costa Rica. This work reflects the tension between the natural world and the transformation of nature into a commodified, industrial or synthetic landscape. The color and structure of this piece is informed by maps that are made from great distances such as satellite, infrared and LIDAR imaging and color maps that are imposed on the landscape when it is revisualized for scientific purposes.

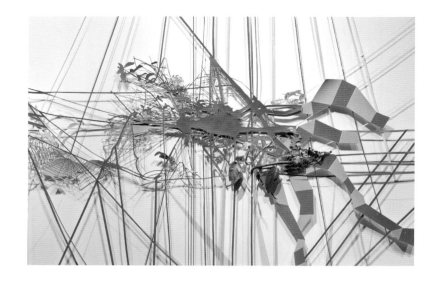

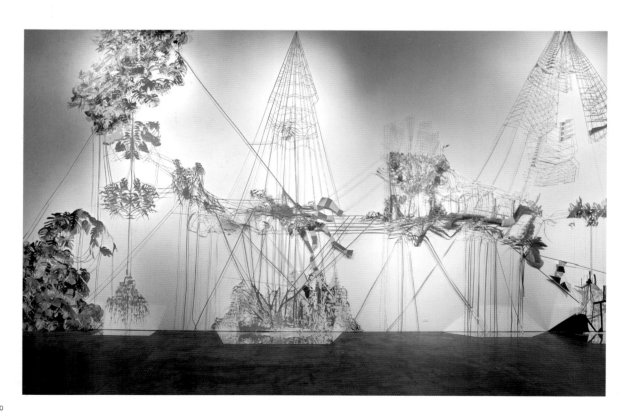

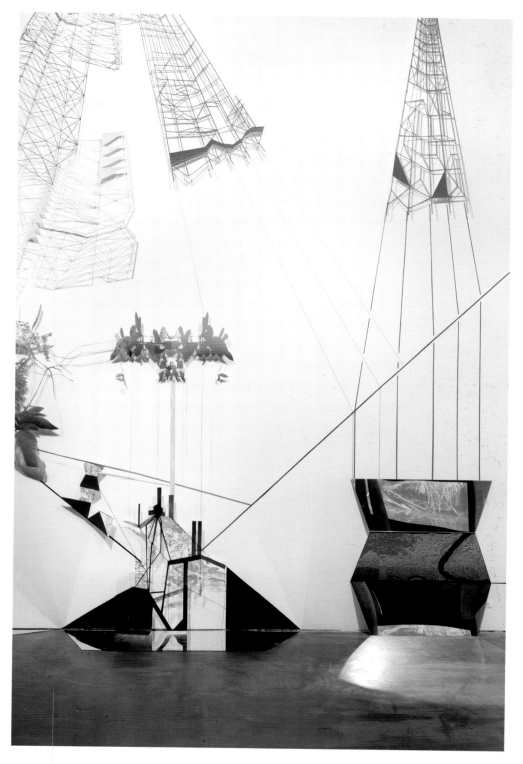

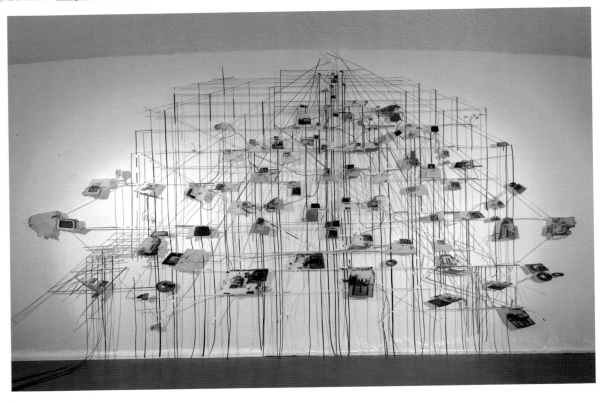

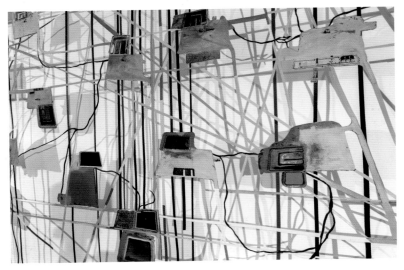

Denatured Ground

This project was generated from a series of photographs Adriane Colburn took from a small airplane over Midland/Odessa Texas, the center of the West Texas oil and fracking boom. The work combines aerial photographs with images from Google Maps to create the grid and network of roads and rigs one sees from the air. All of the natural sections of the landscape have been cut away.

Ways, Points and Means

This installation combined photos, videos, wall works and sculpture that were generated from 3 trips at sea with research scientists in the Arctic and the Amazon Plume. The works in the exhibition specifically focus on the sea as a persistently foreign body, an overlooked wilderness that one attempts to comprehend through technologies, optics and cartography.

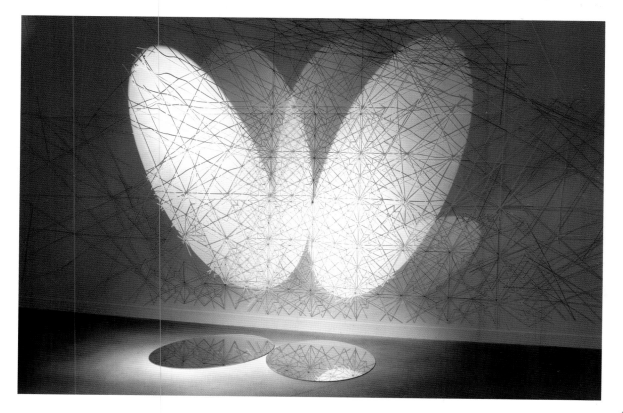

Artist Liz Shreeve, Image Courtesy by Michel Brouet

Light Spectrum & Coriolis

1 / Light Spectrum (200 x 66 x 3 cm)
2 / Coriolis (39 cm diameter)

Light Spectrum is water color on cut and folded paper, while *Coriolis* is torn and curled paper on constructed paper form. Liz Shreeve sees no great divide between science and the arts. She incorporated art into her previous career as a science educator and science informs her art practice. Her work is driven by observation and obsessed with light and color. It is about slowing the eye and seeing beauty in simple forms. She works in low relief using identical units, arranged in predetermined sequence, to catch and color light. Ambient light, varying through the day and night, is her raw material. Recently, she has been working in three dimensions and has observed with wonder that the repeated sequences of generated objects is reminiscent of organic forms. Like mutations in DNA, small changes in sequence lead to differences in structure. She aims to continue experimenting and producing works that engage with ideas of development, diversity and beauty and engage the viewing public.

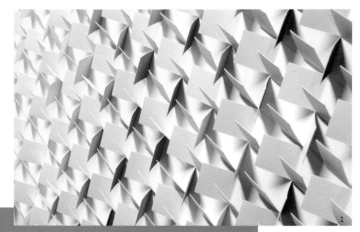

1

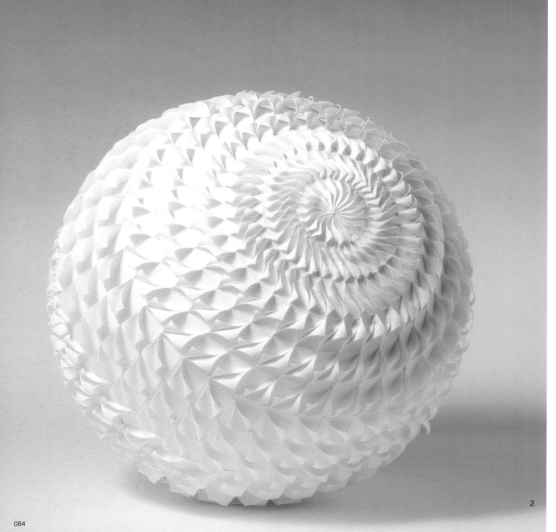

2

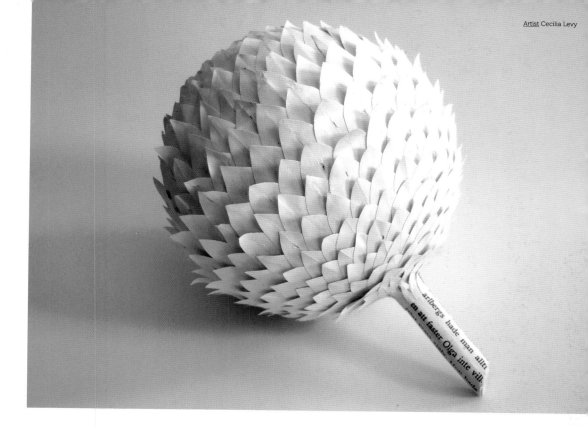

Daily Thistles

Old books carry a history, not just the story written on the pages — dog-ears, stains, a dedication on the flyleaf, a doodle in the margin. Smooth old paper, soft, creamy white or discolored, brownish and brittle — a material full of nuances, different shades, texture and personality. Graphic design and papier-mâché are combined in an entirely unique way in the works by Cecilia Levy. She uses books from the beginning of the last century, takes them apart, tears, shreds or cuts the pages into small pieces that then reassemble new objects. Like eggshell, they are thin and light weight, yet remarkably sturdy. The story lives on, but in a different shape.

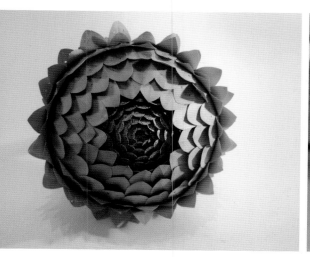

Designer Madeline Silcock Photographer Matt Silcock

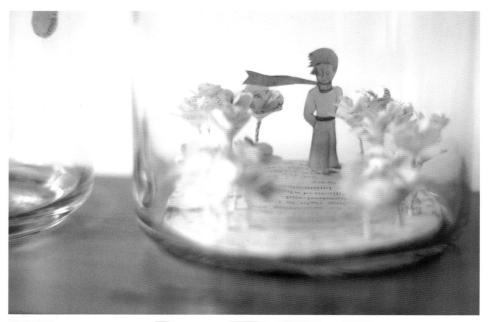

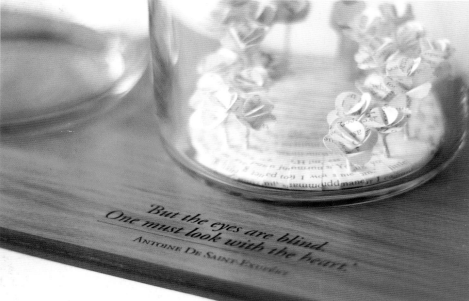

Preserving The Story

Preserving The Story is a work that speculates on what the book could become in the future. While it assumes that the digital and the physical can exist in the same space and time, it explores the idea of authenticity in the materiality of the book. It uses *The Little Prince* by Antoine De Saint-Exupéry to discuss the connections people have to books just as Saint-Exupéry's story explores ideas of personal connections to physical objects. The work consists of three jars that act as a metaphor for the concept of preserving the story for the future, ensuring that its essence does not get lost in the translation to the digital. Inside the jars are objects essential to the story, shaped by its pivotal themes and crafted from pages of the book itself. The work was constructed for *Future of the Book*, a paper in the School of Design at Massey University, New Zealand and supervised by Patricia Thomas.

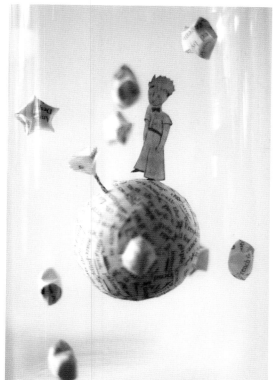
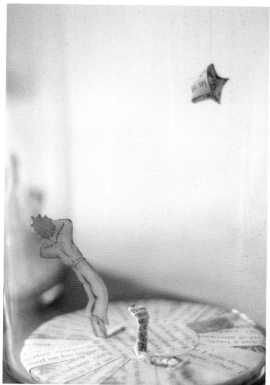
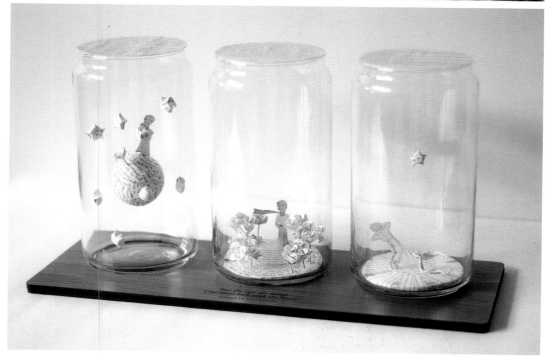

Design Agency The Makerie Studio Photographer Giannuzzi Marino Styling & Curator Amusingold

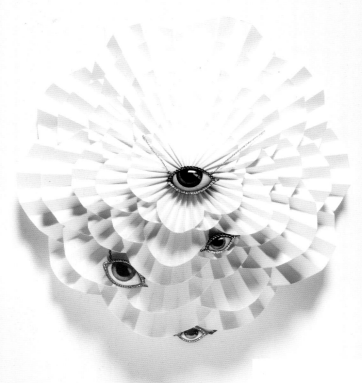

LuisaViaRoma Editorial

Iridescent paper textures constructed for fashion icon LuisaViaRoma's editorial on abstract Italian art. Each texture was created to contrast and complement the jewelry photographed with it, as a subtle but structured backdrop.

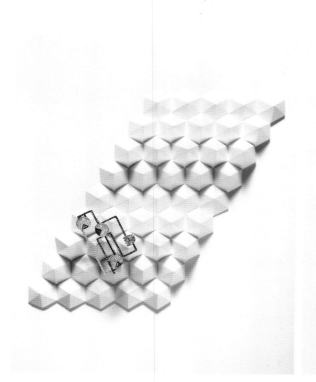

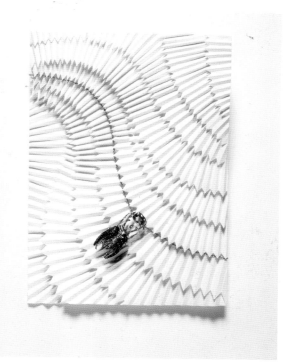

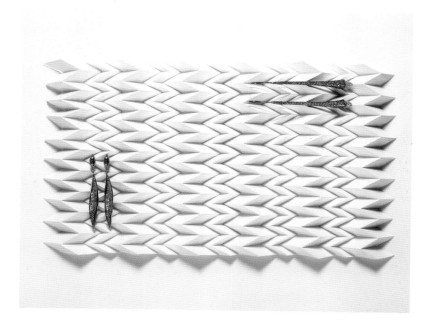

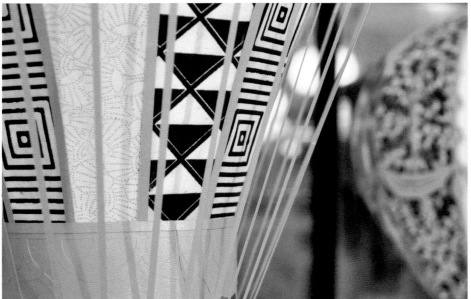

YCN Balloon Window

Decorated paper balloons created for YCN London's window
display and sold at their Rivington Street store.

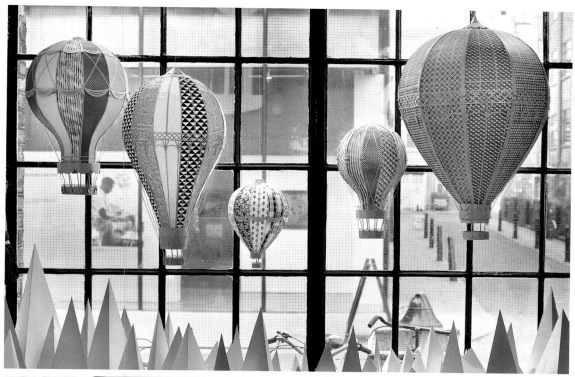

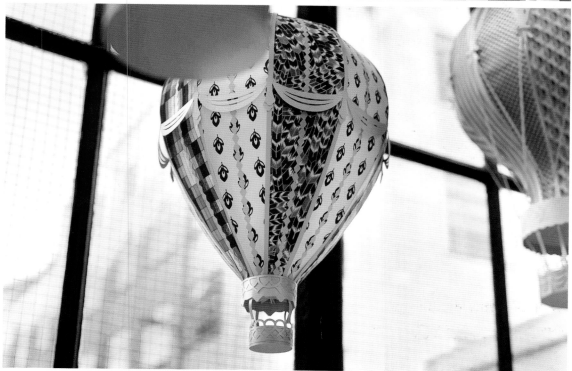

Vessels

1,2 / Smoke
3,4 / Ripple

In early 2013, Rachael Ashe became interested in creating three-dimensional structures of her abstract designs created through paper cutting. These are small prototypes of some of her initial explorations.

1

2

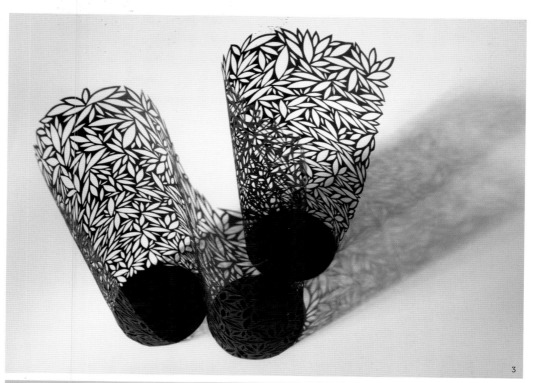

3

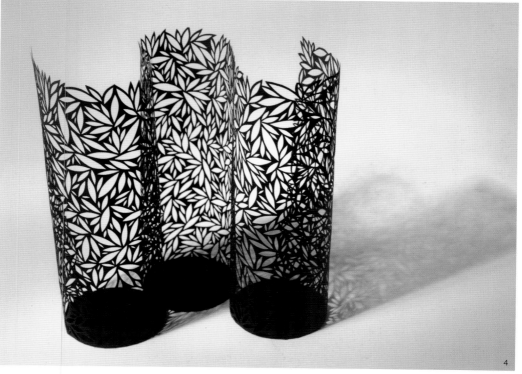

4

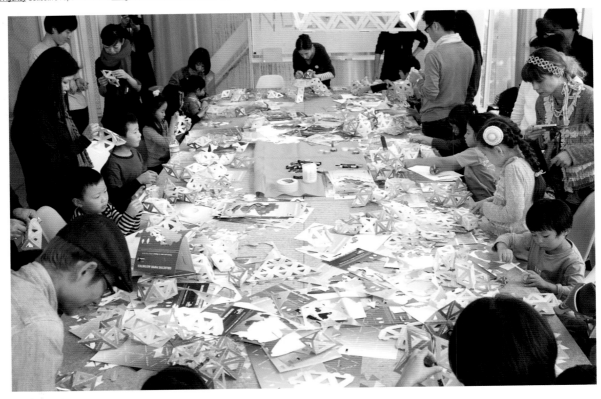

Create your own △ shapes!

The Embassy of the Netherlands in Tokyo, Japan and Tonton Art organization were collaborating on a series of events hosted at Shibaura House to present Dutch artists and designers work to children in Tokyo via workshops. Among participants were: Ina & Matt, Samira Boon and others. For this event, they divided the A4 and A3 building blocks into two different workshops. The A4 took place in the early afternoon and was populated by young children and parents creating imaginary animals, while the A3 took place in the late afternoon and was populated by teenagers creating light objects and decorations.

Together with Stina Fisch they created an activity kit made from A4 and A3 triangular building blocks. The A4 building blocks were made with die cuts and items printed in three different color ranges, while the A3 building blocks were reused laminated packaging cardboard from tobacco industries and cut with laser cutters. The items were designed by Noa Haim to match one with another, in a manner similar to 'Lego' and 'Duplo.'

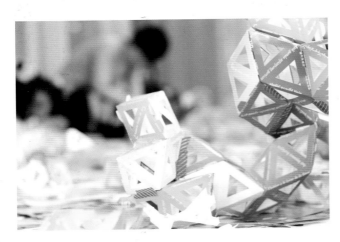

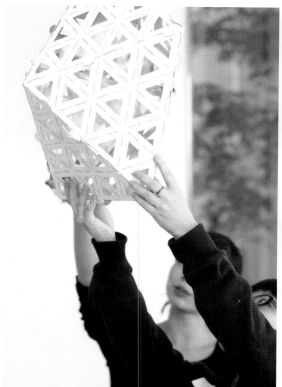

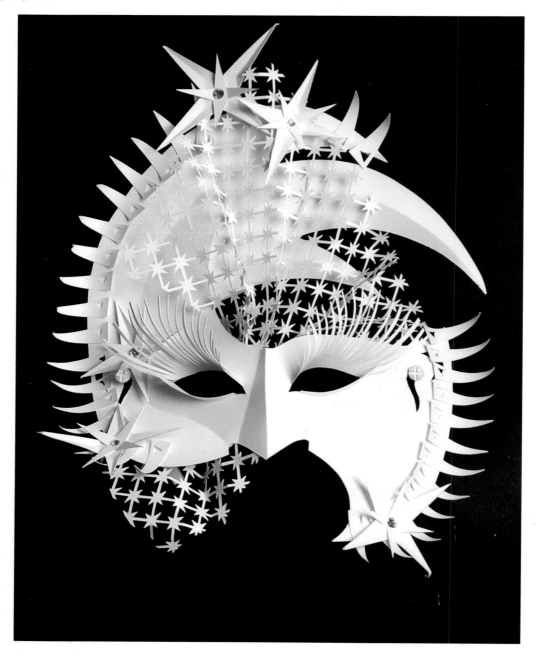

Masks

Paper masks were created as an exhibition project and were inspired by animals and elements of nature. Each of the masks is named according to the image it is devoted to, such as day and night, cat and goat and others. The artist said, "In a mask I tried to create a metaphor that gives only the defining characteristics of each specific animal or element in nature. Reality is not what I am interested in. I do not just try to transfer an object into paper but fetch out its specific characteristics, to emphasize the detail that inspired me in each particular image." This series is also decorated with Swarovski diamonds. A few crystals were enough as the paper is very strong. Due to its white color it appears differently in various illuminations. All the masks are functional and can be worn.

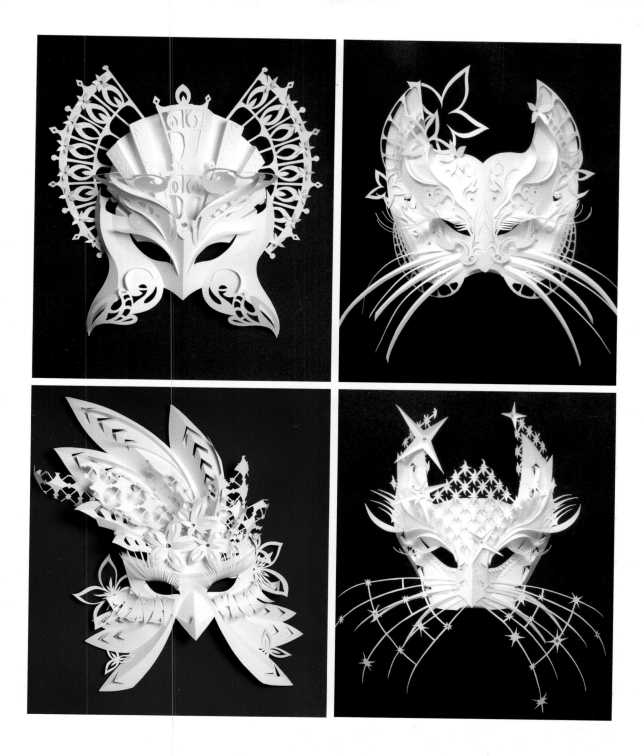

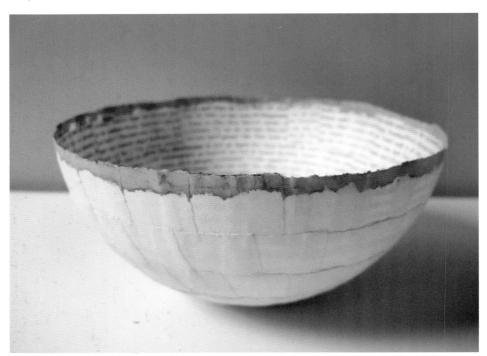

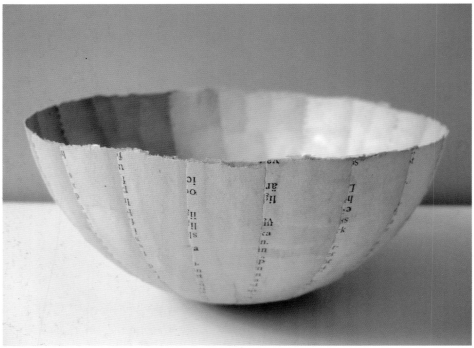

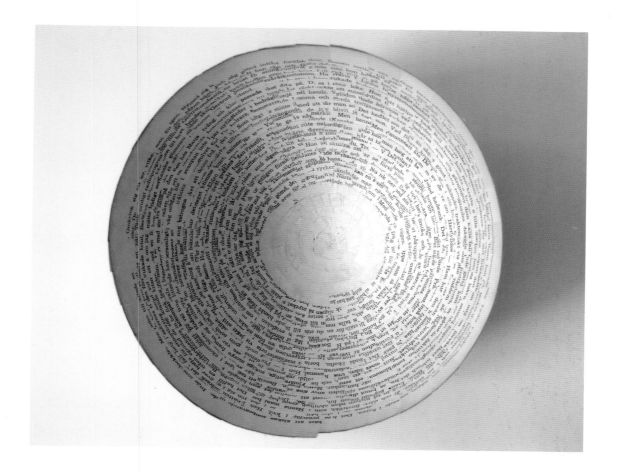

Colony Bowls

Old books carry a history, not just the story written on the pages — dog-ears, stains, a dedication on the flyleaf, a doodle in the margin.

Smooth old paper, soft, creamy white or discolored, brownish and brittle — a material full of nuances, different shades, texture and personality. Graphic design and papier-mâché are combined in an entirely unique way in the works by Cecilia Levy. She uses books from the beginning of the last century, takes them apart, tears, shreds or cuts the pages into small pieces that then reassemble new objects. Like eggshells they are thin and light weight, yet remarkably sturdy. The story lives on, but in a different shape.

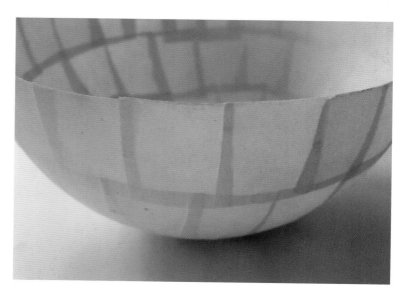

Book Pages Jewelry

1 / Rose Seanemone
2 / Ala Pervinca
3 / Burnt by the sea
4 / Red Seanemon
5 / Black Seanemone brooch

Flora's work is concentrated on materials and experimentation with their qualities. She is driven by a fascination with unexpected results. She prefers organic materials as they change with time, just as she changes when she starts to work with them. She is interested in the sculptural approach to these materials and also in finding unorthodox solutions for connections. Flora used to use traditional goldsmith tools to work with and although the techniques and basic materials are different, the results are also unusual and diverse from the 'classic' look of jewelery. She enjoys that each piece, even the similar pieces, look different and are unique, because every detail is handmade.

When the pieces are complete, they have a new identity. From that point on they change 'location,' or 'canvas' and start to live their own story. Jewelry can be nearly anything, there lies its beauty. Given that the dimensions are more or less limited, they can be wearable and are therefore a mobile work of art.

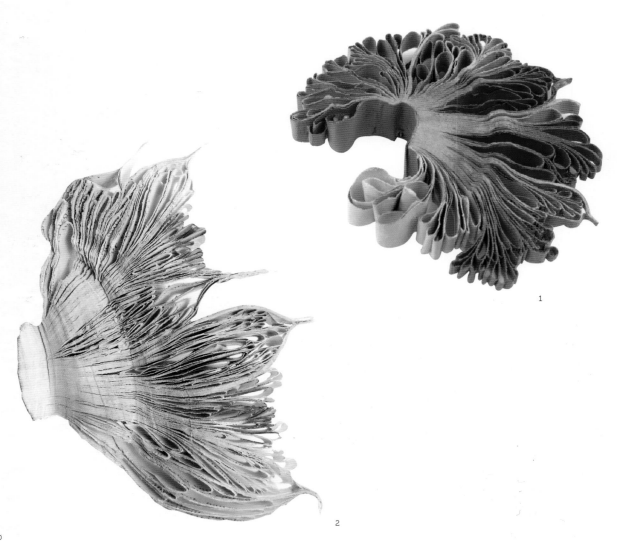

1

2

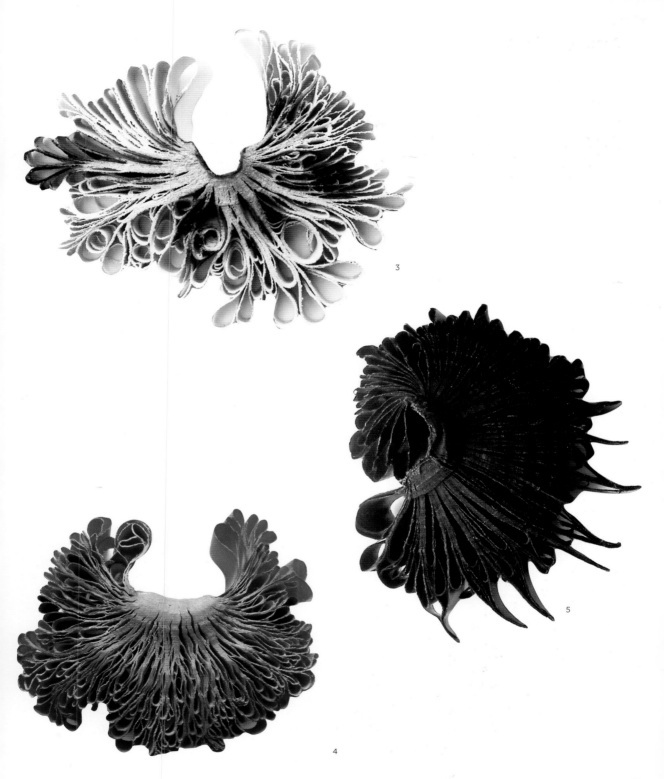

3

4

5

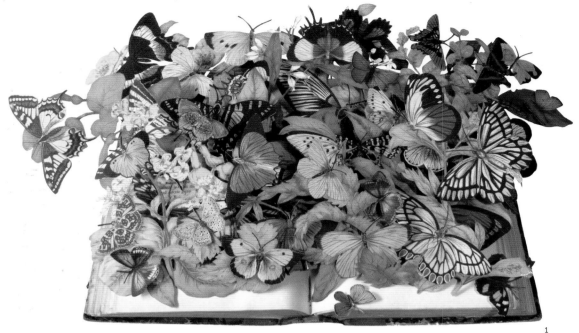

1

Carved 3D books

1 / Handbook to the Order Lepidoptera vol 2 - side view
2 / Pflanzenleben des Schwarzwaldes - detail
3 / Handbook to the Order Lepidoptera vol 2- detail
4 / Pflanzenleben des Schwarzwaldes
5 / Flowering Plants Of Great Britain

Kerry Miller explores ways in which she can make use of discarded vintage books, dissecting and rebuilding them to produce unique artwork. Each book is carefully chosen for both its character and the illustrations. Miller uses only the images found within the particular volume she is working on, often adding color using inks and watercolor to enrich and enhance the final effect, adding a sense of depth and energy. She uses only vintage books in her work as she feels that they lend themselves to the treatment in a way that modern books do not.

These intricately worked 3D books provide tantalizing glimpses into a rich past, becoming miniature worlds that allow the viewer to simply tumble into them. "I enjoy the fact that I can even make use of books in a condition that most people would dismiss as unusable." Miller views her work as a collaboration, a partnership with the past, giving new purpose to old books that may otherwise never see the light of day or simply end up in recycling.

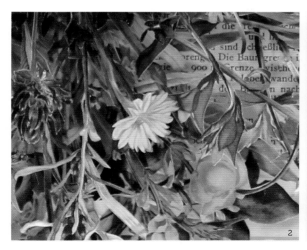

2

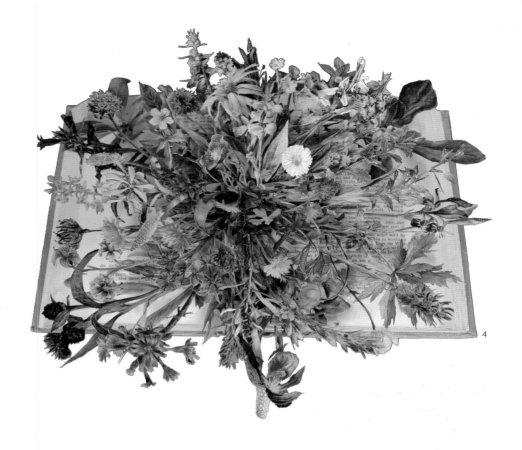

4

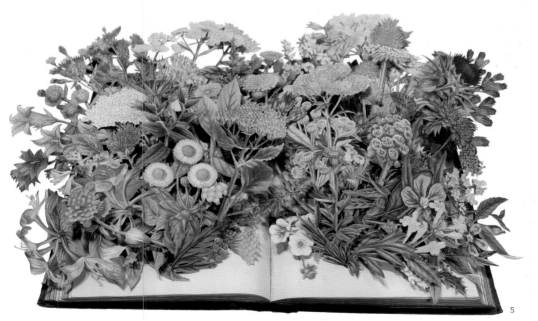

5

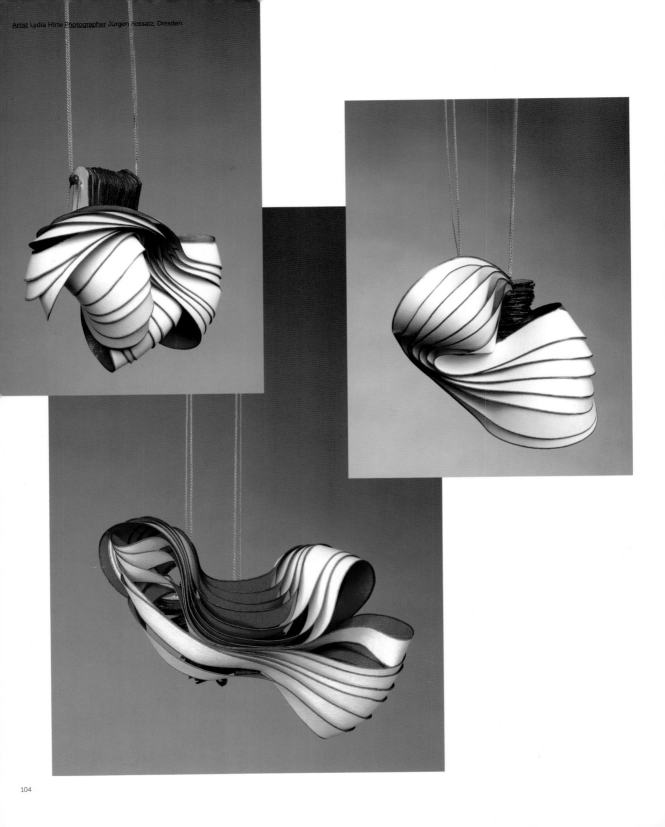

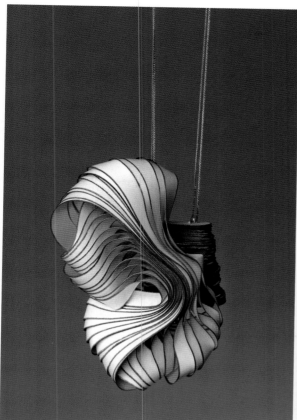
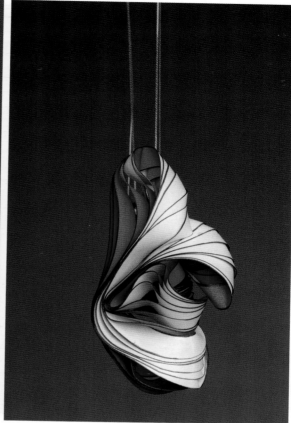

Stripes Jewellery

Since 2004, Lydia Hirte has been working with fine drawing card. The specific characteristics of this material have allowed her to develop her working principle: she cuts out basic shapes and bundles them together.

She moves them by hand in a specific way to force the material to its limits and detours the power and resistance of the material so that it serves a purpose: to invent new shapes and movements that can be fixed into a stable piece of sculptural jewelry.

She is continuously reflecting on the flat basic forms and how she can change them to provoke resistance in another way and allow her to apply different movements. Lydia finishes a work only if there is a new unique element. She does not accept it if it is only based on mechanical variation. It is this working principle that enables her to focus on her own thoughts, observations and experiences that arise when working.

Carbon

Inspired by scientific anatomical and botanical illustrations, the constellation of graphite-cut paper drawings evokes the carbon cycle that exists between plants, animals, soil and humans as it moves from one organism to the other, creating life and continuing on.

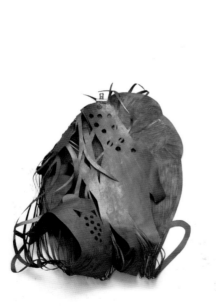

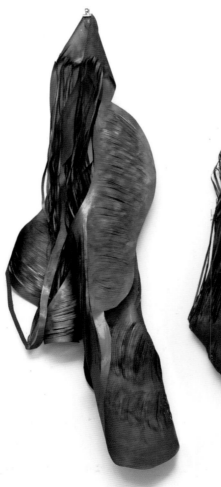

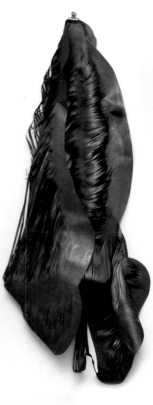

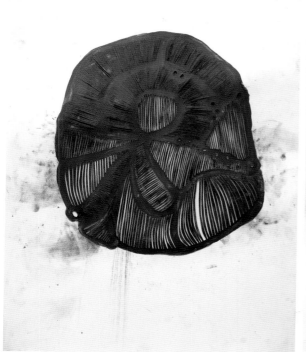

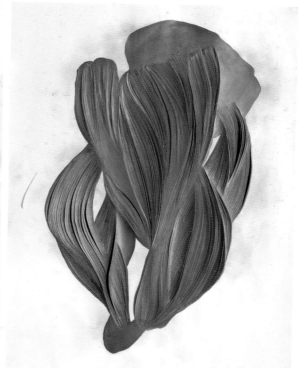

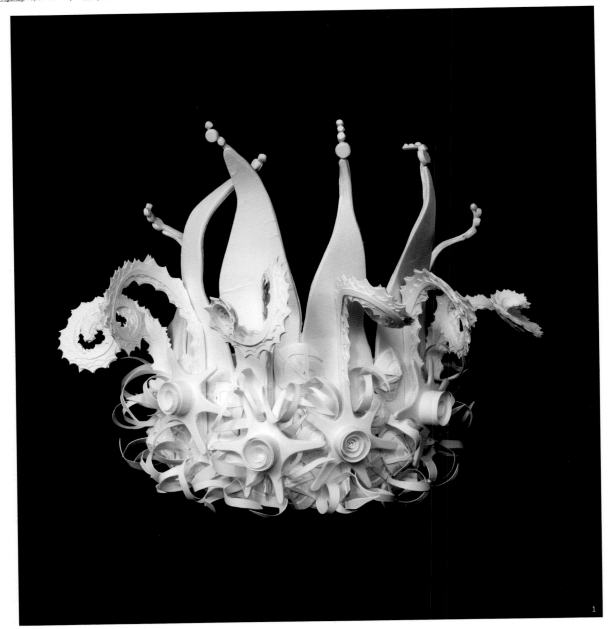

1

Crowns

1,3 / Seahorse
2 / Driftwood

These 'crowns' were part of a six-piece Paper-Cut-Project collection commissioned by La Mer in the fall of 2013. All were inspired by the idea of an underwater kingdom where sunken treasures, capsized ships or busted up boats, over time, have been claimed by sea-life and made anew. The metamorphosing effects of the ocean on the lost pieces, now encrusted in barnacles, coral and shells, take on new direction. The sculptures were part of the decor for a special press event in Saint Tropez and were displayed atop Lucite frames on a long wooden table with an ocean view backdrop.

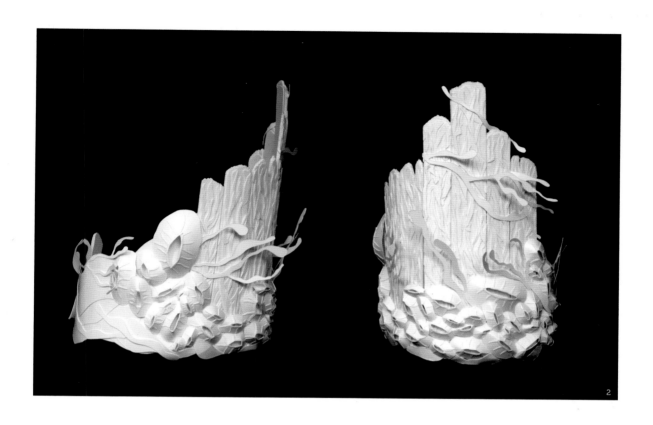

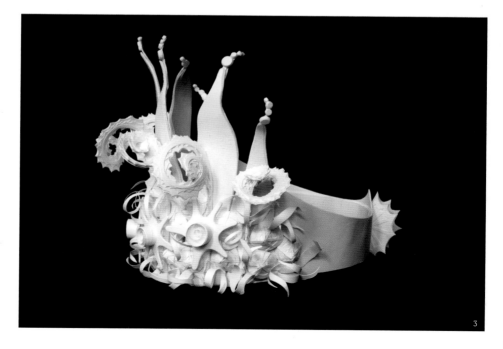

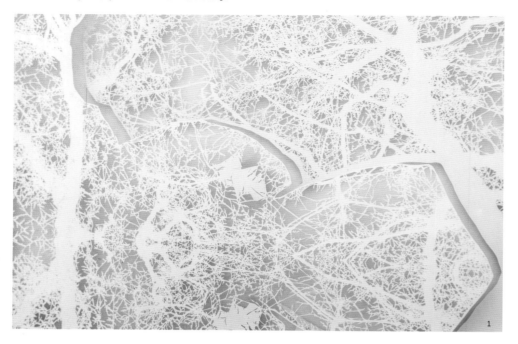

1

Kaleidoscopic Paper Cuts

1 / Primordia (detail)
2 / Primordia
3 / Entity
4 / Open Network
5 / Splice

Caroline Jane Harris transforms paper into unique kaleidoscopic marvels that encapsulate the inherent beauty of nature. Using digitally manipulated prints of trees as her starting point, Harris painstakingly hand-cuts the infinite gaps between the branches and leaves. The works consist of layers of these lattice-like compositions placed with a small gap between each layer, which create an intriguing weave of shadows that flicker throughout the abstracted landscape bringing it to life. She is fascinated by natural phenomena and the geometric symmetries found in all levels of existence such as the bronchi of a lung, river networks and neuron activity. The hand allows for natural distortions that induce the random, chaotic and asymmetrical — the antithesis of the digital conception. Influenced by Eastern printmaking and paper-cutting techniques, the simplification of lines to convey the essence of nature in Japanese wood-block prints informs her lineated hand-cut paper compositions. Caroline's practice demonstrates her meticulous and labor-intensive skill and pushes the boundaries of what is possible with such an accessible and ubiquitous medium.

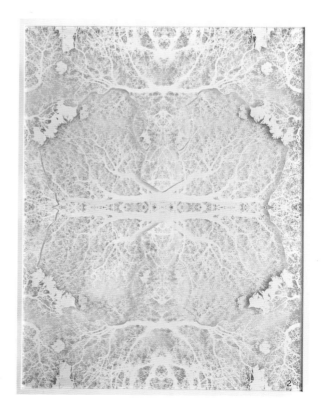

2

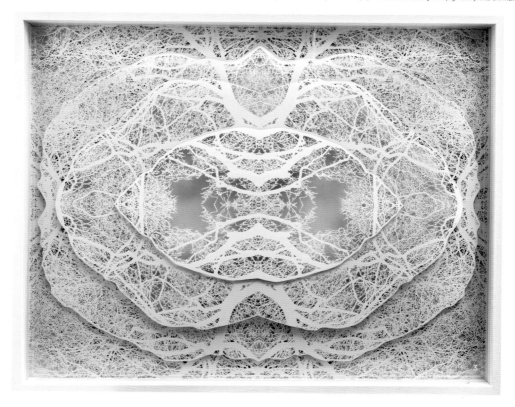

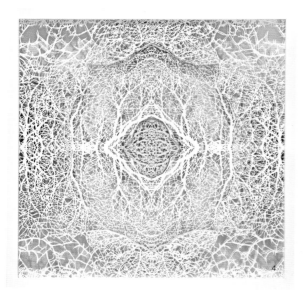

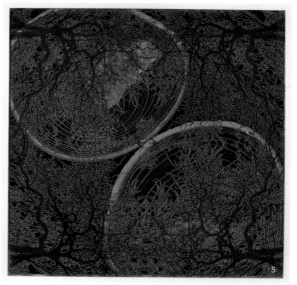

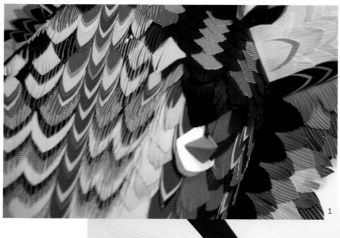

My Kind of Animal

1,2 / Deer
3,4 / Monkey

My Kind of Animal was inspired by perceptive perversion of one sickly mind. Oksana Valentelis doesn't just love animals, she's obsessed with them and their ways. She has a growing collection of folklore masks bought and shipped from different countries around the world. It's the combination of both these passions that inspired her to create masks. Each animal is not just a reflection of how Oksana sees that particular creature, each animal has a carefully selected color expression that is symbolic to that particular being. These masks have a distinctly handmade feel to them on purpose, because perfection and flawlessness is an alien expression to the nature of ANIMAL.

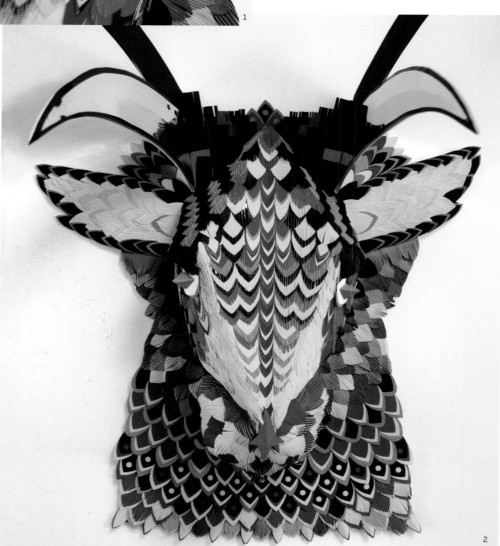

2

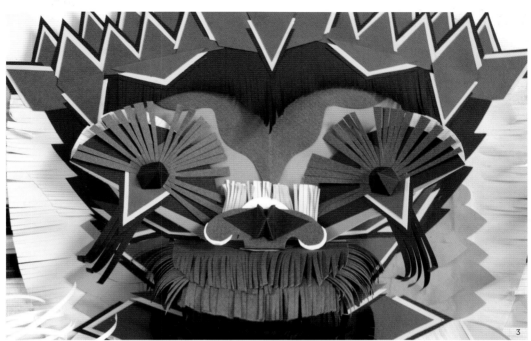

3

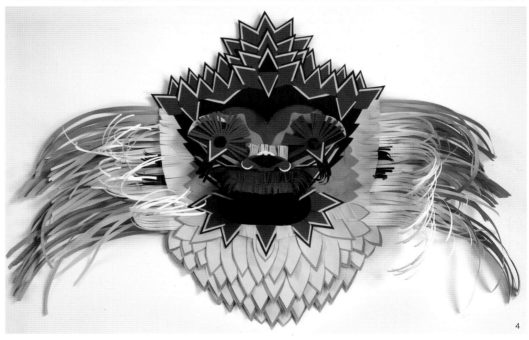

4

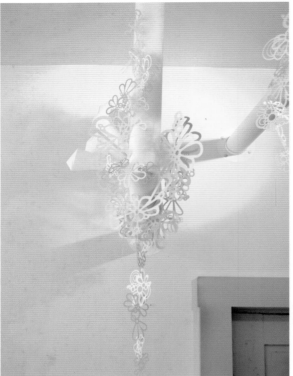
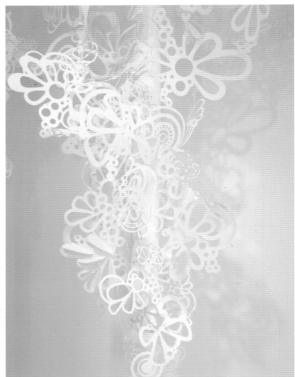

Efflorescence

Due to an increase in natural disasters, many buildings
have become abandoned and overtaken by nature.
Given this opportunity, the environment will use fungus
organisms to restore a balance within an ecosystem
offset by man-made damage. Organisms such as
mushrooms and mold have evolved to breakdown and
deteriorate human artifacts to provide nourishment back
into the soil. Efflorescence presents an allegory of this
decomposition process. It is an installation representing
an artificial species composed of manually and digitally
cut white paper colonizing a vacant interior space.
Flourishing out of delicate abandoned instruments, the
entity overtakes and germinates from the manufactured
object. The positive and negative shapes come to life
within the space imitating the growth patterns of their
analogs of fungi in nature. The manufactured objects and
spaces become inhabited with proliferations by bringing
the outdoors into the interior.

This paper Victrola and flourishing mold are both
constructed entirely out of white card-stock. Different
pieces are cut by hand while the more ornate filigree was
digitally drawn and then cut with a plotter cutter. Each
element is glued together to build the overall structure
and is hung from the ceiling. Each petal of mold is the
negative space to another cut design, so as much of
the paper as possible is incorporated into the artwork
without waste.

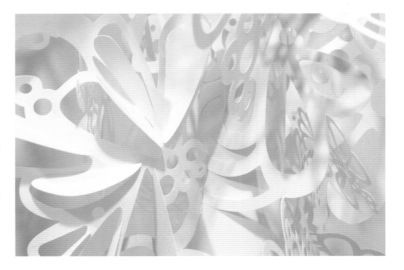

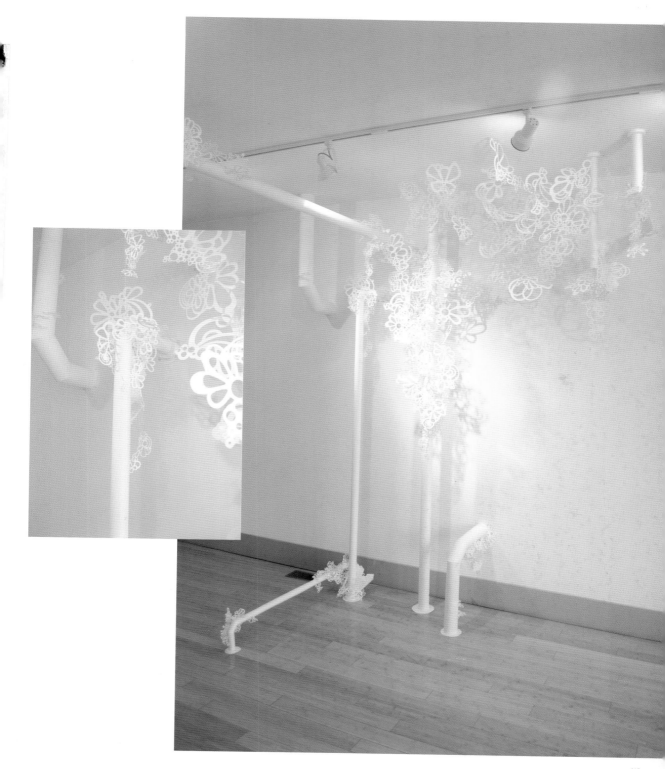

Artist Alice von Maltzahn Gallery Representative Wendt+Friedmann Galerie Photographer Ludger Paffrath, Images courtesy of Wendt+Friedmann Galerie

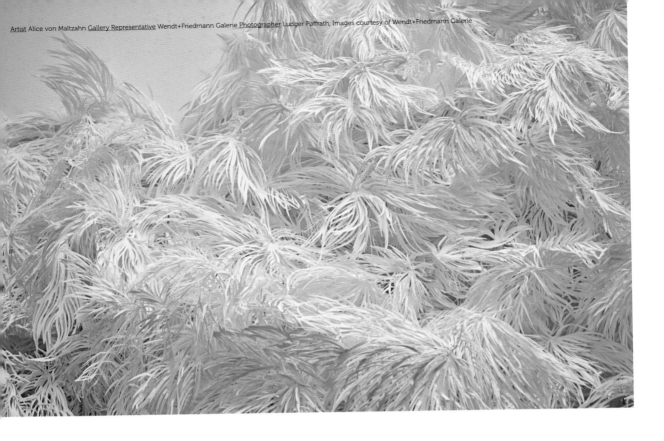

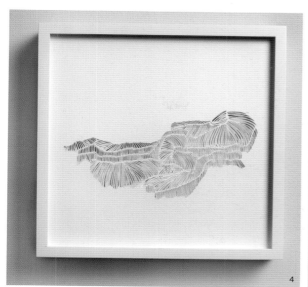

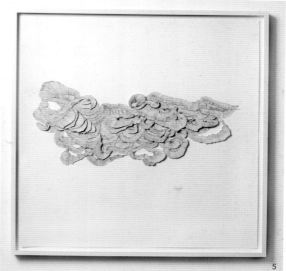

Inheritance

1 / Territory Mapping
2 / Desire Lines (detail)
3 / Inheritance (detail)
4 / Desire Lines
5 / Inheritance
6 / Desire Lines

Alice von Maltzahn's intricately cut paper works have an energy that comes of the relentless cutting of the material. Working with surgical blades she renders the paper alive, taking it from two to three dimensionality.

The works balance on an edge between the robustness of their visual intensity and their visibly fragile nature. Each smaller section of paper is cut so intensely that the result appears unsustainable; however, when each section is combined, the whole becomes self supporting and formidable and significantly more resilient than the single uncut sheet before it was manipulated.

Though abstract, the images somehow seem familiar. The artist's preoccupation is that of transferring an internal territory or landscape onto her current environment. The installation works encroach quietly on the viewers surroundings, while remaining very real and irresistible. The way they grow, unexplained, out of and within the space, is disconcerting and sinister.

The smaller cut works are like maps describing known places, inviting the viewer to enter into a small visual journey around the space within the frame. These are understood territories and well trodden paths. They are intimate and familiar, desired and understood. Alice von Maltzahn creates environments where space is finite and the viewer becomes bound within the designated scene. An experience that can be claustrophobic and disquieting as much as it is seductive and compelling.

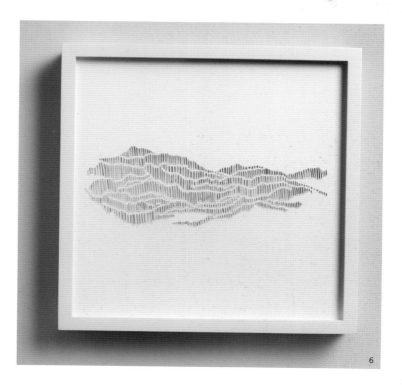

Paper Dolls

Can clothes made of paper change the way people see their daily life and the way they relate to objects around them?

With the Paper Dolls collection Bea Szenfeld wanted to recycle one of the most common materials in our surroundings in an unexpected way. As you can see the paper has an endless amount of structure and technical solutions, which opens the door to new perspectives. Her intention was to experiment with variations of paper, from the still cardboard to the tender tissue paper, from the strict lines of the A4 format, to the pleated chaos of the paper shredder. This collection was also a way to reuse a material that already makes people think of recycling — and it became a continuation of the recycling theme in her previous design.

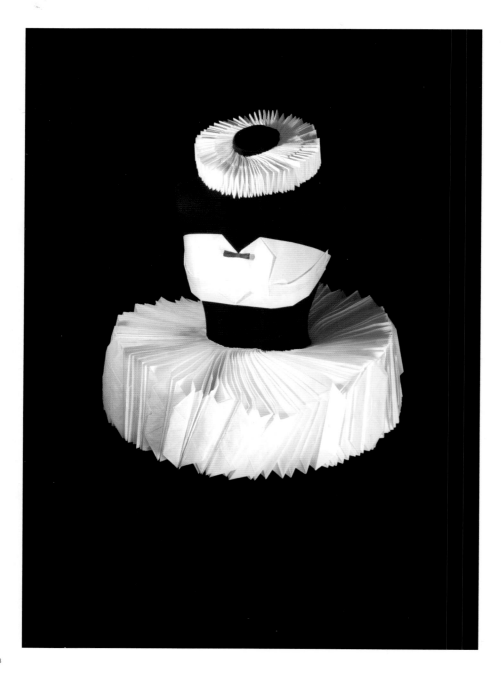

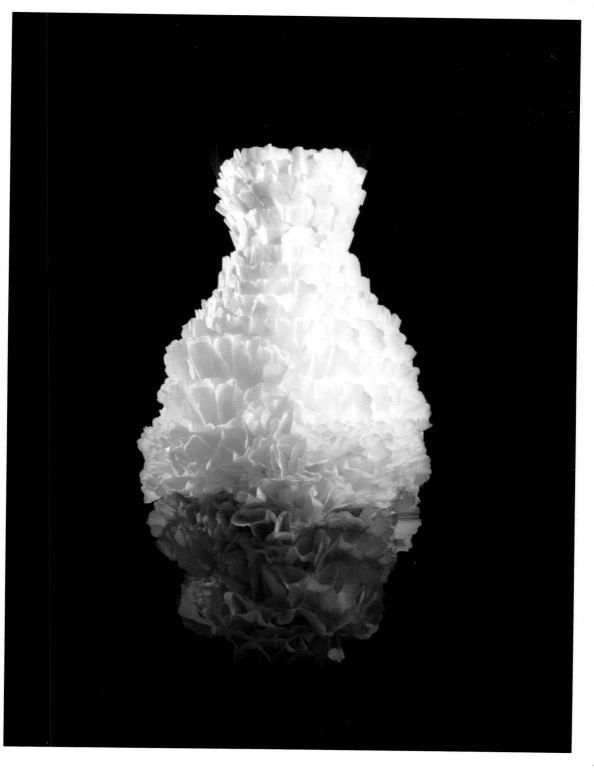

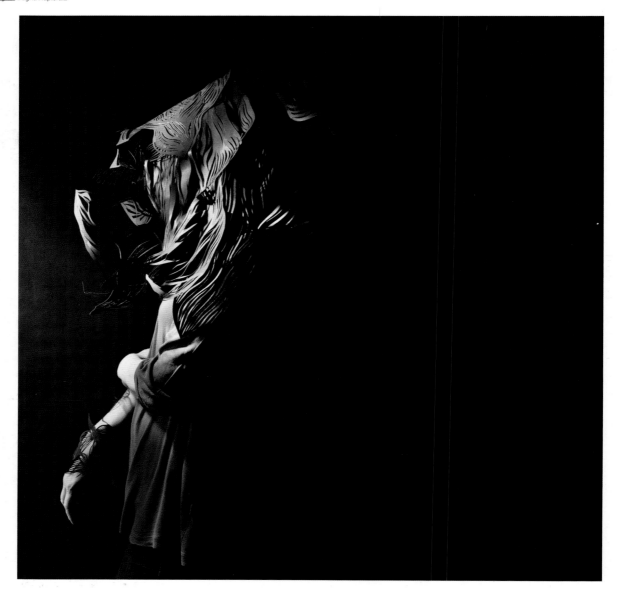

Portrait of Thoughts

Dagna Napierala wanted to show a person through the prism of their thoughts. To present us. Not our appearance, not what we are doing, but what is hidden in our heads. And it seems, that there is a lot hidden: joy, fear, caring, calmness, anxiety, strength, weakness, struggle with oneself, madness, insanity. In fact, it seems to her that a person often struggles with their thoughts, and this struggle shapes their character. States of anxiety, euphoria and apathy are sometimes dangerous and disturbing, but at the same time they are fascinating and even creative. In such moments, we briefly reveal our inner self. In Dagna's works, she tries to reproduce them. She wanted these ideas to really work in space, so she had to create them. The most laborious step was cutting out the paper forms. At first she envisioned a general idea of how it should look, more or less, but the effect of the photos surprised her. The people she photographed are her friends. They are not professional models. It was amazing that after the paper was placed on people's heads, they completely stopped feeling inhibited. Only when the mask was on did they let what was inside of their head come out of their bodies, in front of the camera.

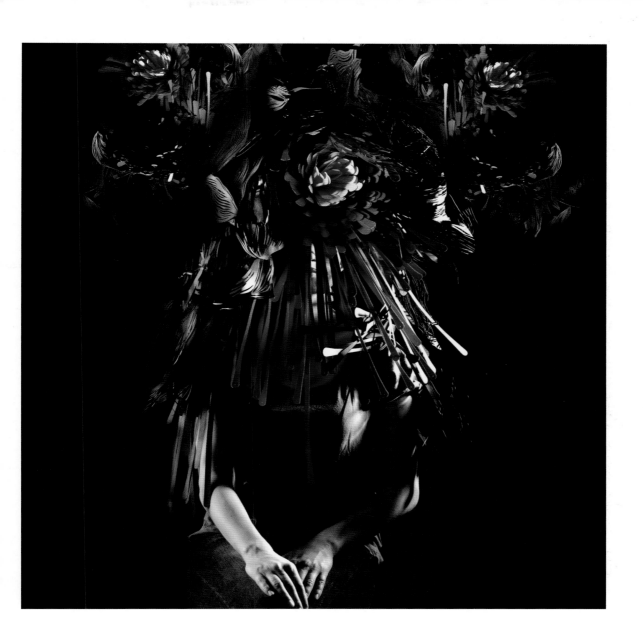

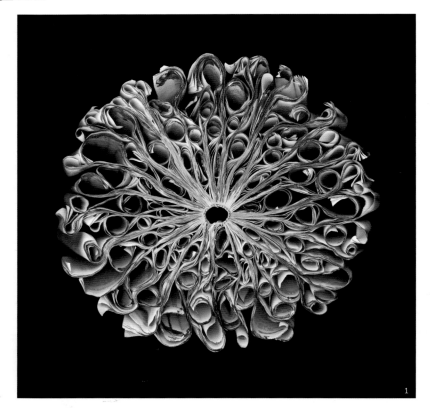

1

Books' New Life

1/ Tie Dye
2 / Ocean
3 / The Word Tree

Cara Barer transforms books into art by sculpting them, dyeing them and then, through the medium of photography, presenting them anew as objects of beauty. She creates a record of that book and its half-life. Books and repositories of information are being displaced by zeros and ones in a digital universe. Through her art, she documents this and hopes to raise questions about the fragile and ephemeral nature of books and their future.

This transformation and photographic documentation led to thoughts on obsolescence and the relevance of libraries in this century. Half a century ago, students researched at home with the family set of encyclopedias, or took a trip to the library to find information. Now with computers, tablets and smartphones, plus an Internet connection, a student has the ability to amass knowledge and complete a research paper without ever going near a library. Cara has fully embraced all this technology and would not want to live without it, but fears the loss of the beautiful record of books common over the last two centuries.

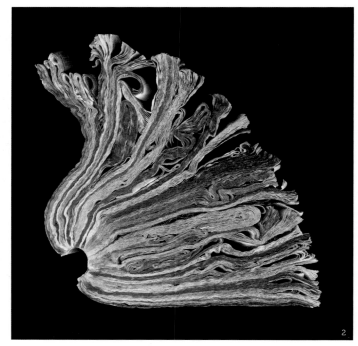

2

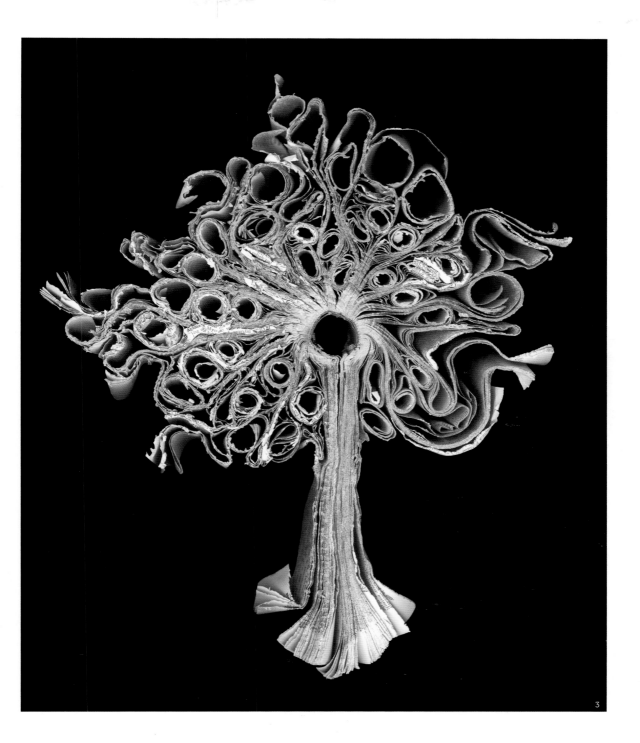

3

VIBES(振動)

As for the tune "VIBES" expressed in Japanese Lyrics of Shing02, it is cutting out one sheet of paper with the cutter. Haruhiko Tanaka visualized the soul of words of Shing02 by using all words of it.

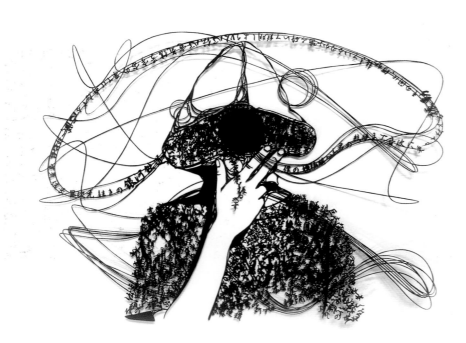

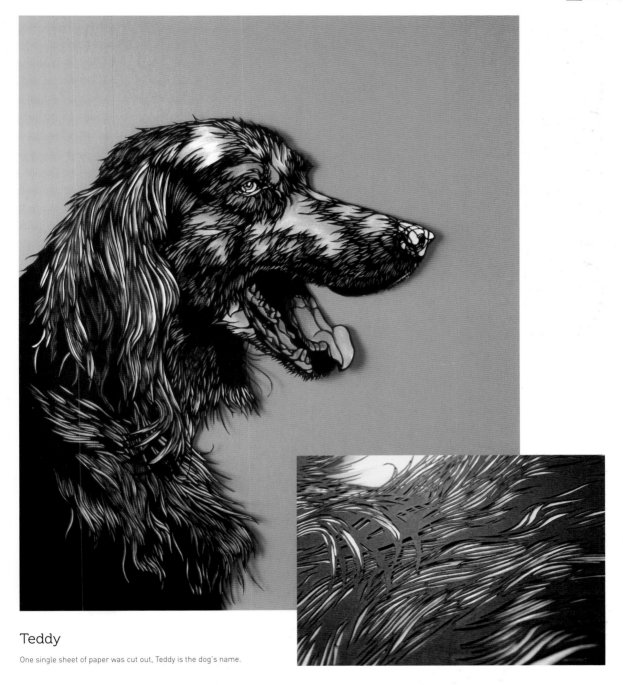

Teddy

One single sheet of paper was cut out, Teddy is the dog's name.

Design Agency Sixstation Designer Benny Luk, Rose Lee Client Groovisions

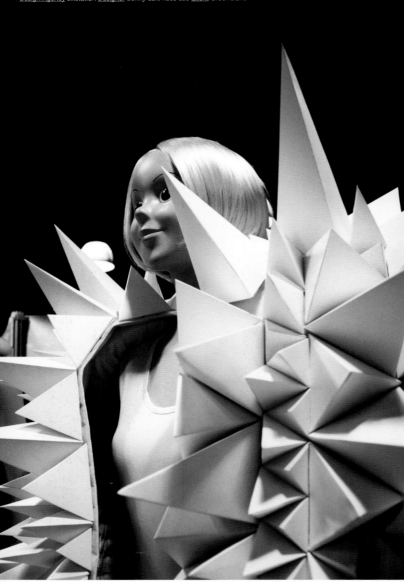

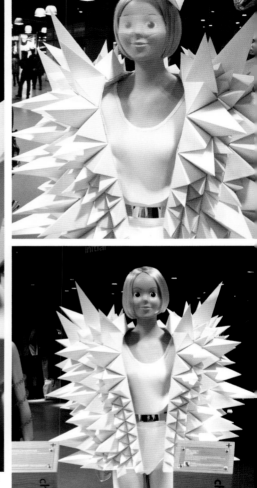

LCX Groovisions

CHAPPIE is an affable and celebrated Japanese Figure. The icon is managed by talented Tokyo creative firm Groovisions. Invited by local shopping mall LCX, Groovisions co-created with other local creative units a different design style for Chappie, based on the concept theme — Possibility. The structure of the suit was built with a few hundred pieces of paper sculpture and the suit base can be movable. Viewers can use their imagination to create multiple unique combinations with the pieces.

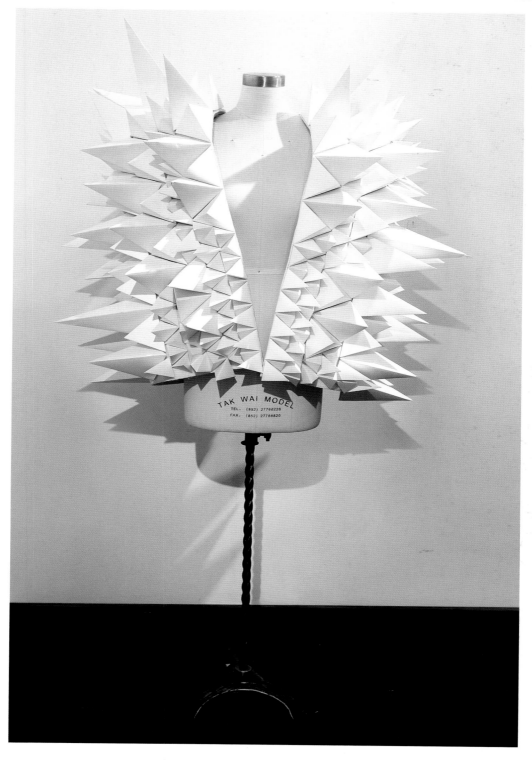

TAK WAI MODEL
TEL. (852) 27766226
FAX. (852) 27788820

Metropolis and City Planners

1 / Within Chaos (Detail) 80x 80 inches
2,3 / Untitled from the series Metropolis and
the City Planners + (Detail) 40x 40 inches
4 / Metropolis and the City Planners_01 60x
60 inches
5 / Untitled from the series Metropolis and
the City Planners 80 x 80inches

Paper has always been a fascination for Sachin George
to work with. Its fragile nature and flexibility makes
paper the perfect material for him to talk about the
stories and realities we live in. Over the years, his
theme has been 'Metropolis and City Planners.' The
works offer a peek into our culture of mass migration
to Metro cities, in search of 'greener pastures,' which
results in the deforestation and immense growth of
cities both vertically and horizontally.

With his work, Sachin attempts to discuss the
regression that happens in the name of a progressive
society. To possibly answer the question within
himself and for humanity, "how long and how far are
we going to operate in these spaces in the name of
development?"

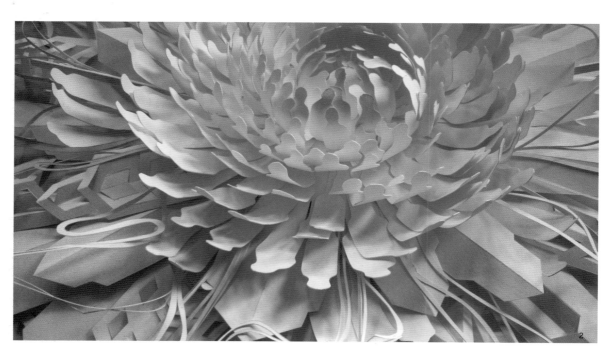

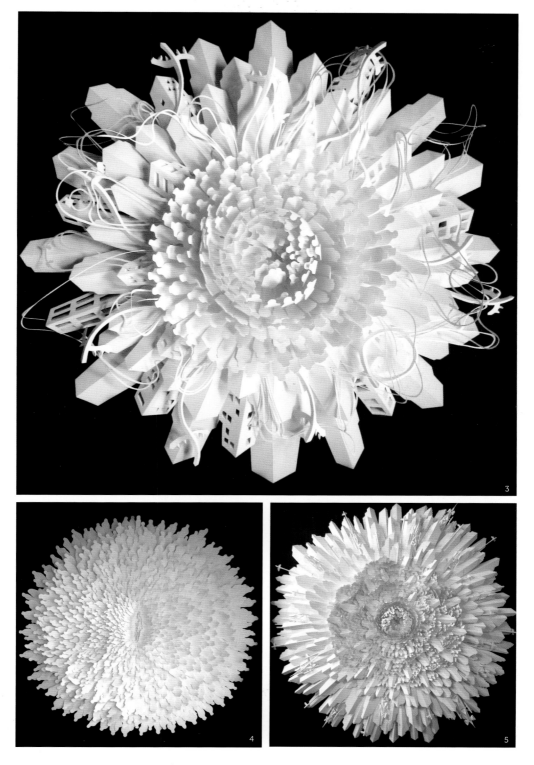

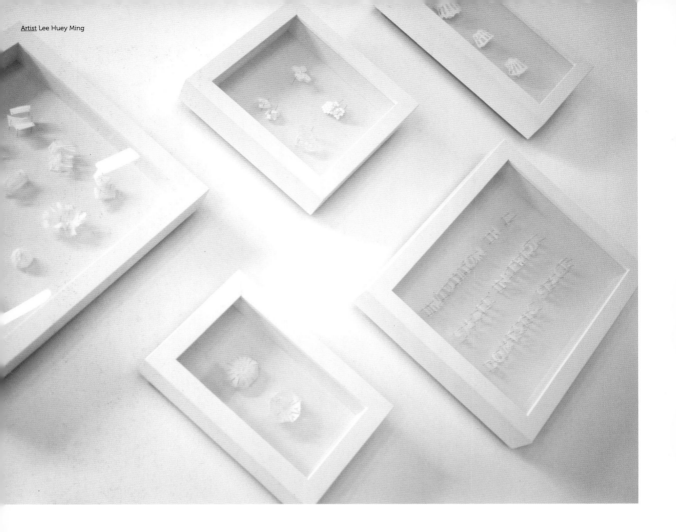

Intuition in a small interior domestic space

This practice-led research project explores the potential of paper as a medium to communicate complex ideas and emotions. Through this exploration, Lee Huey Ming employs the notion of water as a conceptual lens through which Lee considers ideas related to the small domestic space. The project work will not set out to overtly represent water, but will be used as a way to imaginatively retreat from and respond to the small domestic space. Through these conceptual strategies, he intends to test the way paper can be manipulated and question if it is able to communicate the subtle and complicated ideas that underpin this research.

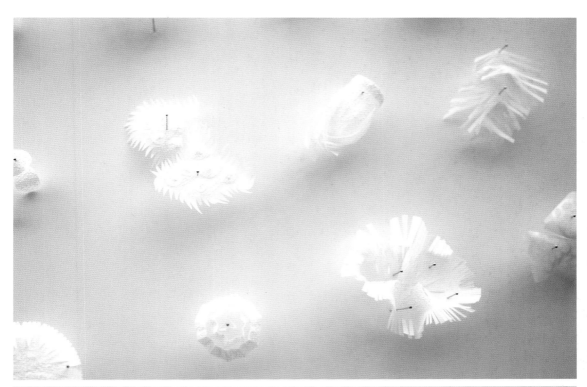

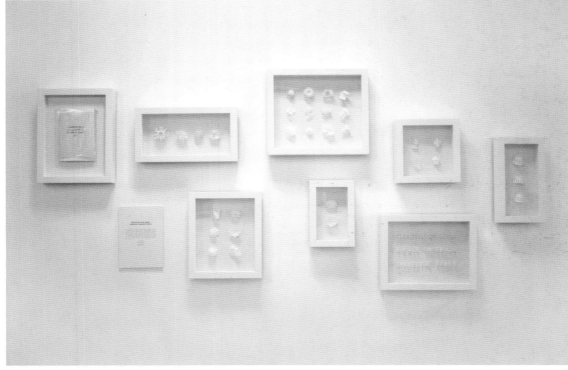

Cities in Paper

1. The client was Clerkenwell Design Week and the
photographer was Catherine Losing, 2012.
2/3. The client for 'Paris' and 'Miami' was Stylist magazine,
and the photographer was Ania Wawrzkowicz, 2013.

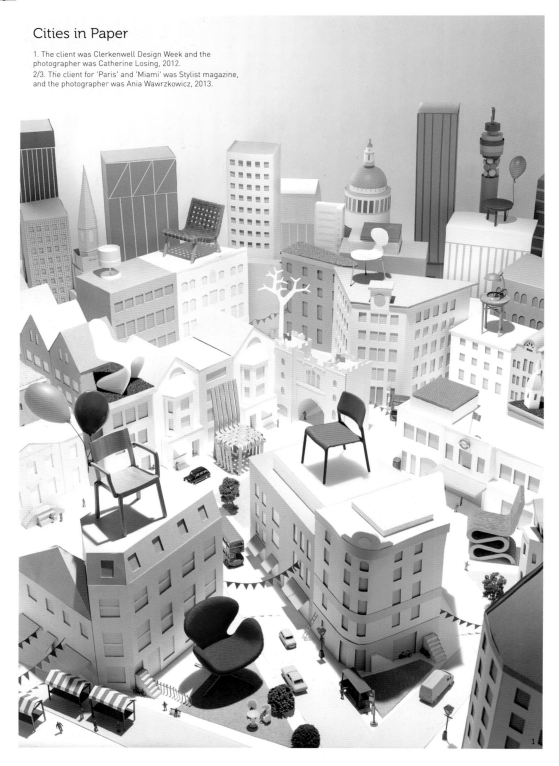

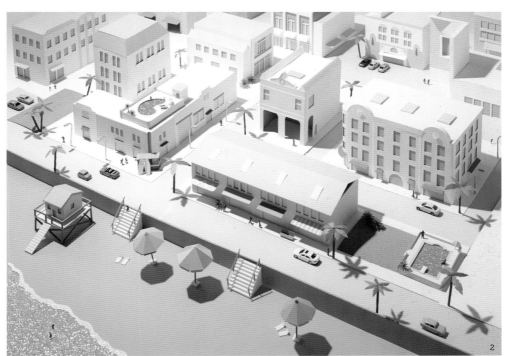

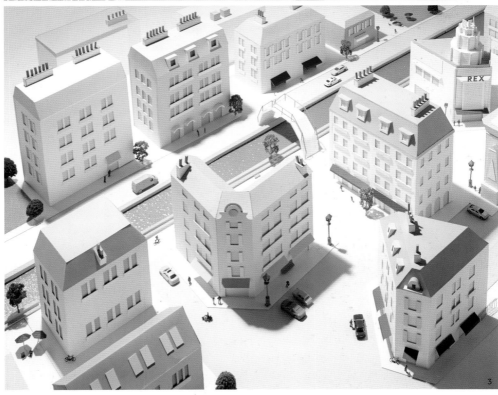

133

Designer Naoki Terada Photographer Kenji MASUNAGA

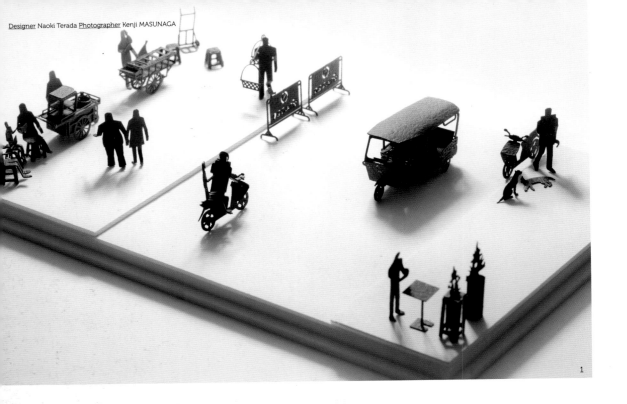

1

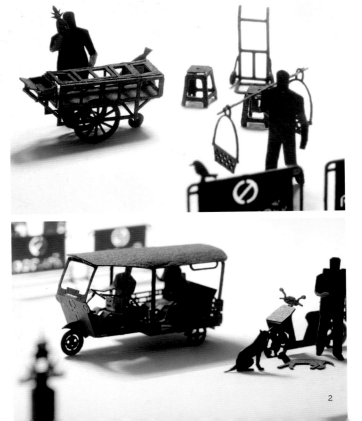

2

TERADA MOKEI

1,2 / No.34 Bangkok
3,4 / No.32 Camp

TERADA MOKEI was established with a desire to explore the potential for modeling, which is created when objects are scaled down and given detail, through models. This reflects the companies' belief that when real items are replaced with models, the latter have an essence of reality, filled with dreams and the potential to become more vibrant - living in a better world, in the artist's opinion, than the original. It is also important to enjoy the process of assembling models. TERADA MOKEI hopes to convey the fun of assembling models and the imagination that went into the process.

1/100 ARCHITECTURAL MODEL ACCESSORIES SERIES
Good news for design office staff who pull all-nighters! Simply detach and assemble. The simple modeling that omits fine details are highly versatile and accentuate the sense of scale.

No.34 Bangkok
Bangkok, the bustling capital of Thailand, has been recreated in 1/100 scale complete with street stalls and tuk-tuks plying the busy streets. Number four in the 'Cities of the World' series following Tokyo, New York and Amsterdam. Included: Tuk-tuk, motorcycle taxi, san phra phum shrine, street stall, dog, etc.

No.32 Camp
Escape the chaos of the city and relax in natural surroundings. Experience the fun of camping in 1/100 scale. Leave the barbecue to me! Watch out for bears. And don't forget to take your trash when you leave.

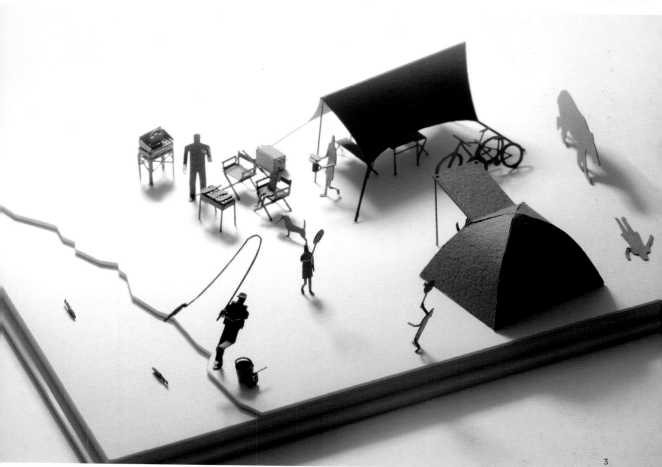

3

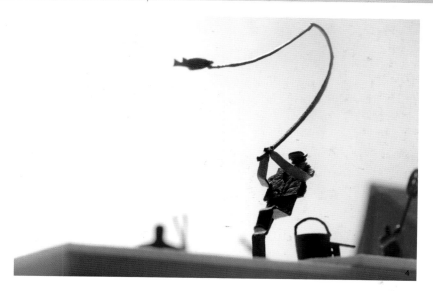

4

Spring

Set Design created for a spring fashion story. The idea
was to create a background of flowers, green vegetation
and spring elements, all made of paper.

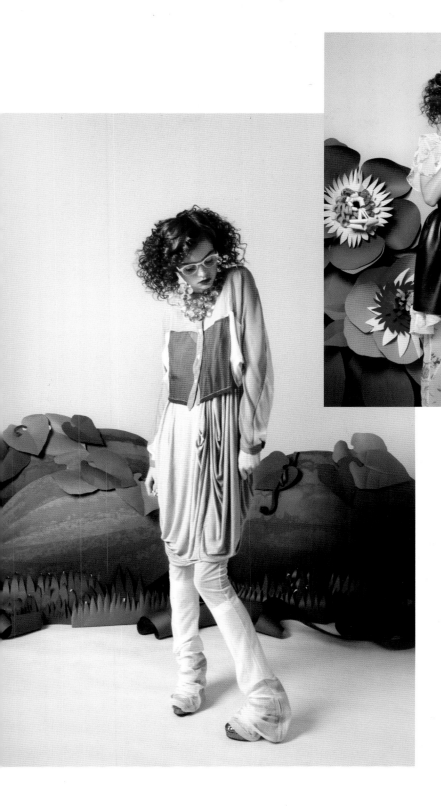

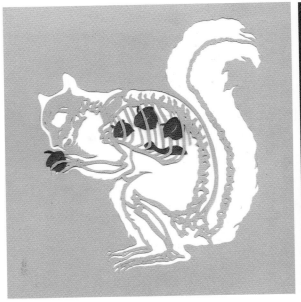

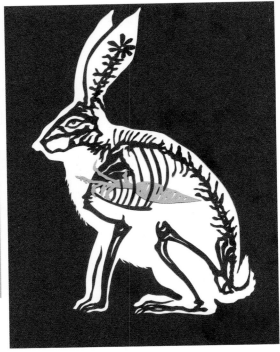

What They Ate Series

The paper cut pieces of Wendy Wallin Malinow reveal the deeper workings of animals. Wendy's pieces are cut to expose an 'x-ray' view of various forest and ocean animals. In addition to the bone structure, a meal is visible inside each animal. While playful, there is also a sad quality to her work. Wendy's work reveals the nourishment and effort needed to survive and the violence that is at times inherent in that. A squirrel has ingested some acorn's, while a wolf seems to be filled with the ghost of Red Riding Hood.

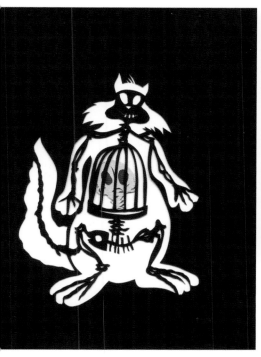

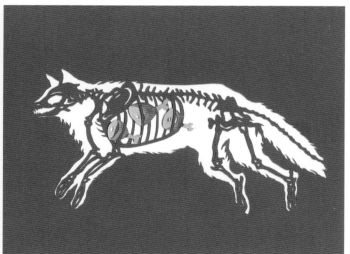

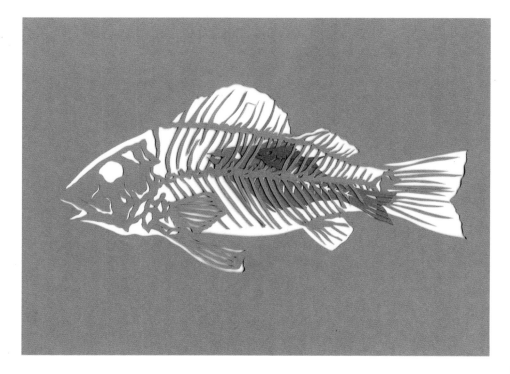

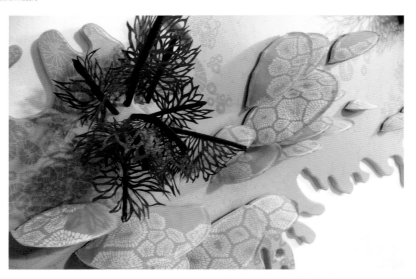

Our Ocean

Through the printed surface and the sculptural forms in Lauren Kussro's work, she reflects her appreciation for the splendor of the natural world, by referencing its inherent design, variety and abundant multiplicity. Observing and researching objects from nature and their components, gives her insight and ideas into how to build her own structures in an aesthetically pleasing way. The inspiration behind this piece came from looking at various forms of coral and other oceanic organisms. Lauren constructed a series of sculptural forms using combinations of paper and wood, small groups of objects that were almost like little families. Each 'family' had a specific way the pieces within it were made and all the different 'families' were held together in the same way a coral reef is, with each type of coral contributing to the whole unit. The first time this was installed, each individual sculptural piece was attached directly to the wall using Velcro. Later, Lauren added larger painted wood structures that the individual pieces were attached to, in order to increase the amount of space they took up when they were exhibited. Each time the piece is installed, the wall behind it is silkscreened with patterns and then the sculptural forms are attached.

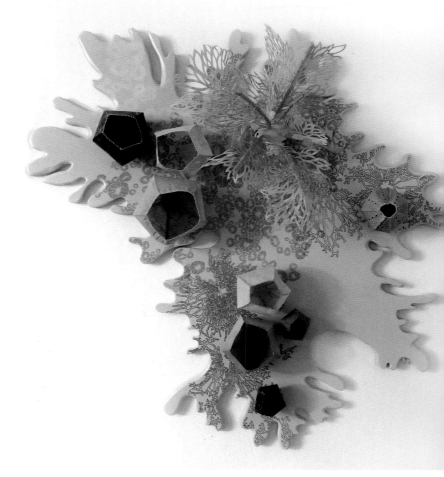

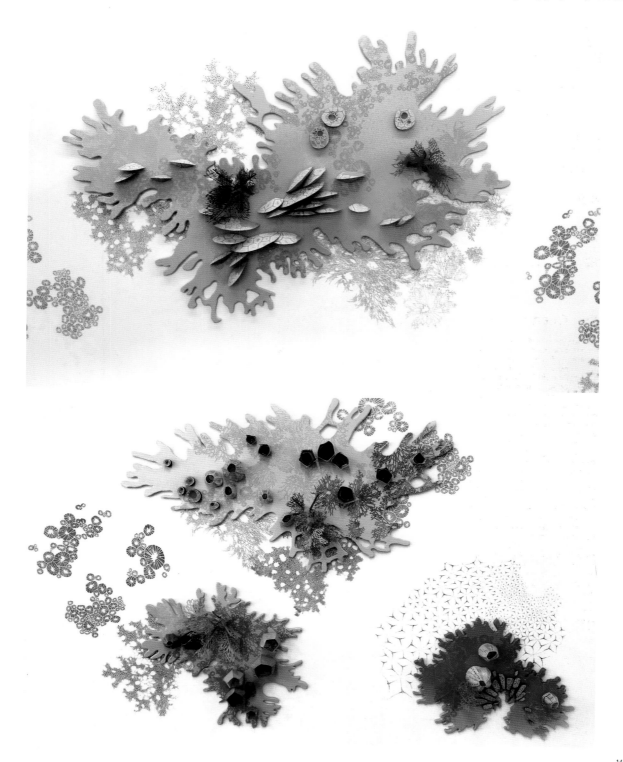

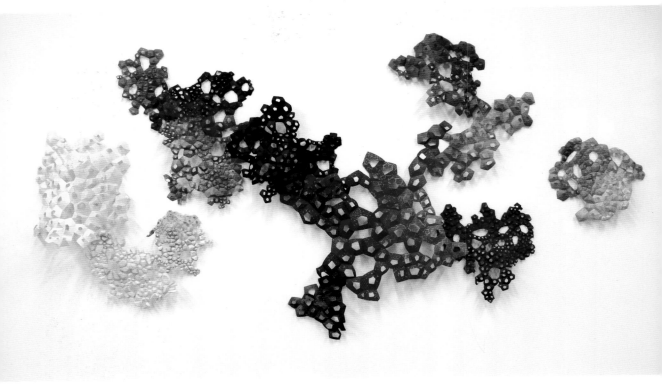

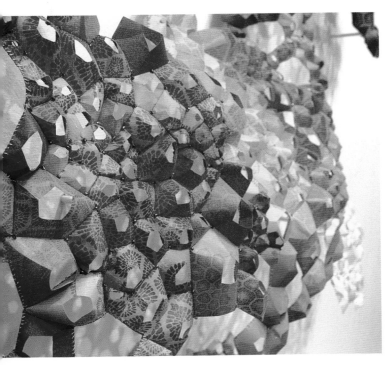

We held to each other so tightly, we became as one

Through the printed surface and the sculptural forms in Lauren's work, she reflects her appreciation for the splendor of the natural world, by referencing its inherent design, variety and abundant multiplicity. Observing and researching objects from nature and their components gives her insight and ideas into how to build her own structures in an aesthetically pleasing way. The inspiration behind this piece mainly came from looking at images of barnacles.

Usually for sculptural work that involves paper, Lauren likes to first create a series of drawings that are created with the intention that they will be turned into silkscreen stencils. She prints a quantity of paper using an oil-based monotype printing technique to establish flat colors or blends of colors, and then prints the drawn designs using silkscreen. This gives the paper its rich colors and detailed patterns. To create the individual barnacles, the paper was cut into specific shapes, folded and then glued into place. To create the larger sections, the barnacles were stitched together by hand and beads were attached in the junctions where the corners met.

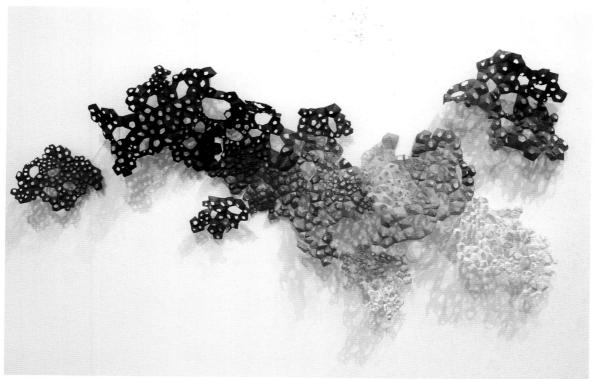

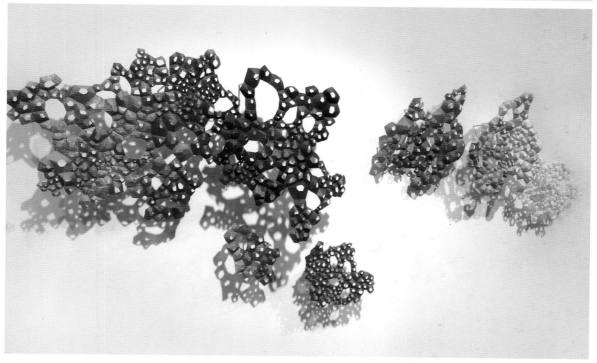

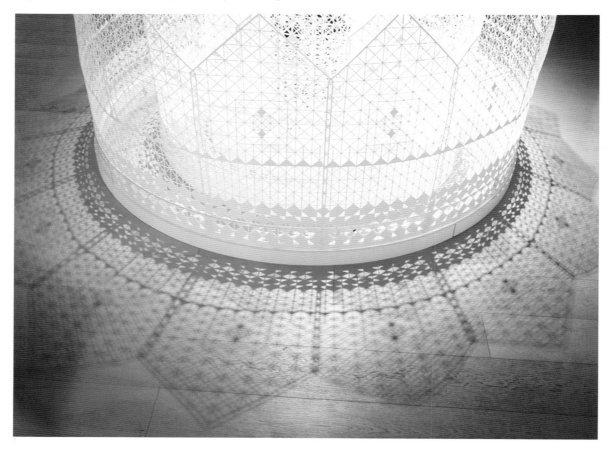

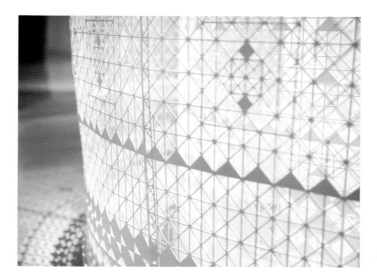

The Garden

There is a pure and beautiful garden in our hearts.
Finding the purity of our heart in this garden allows us to
touch the invisibility of the delicate beauty. When silence
falls, it allows love to bring us back to this inner garden
and seek the truth within ourselves.

'The Garden - 花苑 ' is Super Nature Design's first
paper art installation for the 'Paper Infinite Invitation
Exhibition' held at Réel, Shanghai.

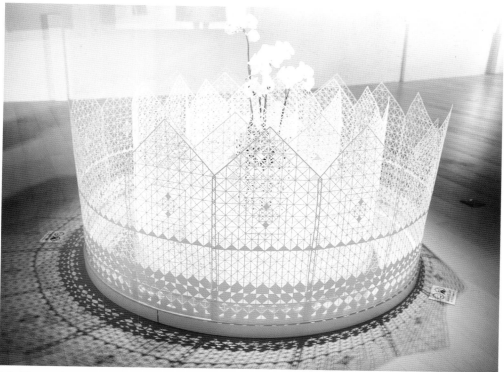

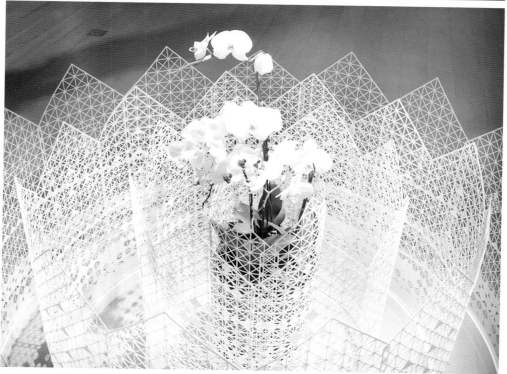

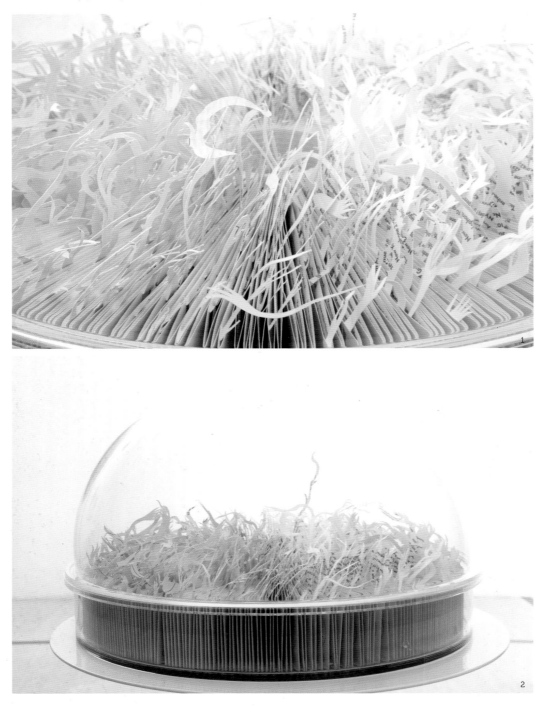

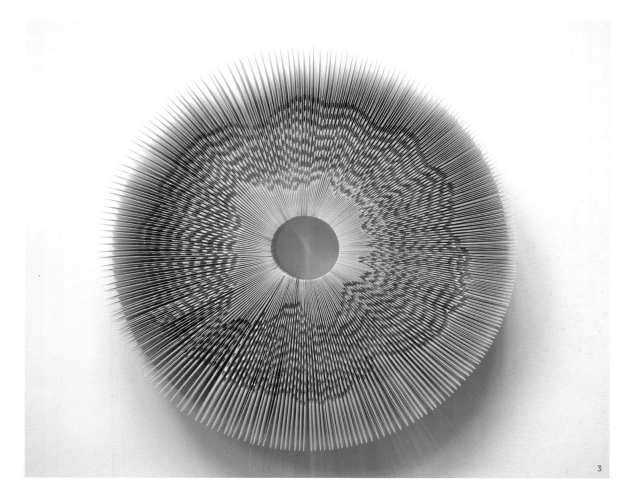

3

Donuts

1 / My Terrarium: Let's Circle Back
2 / Guggen' Donut

These works use Guggenheim Museum's tickets as
the creative medium and attempt to use this medium
in a journal-like documentary project. Using the ticket
hole-punched method, Mia Wen-Hsuan Liu has turned
her daily routine of eating donuts at the Guggenheim
Museum café into the topic of her creative work.
Through the process of punching holes, she has tried to
turn the orange ink used on the tickets into the primary
color on the artwork's surface. The completed work
shows an interesting reconstructed twist of the ready-
made object. These two projects would not be possible
without the Director of Visitor Services at Solomon R.
Guggenheim Museum, Maria Celi, Trevor C. Tyrrell, Kai-
ti Kao and other museum staff.

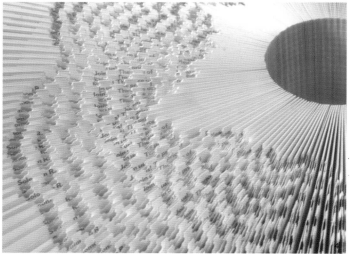

Artist Mia Wen-Hsuan Liu, Images courtesy of Eslite Gallery

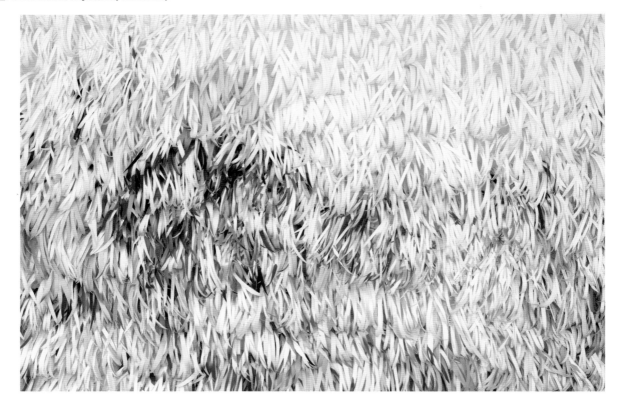

I can't stop rolling it up

Artist Mia Wen-Hsuan Liu describes her works as "focusing on fun and interesting visual experiences as well as letting spontaneous emotions of the moment flow freely." She is fascinated with drawing and her inspirations mostly come from the characteristics of the material that carry her drawings. Sometimes the material itself tickles her imagination; therefore, she has reinvented the idea of a two-dimensional drawing. What the artist calls "Drawing Installation" was thus born. The story of 'I can't stop rolling it up!' began from a flat drawing. After it was proportionally enlarged onto 144 full-sheet water color papers, the drawings were cut, curled and then pieced together onto an aluminum board. Shades that appear underneath the curls also become part of the visual elements in the work. Simply by adjusting the viewing distance, the audience also shifts between macrocosmic or microcosmic views, experiencing the work in both two-dimensional and three-dimensional aspects.

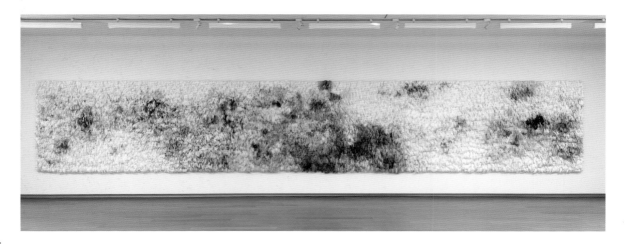

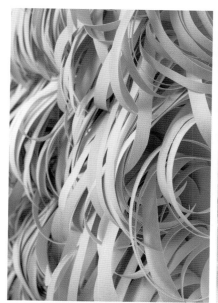

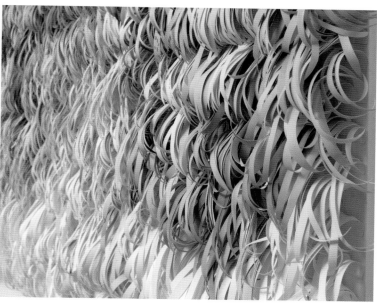

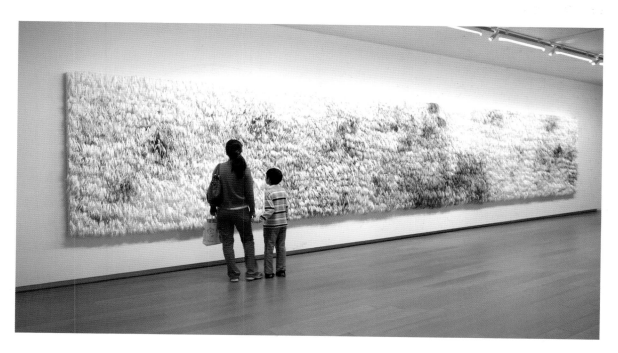

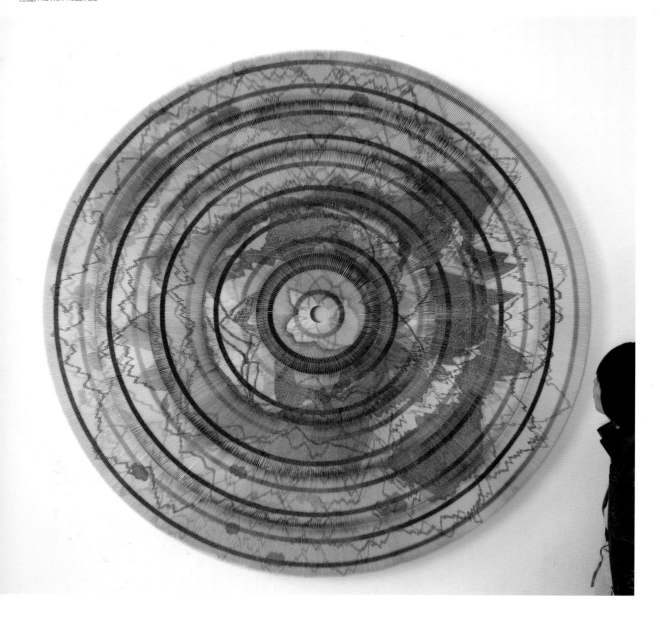

I am Mia Liu

This work originates from Mia Wen-Hsuan Liu's experience of working in the Visitor Services of the Guggenheim Museum New York. Using the tickets of the museum as medium, she attempts to alter a daily object's preexisting meaning. The work transforms flat drawings into something of multi-perspectives through individual images and visual effects. She also attempts to use her English signature to replace drawing and the outcome is not only a drawing, but is also a further step in indicating to the viewers her individual dream.

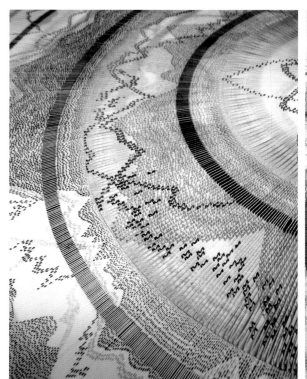
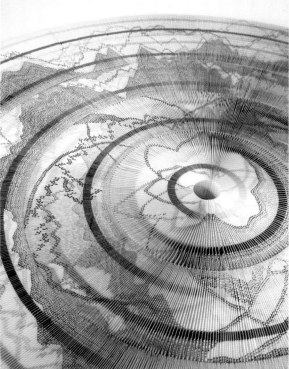
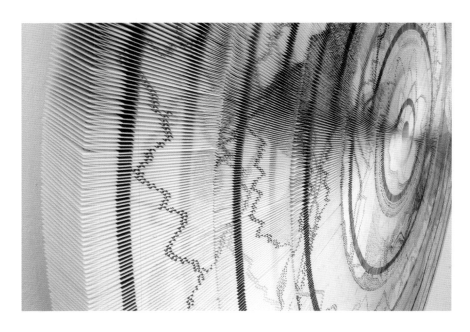

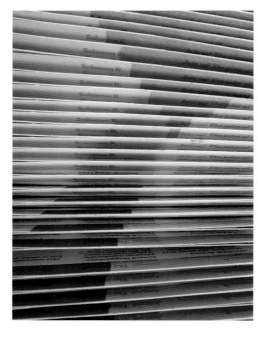

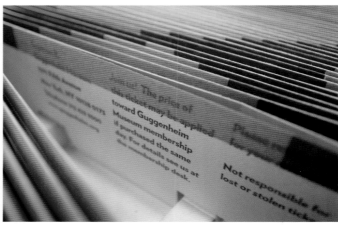

Guggen' Dizzy

This is another work that uses Guggenheim Museum's tickets as the creative medium and originates from the artist's experience of working in the Visitor Services of the Museum.

The spiral gallery designed by the great architect Frank Lloyd Wright is a favorite of visitors; however, having to sit everyday on the first floor ticketing booth, Mia often felt a sense of dizziness when looking up at the great spiral. This work uses two types of paper tapes to stick together the two sides of the museum tickets and the configuration of the tickets naturally forms a strong optical effect - the tape appears to give off a sense of color and light. The final work uses this color and light as the creative element to transmit the sense of spatial vertigo Mia felt. This work also acts as the initiator in the transformation of this series of paper sculptures into light sculptures.

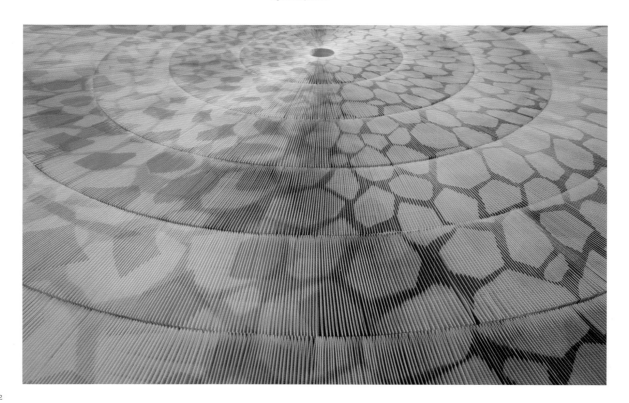

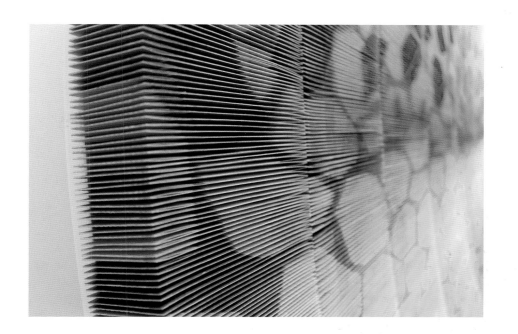

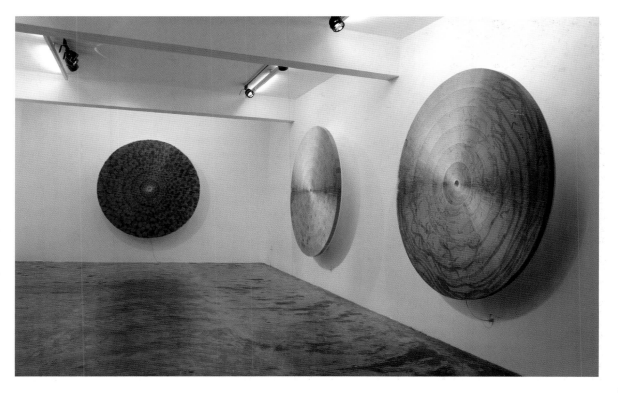

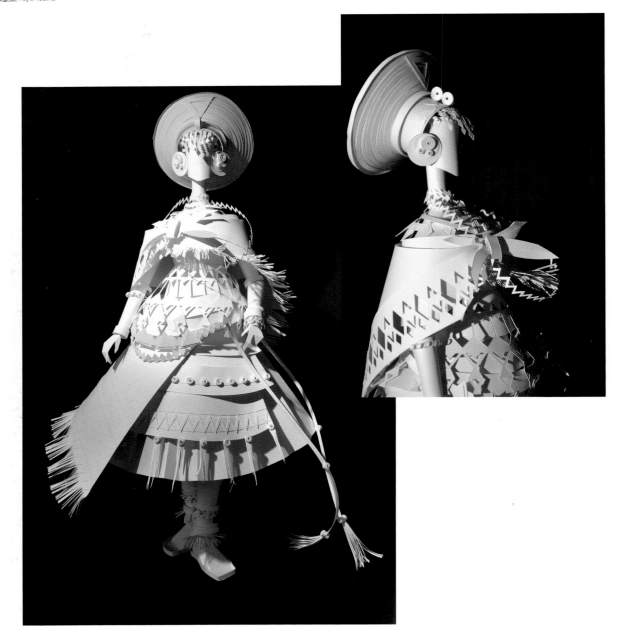

Wedding gear paper sculptures

This project is a series of paper sculptures of brides in various ethnic wedding gear. The artist places emphasis on specific characteristics of wedding dresses in different countries. Each sculpture expresses the variety and richness of wedding gear and how it embodies the most specific characteristics of each national costume. Today, ethnic wedding dresses are a dying tradition. They are preserved mostly in photos, descriptions by ethnologists and fashion historians. So the particular idea of this series is to create a so-called 'Red book of fashion.'

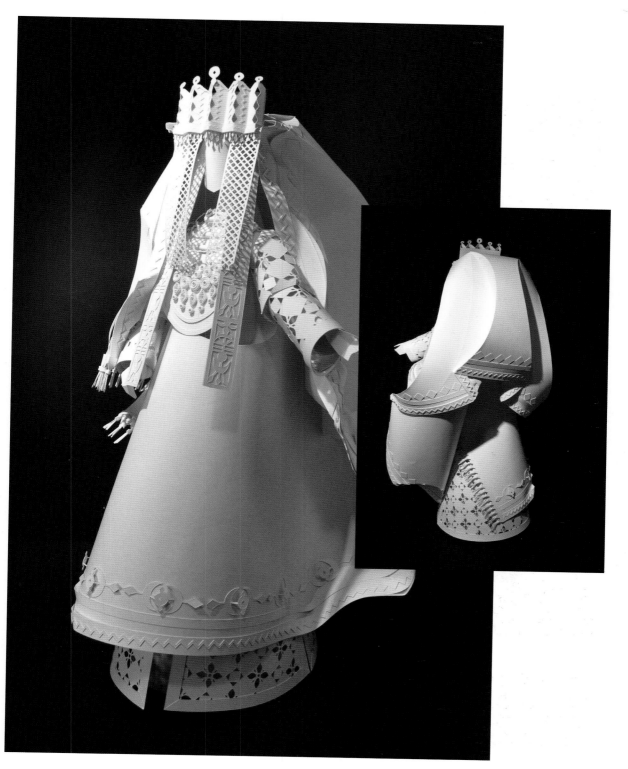

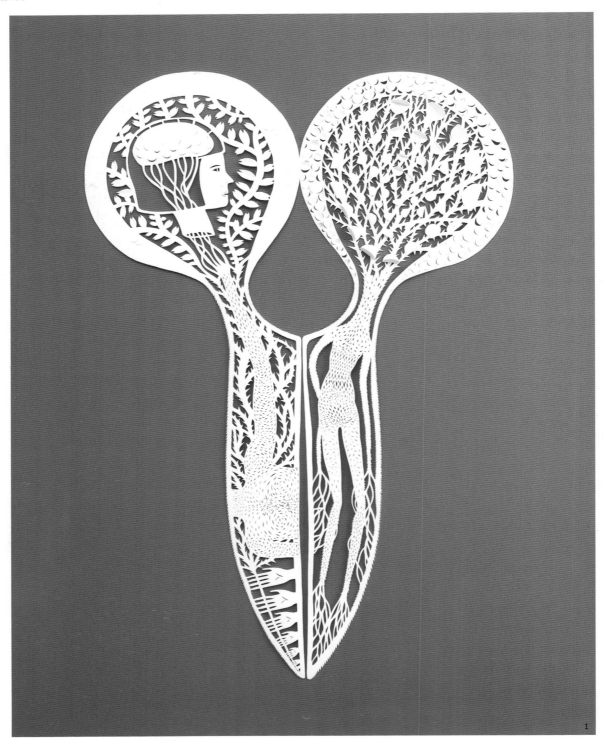

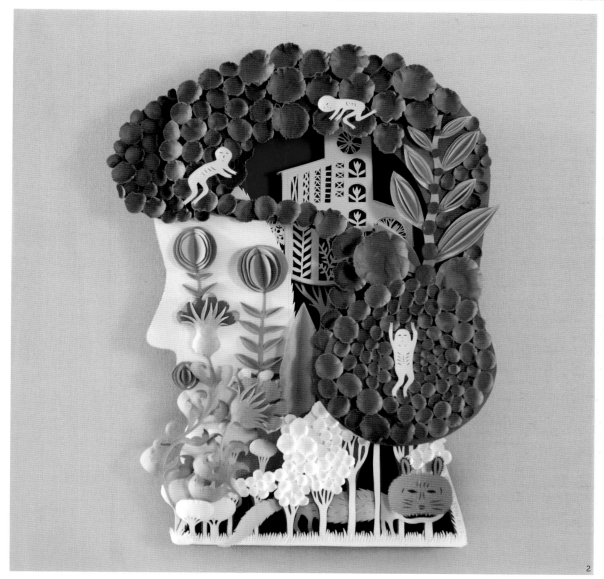

2

Paper Scissors

1 / Paper Scissors
2 / Head

In *Paper Scissors*, Elsa Mora first drew the design directly on the paper with pencil and then cut it using a #11 X-Acto knife. To give body to the surface, she folded a few small parts of the paper in a vertical position. For the *Head* Project, Elsa built it by adding several cut and molded paper elements on a basic core form made of card. These two pieces are part of a group exhibition titled: About Paper. The show took place at Couturier Gallery, in Los Angeles, California.

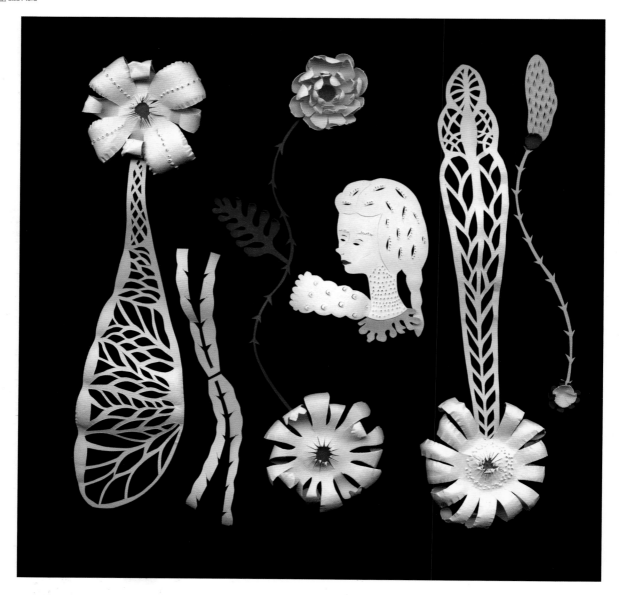

Botanical

Elsa Mora built this piece by arranging cut and molded paper elements on
a flat surface. This piece is part of a group exhibition titled: About Paper.
The show took place at Couturier Gallery, in Los Angeles, California.

Organic 1

Elsa Mora built this piece by adding layers of cut and molded paper and thin tissue-like paper to nature-inspired shapes. This piece is part of a group exhibition titled: About Paper. The show took place at Couturier Gallery, in Los Angeles, California.

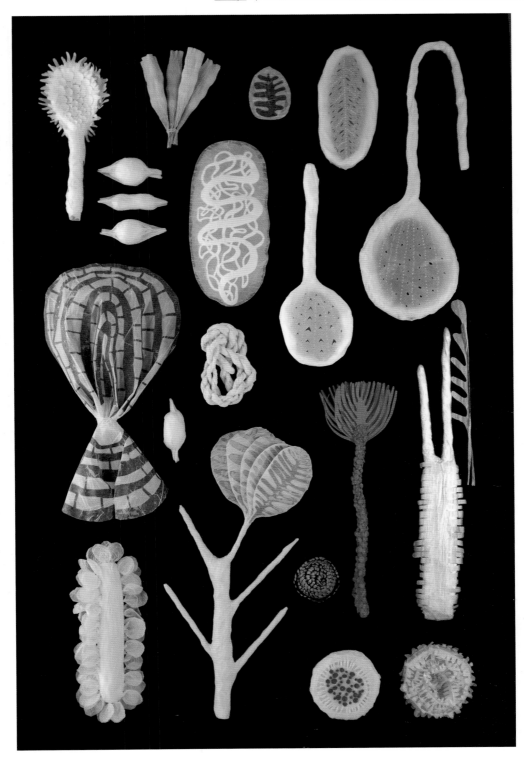

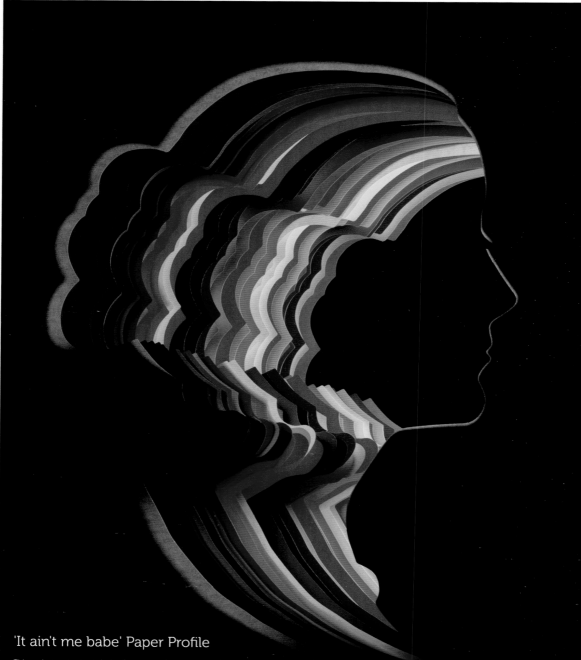

'It ain't me babe' Paper Profile

This project was a commission for a cover of a magazine all about the paper industry. Rachel Thomas's team was commissioned to make two images, but they eventually made ten. Rachel made a metal die (this was before she discovered laser cutting) of a woman's profile and then cut her profile into sheets of colored cartridge paper. She doesn't remember how many sheets she cut, but knows it was a lot, enough that there was a large amount to play with. Once they were in the studio, they created a rig that made it easy to change the order of the sheets of paper. That gave them flexibility and as soon as they started to play and shoot, they found that there were a lot of possibilities to create variations with color and light. It was an easy and pleasurable process and is one of Rachel's favorite projects.

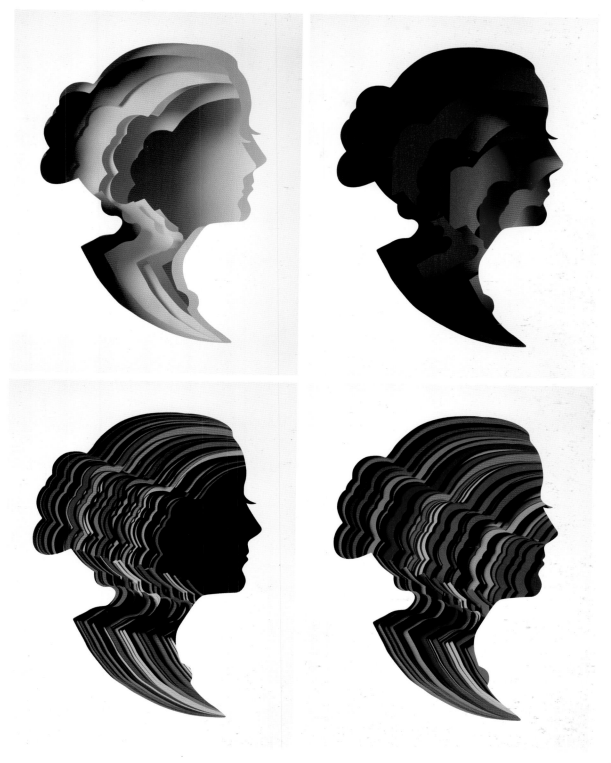

Design Agency Zim&Zou <u>Artist</u> Thibault ZIMMERMANN, Lucie THOMAS <u>Client</u> Hermès <u>Photographer</u> Zim&Zou

Atlantis

Hermès hired Zim&Zou to design the windows for the re-opening of their flagship store located on Rodeo Drive, Beverly Hills, California. Everything was handmade for the three windows.

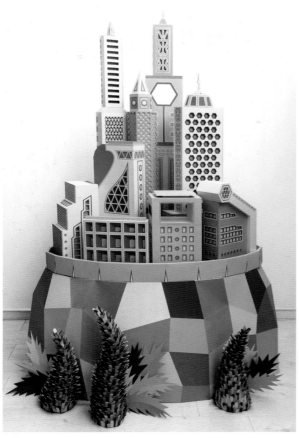

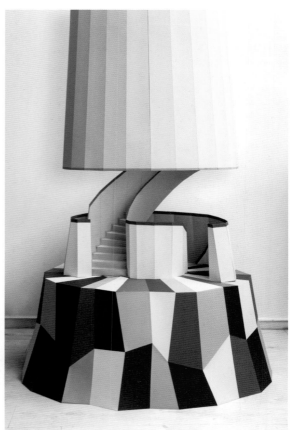

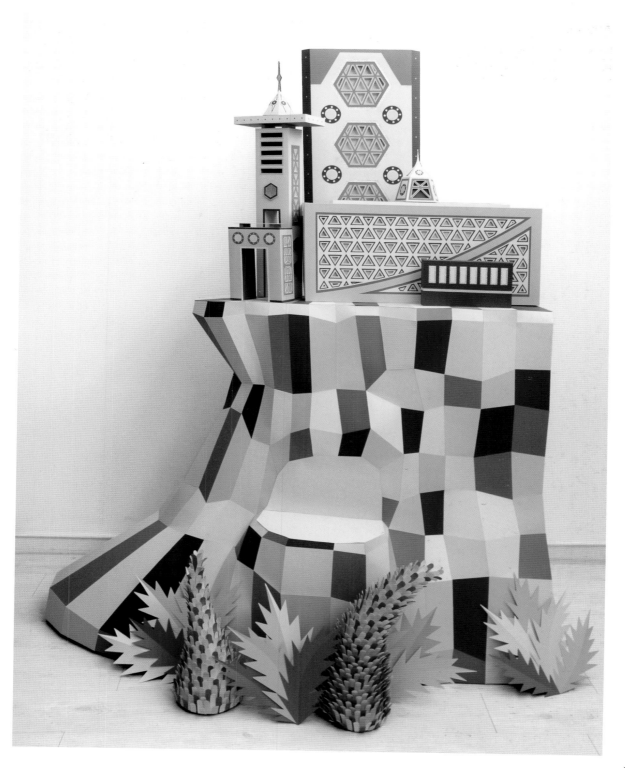

Artist Andy Singleton Client Manchester Art Gallery Photographer Alan Seabright

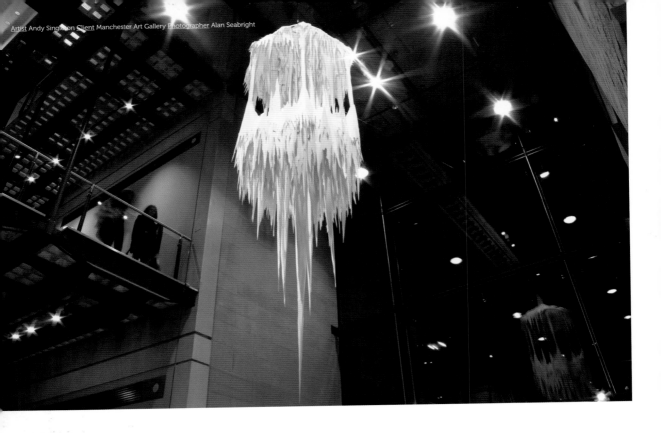

Ice Structure

Manchester Art Gallery asked Andy to design and build an winter themed installation from paper for the Christmas celebrations at gallery. The large space where the work would be situated was perfect for a hanging object. He started looking at ornate chandeliers as a form that could be used in such a space and also took inspiration from frozen waterfalls and ice structures in nature. Andy wanted to combine the two to create a beautiful ornate paper sculpture that looked like a water had frozen around a chandelier.

The piece was made using a wooden skeleton to give the basic structure and then the paper forms where constructed around this. The paper was hand cut, scored and folded to create 3D and 2D paper forms that were then glued and stapled to the wooden skeleton.

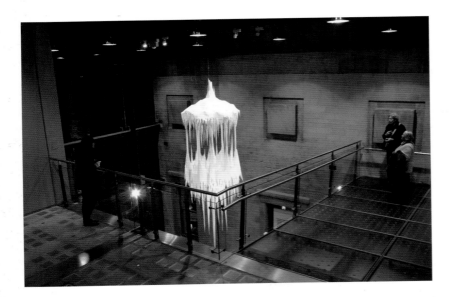

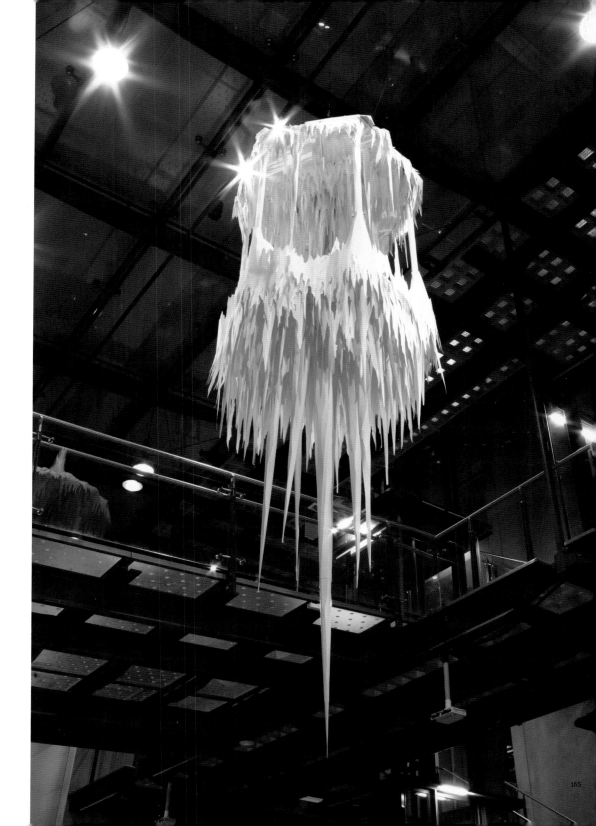

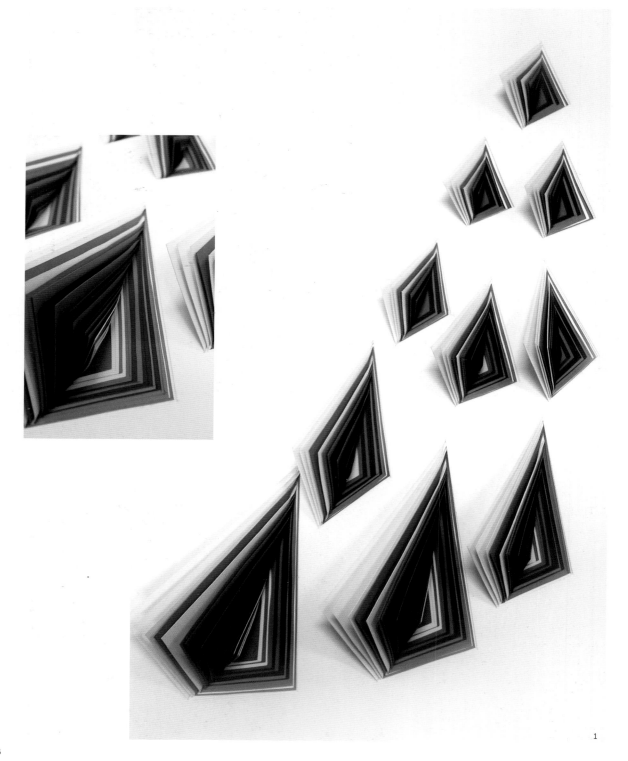

1

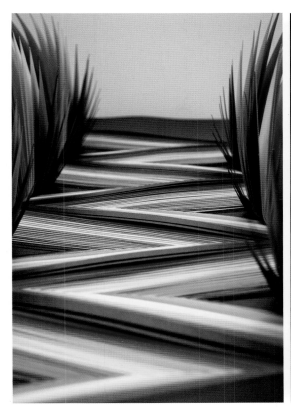

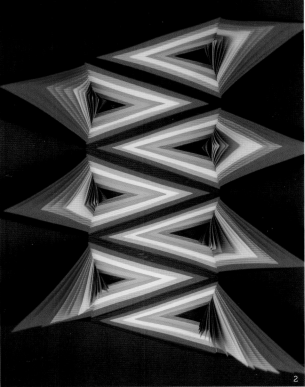

STRATIFY

1 / Zenith
2 / Monster
3 / Bloom

"The physical embodiment of my work is expressionist leaning on abstract with surreal concepts and fantastical connotations.

Seeing beauty in basic principles and mathematical ratios of nature and patterns in human emotions is transcending. Derivative of a number of concepts, these works started out as an exercise in exploring ways to use permutations, ratios and colors to portray emotions and details of beauty in natural forms. The entrails of these sculptures are inspired by emotions and fantastical instances of circumstances and are portrayed using mathematics, physics of materials, theories in color and study of lights and shadows. The technique involves repetitive cutting of paper in various desired shapes and forms and subsequent layering. Utilizing the characteristics of the paper itself, like the quality, color, weight and malleability, the final decisions on the sculpture are made, while keeping true to the concept."

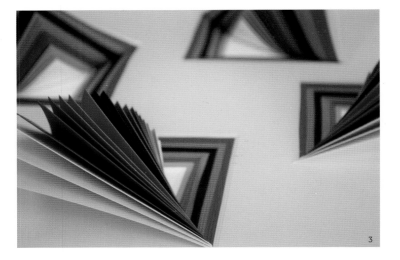

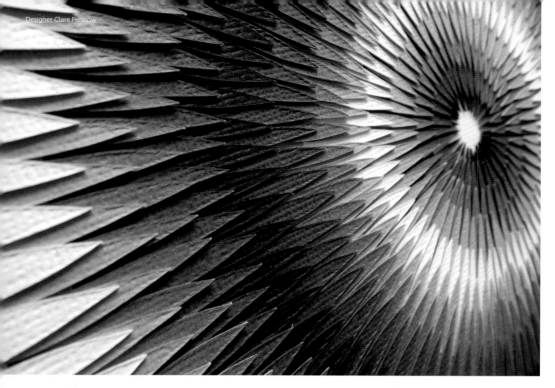

Geometric

The transformation of a flat sheet of paper through cutting and folding is one Clare Pentlow still finds to be a constant source of inspiration as she continues to explore the many possibilities that paper presents and she challenges people's perceptions of such an everyday material.

Geometric designs and patterns are of particular inspiration for this project, especially within nature and the way that mathematics is so closely connected to the natural world. Here, Clare has been exploring the use of multiples and the way colors can change and interact to create a sense of movement. By layering and blending the colors to create a sense of depth, drawing the viewer in and conversely using striking obtuse colors, the results produce an almost hypnotic quality. Clare is also fascinated by the effect of light and shadow upon the work; how it changes the composition and introduces an ever-changing element to the work, aiding in the movement and beauty of the piece.

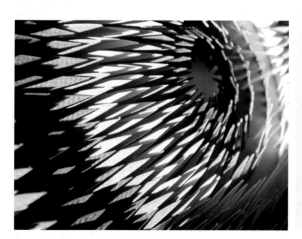

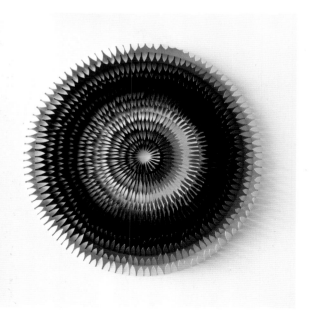

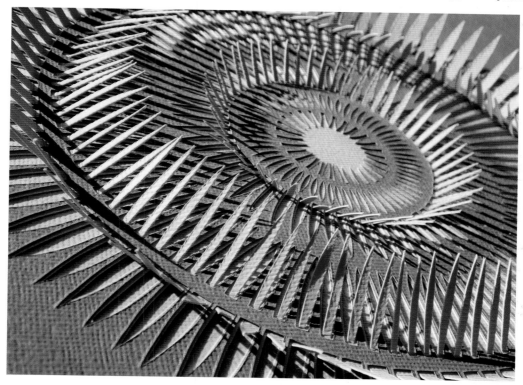

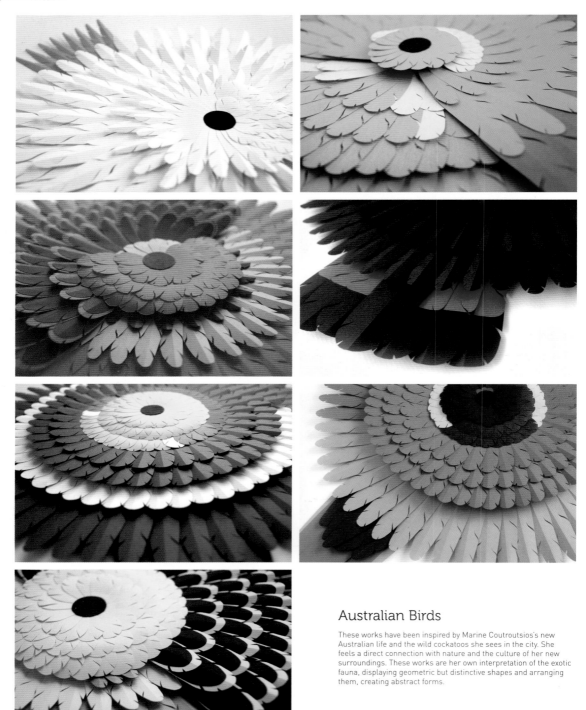

Australian Birds

These works have been inspired by Marine Coutroutsios's new Australian life and the wild cockatoos she sees in the city. She feels a direct connection with nature and the culture of her new surroundings. These works are her own interpretation of the exotic fauna, displaying geometric but distinctive shapes and arranging them, creating abstract forms.

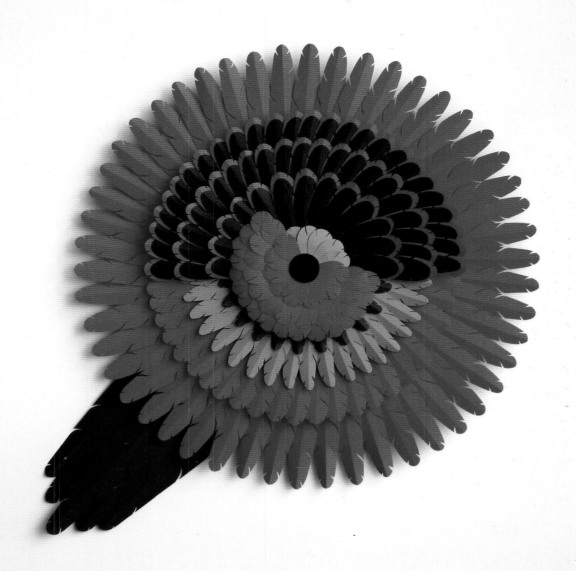

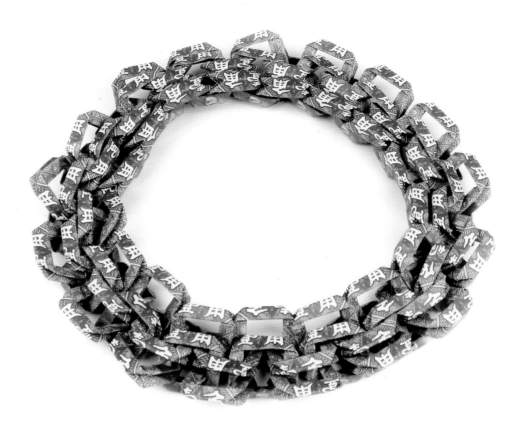

1

Money Jewelery

1 / Double China necklace - back
2 / Square China necklace
3 / Double China necklace - front
4 / Laos Green Flower necklace
5 / Around the World necklace

This jewelery collection is completely made from paper money. All banknotes were valid currency at the time the jewelery was made. They are only folded and not damaged in any way: no cutting was involved, nor was any glue applied. Each note can still be unfolded and used as currency. The jewelery is surprisingly strong; it does not tear easily or fall apart quickly.

The collection is a comment on the perceived value of gold and money and their relationship. Can one replace the other? For this collection, that is exactly what Tine has done: the precious necklaces and bracelets are made from banknotes instead of gold. They send out the same message (I'm rich!) and provide financial back up in case of need.

At the same time, the collection draws attention to the current worldwide economic crisis. What really is money? How much is it worth? What gives it its value? How does one currency relate to the others? Why is one currency stronger than another and for how long?

By replacing gold with money, Tine draws attention to our attitude towards wealth. She hopes to make people think about what money means to them and to society as a whole.

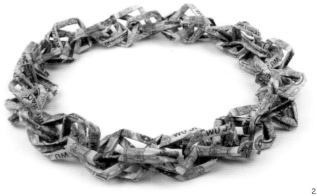

2

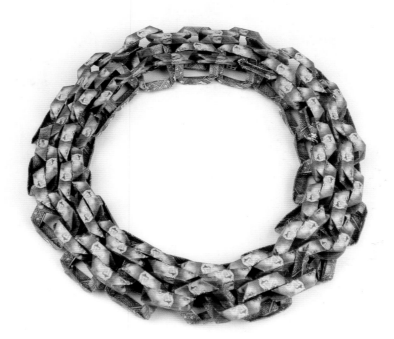

3

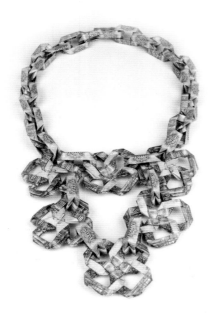

4

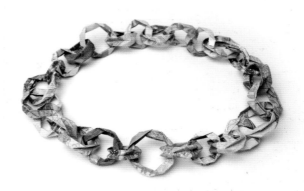

5

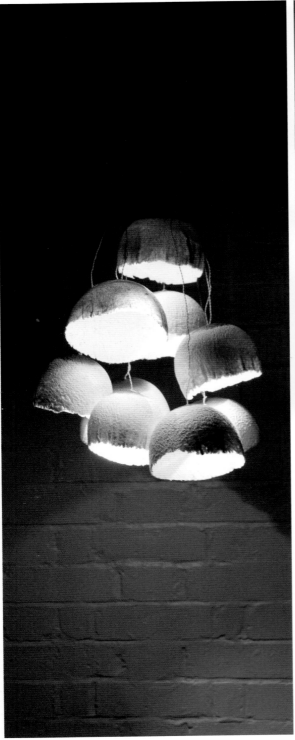

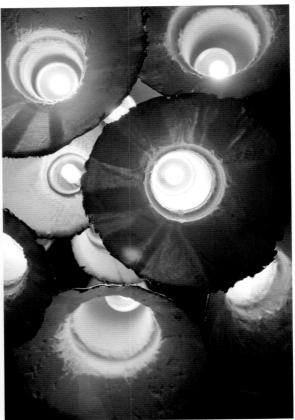

Paper Productions Lights

A handcrafted light collection made by artisans in Ahmedabad, India. Paper Productions is the outcome of a collaborative development project between designers and artisans.

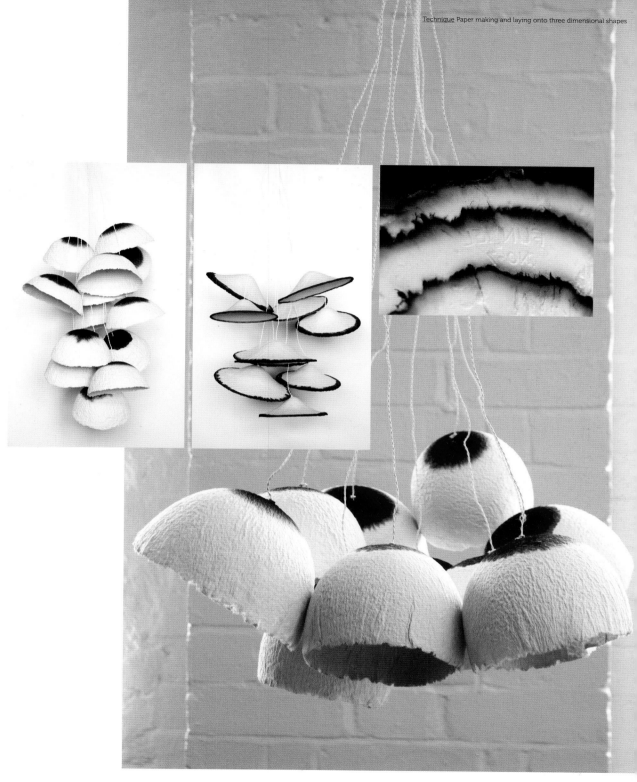

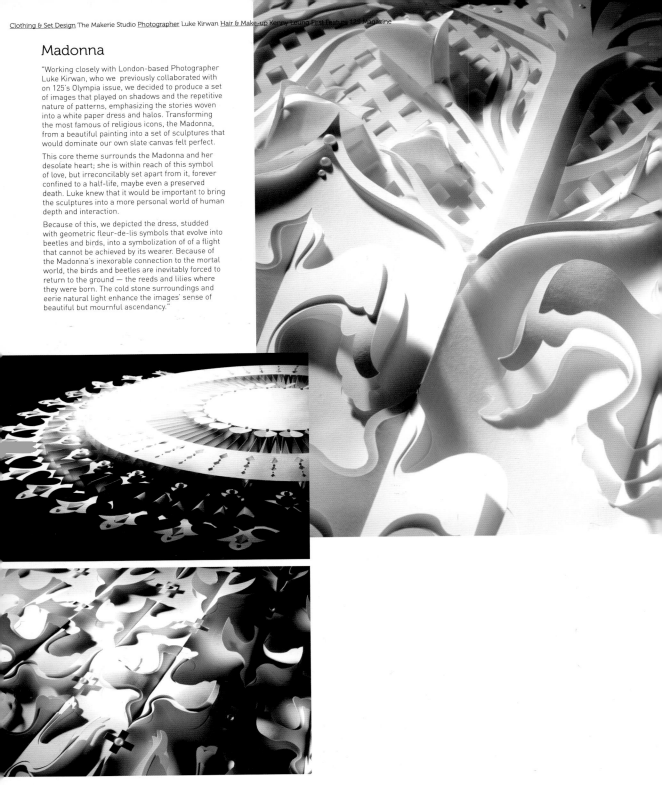

Madonna

"Working closely with London-based Photographer Luke Kirwan, who we previously collaborated with on 125's Olympia issue, we decided to produce a set of images that played on shadows and the repetitive nature of patterns, emphasizing the stories woven into a white paper dress and halos. Transforming the most famous of religious icons, the Madonna, from a beautiful painting into a set of sculptures that would dominate our own slate canvas felt perfect.

This core theme surrounds the Madonna and her desolate heart; she is within reach of this symbol of love, but irreconcilably set apart from it, forever confined to a half-life, maybe even a preserved death. Luke knew that it would be important to bring the sculptures into a more personal world of human depth and interaction.

Because of this, we depicted the dress, studded with geometric fleur-de-lis symbols that evolve into beetles and birds, into a symbolization of of a flight that cannot be achieved by its wearer. Because of the Madonna's inexorable connection to the mortal world, the birds and beetles are inevitably forced to return to the ground — the reeds and lilies where they were born. The cold stone surroundings and eerie natural light enhance the images' sense of beautiful but mournful ascendancy."

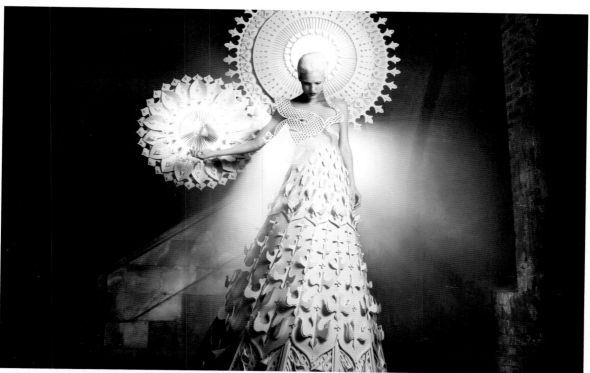

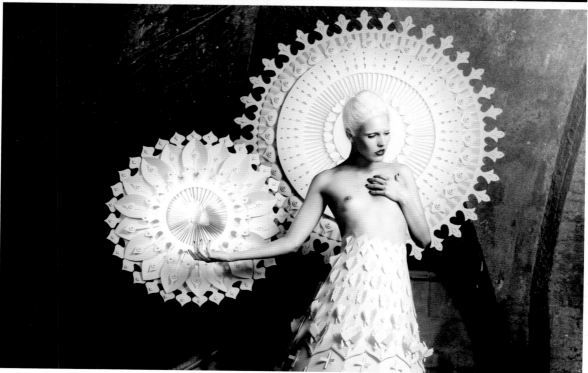

Design Agency The Makerie Studio Photographer Lucia Giacani Stylist Dinalva Barros Set Designer Bruno Tarsia

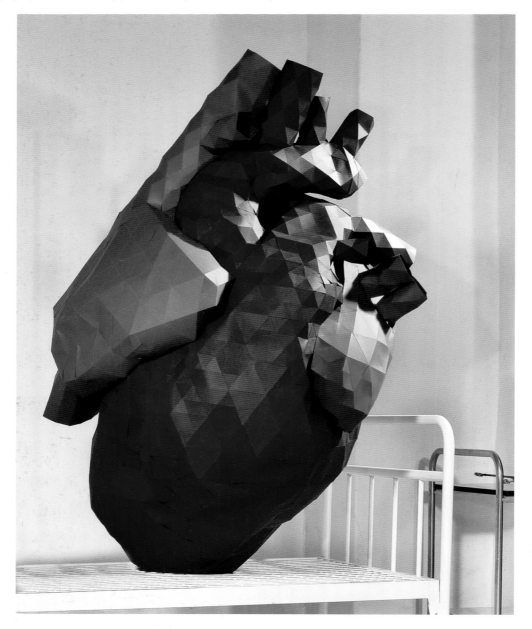

Splash 2013 Calendar: Room 2013

Oversized faceted paper heart, created for Lucia Giacani's shot of Room 2013 and
commissioned by fashion label Splash Dubai. Also created as part of the shoot were
a brain, lungs and eye, all in textured and reflective papers.

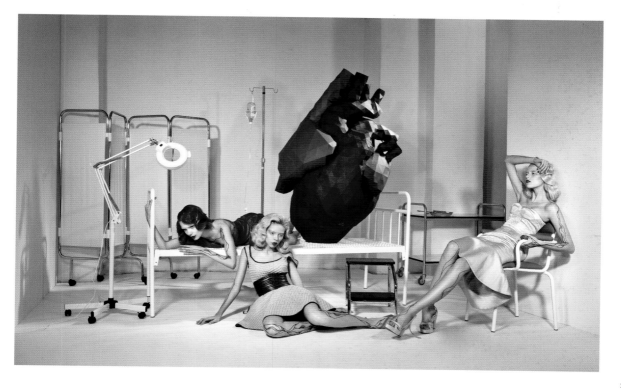

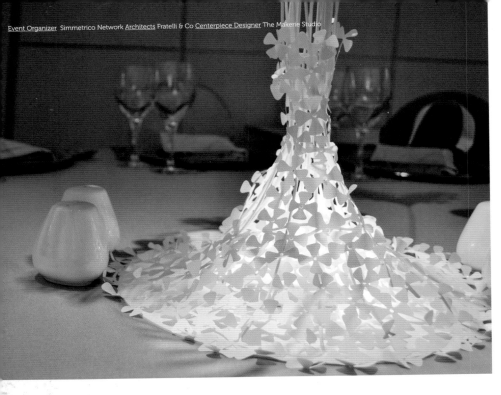

Presidential Gala Dinner Installation

Centerpiece decorations designed, built and installed the for the Azerbaijani President's gala dinner in Baku, celebrating Heydar Aliyev's 90th birthday. The prestigious dinner was hosted in Zaha Hadid's Heydar Aliyev Centre, opening together with their Treasures of Azerbaijan exhibition and organized entirely by Simmetrico Network. The Gala room of the center was completely redesigned, fitted with ceiling decors, set designs and a stage plan by Italian architects Fratelli & Co, with whom they had the pleasure of collaborating.

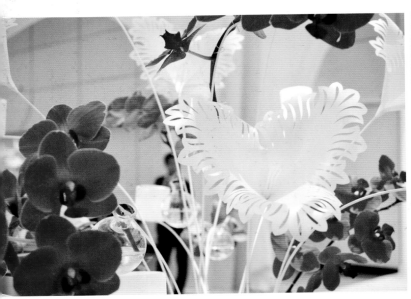

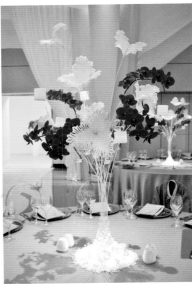

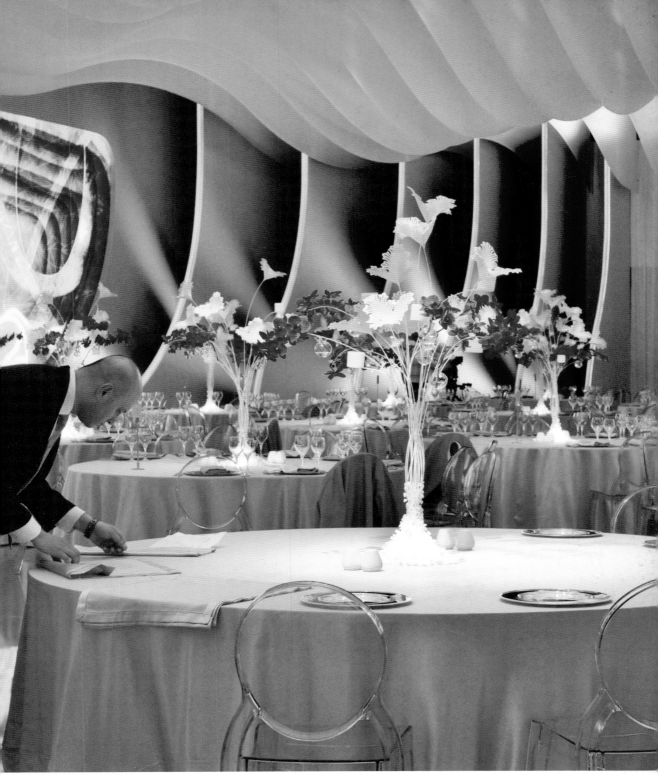

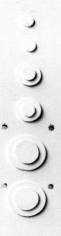

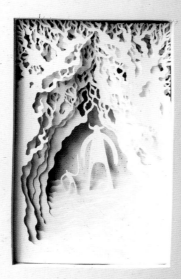

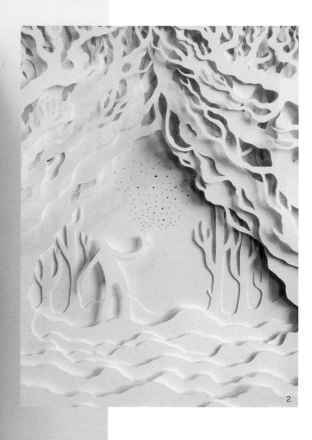

2

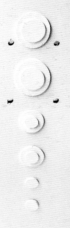

1

1, 4 David & Goliath

'Bordo Bello' is an annual skateboard art show hosted by AIGA Colorado, which has worked with more that 1,000 artists to create a collaborative exhibition of skateboard decks in celebration of the colorful Colorado lifestyle.

This year, AIGA Colorado was invited to NYC to exhibit at the AIGA National Design Center. The exhibit is a unique collection of skateboards from previous 'Bordo Bello' events and showcases brand new artwork available for purchase during the opening reception.

David & Goliath is the title of Harikrishnan Panicker's piece especially created for this show. This piece involves hand cut watercolor paper with back lit LED that is assembled in a wooden box and embedded in a skate deck.

The artist's inspiration was the story of the little warrior David who takes on the bigger, stronger giant Goliath and prevails. It's a metaphor for Colorado, with its exciting and upcoming art community representing itself in a big city like New York and making its presence felt and appreciated through amazing skateboard art.

"I have been working with paper as a medium and building illustrations in shadow boxes for the past few years. I wanted to elevate the experience of the layers to another level and decided to experiment with lights and shadows inspired by the shadow puppets of Bali. The pieces are all hand-cut water color paper (Acid Free/Archival) and have been manually assembled in a shadow box, which was then embedded in the skateboard. The light is a flexible LED Striplight that runs on a 12V Adapter power source."

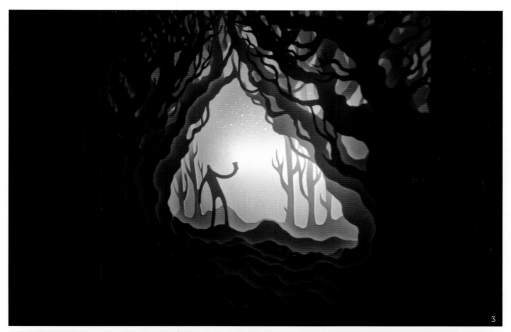

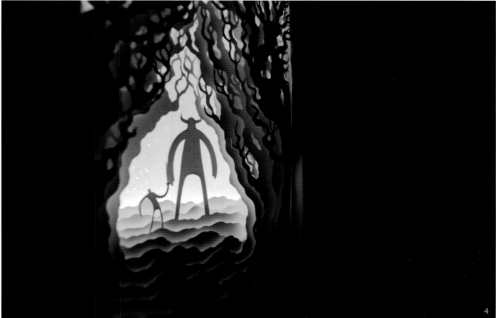

2, 3 Fireflies

Medium : Hand cut archival quality acid free water color paper, assembled in a white wooden shadow box and backlit. This piece is reminiscent of Harikrishnan's holidays in his native village of Kerala where fireflies are abundant. Moving to Denver, he missed seeing these magnificent creatures and that translated into this figment of imagination of exploring a forest filled with fireflies.

Hôtel Jules & Jim

The owner of the very Parisian hotel, Jules & Jim, commissioned Mathilde
Nivet to create a piece of art inspired by the building. She began to think
about what a hotel is and finally concluded that it is a place living fully
through night. She created a luminous system allowing the model to be
lit from the inside. When the light switch is off, the building is very regular
and classic, representing day time of hotel life. When the light is switched
on, scenes appear behind each window, showing all the things that happen
in hotels by night: diner, sleeping people, party, lovers, tired travelers, etc...
This piece of art is full of details and the simple gesture of turning the light
switch on or off, completely changes the atmosphere at the hotel.

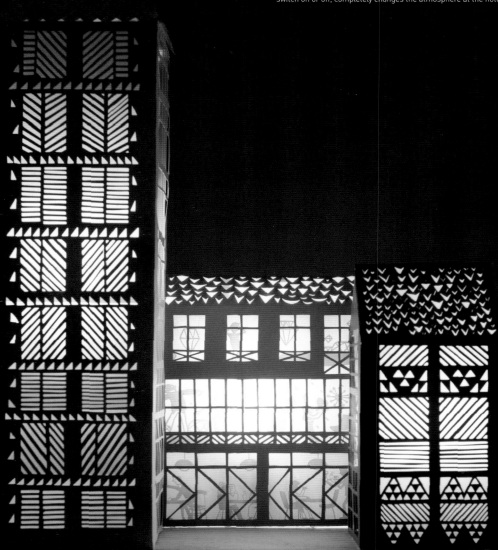

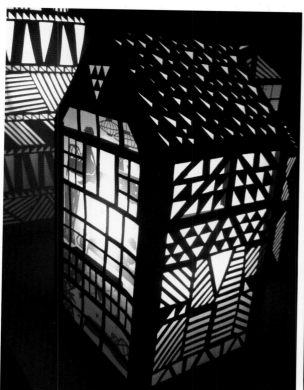
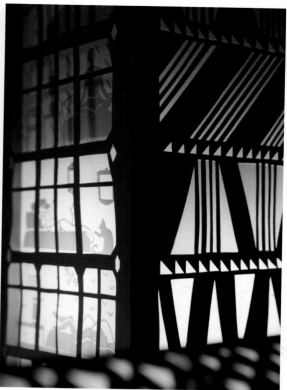

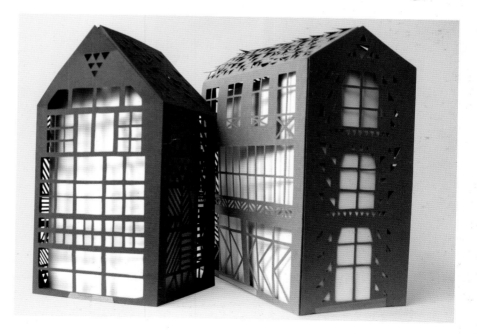

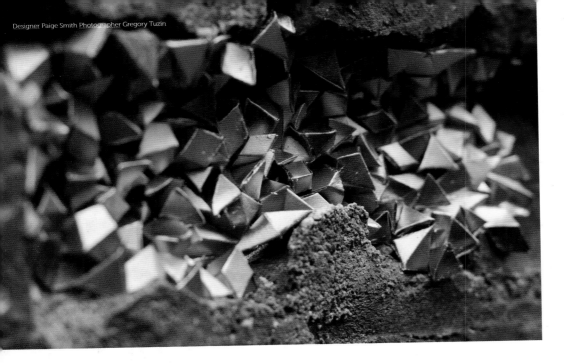

URBAN ART—URBAN GEODE

Paige Smith has been creating street art in the Los Angeles area, greater California and internationally since late 2011. Rather than using traditional paint or wheat paste methods in a 2D platform, Smith uses folded paper to create 3-dimensional installations. These sculptures come in all sizes and fit in the holes of buildings, decommissioned pipes and crumbling infrastructure. The finished shapes represent geodes, crystal, quartz or any mineral formation that you would normally find in nature, but is now found in our urban settings.

Each installation is a hidden treasure waiting to be discovered as people go about their daily routine. Smith's work has a palpable sense of 'magical realism' that says, "take a look around, notice the small things. Find wonder and beauty in the mundane."

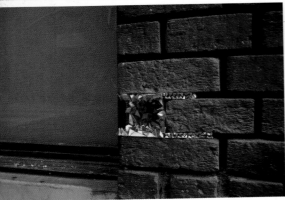

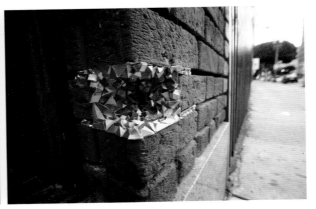

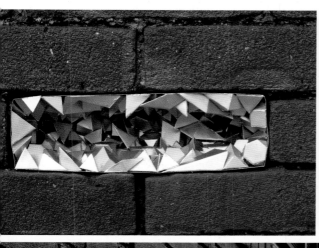

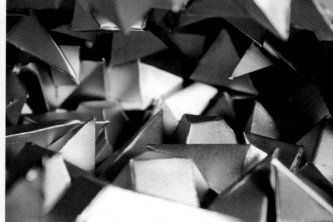

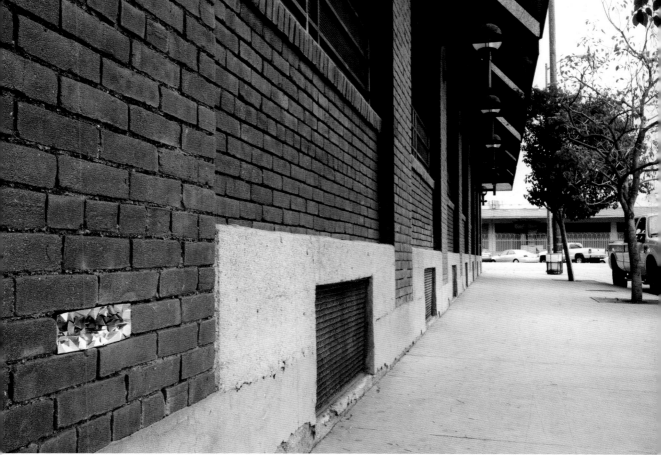

Design Agency 24° Studio (Fumio Hirakawa + Marina Topunova) Client Santorini Biennale Organizing Committee Curator Paola Gentili

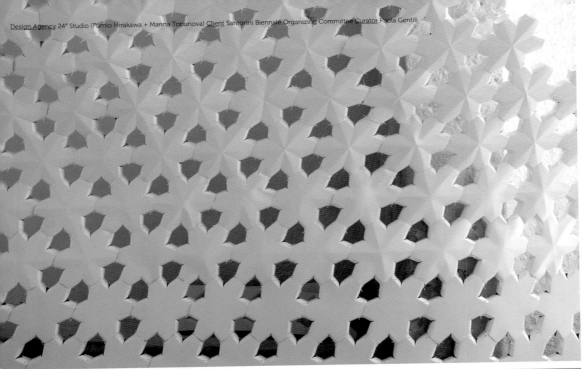

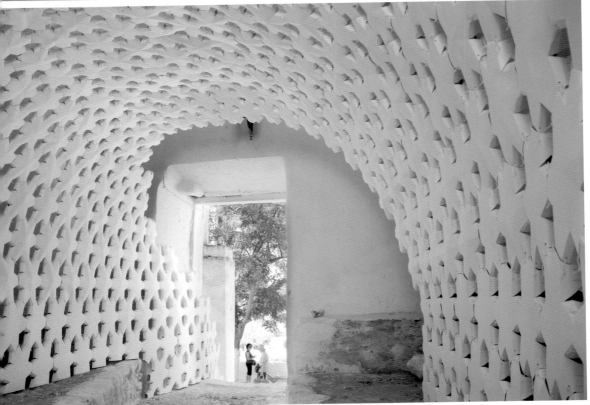

Collaborators Vassilis Zorzos, Sophia Arapoglou, Gregory Frangos, Andri Siaele, Vasso Asfi, Costas Bissas, Ioannis Vlachos, Samson Fytros, Antonis Tsemai

Daphne

Daphne makes a mundane moment of procession through this enclosed space into a highly charged experience that will celebrate the coexistence of past, present and future. A trace of Daphne will appear at the entrance of the tunnel. Beginning with a few panels at the foot of the stairs, it will grow in number and encapsulate the interior surface of the tunnel, only maintaining its key element to wrap the space and juxtapose the 'past' with the 'present' intervention. The interior illumination will accentuate the space from dusk to dawn, which can be an emphasis on how the existing materiality can coexist with new materiality and suggest uncanny, yet mesmerizing possibility.

During the Santorini Biennale, further impacts from environmental conditions will also play an important role in this installation. Wind, humidity and passersby who interact with the installation will affect the aging of the material.

This inevitable, and also unpredictable factor of the installation and process, will illustrate how the transformation of textural and color quality can bring phenomenal conditions of time and space. These latent effects of material expressing this ephemeral condition will become a key factor, in which the 'past,' 'present' and 'future' will all be contained.

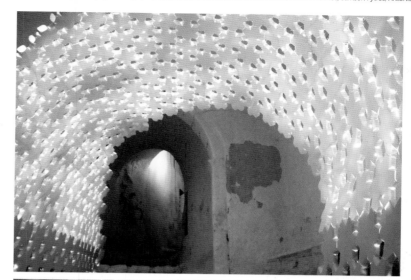

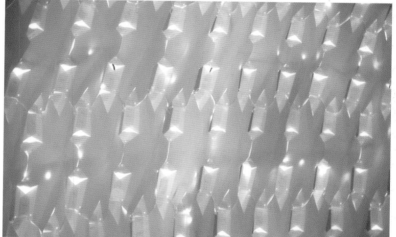

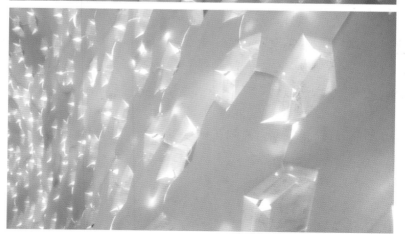

Artist Charlotte McGowan-Griffin Photographer Patricia Sevilla Ciordia

From Sarsaparilla to Sorcery

Originally developed for Charlotte McGowan-Griffin's solo exhibition, *The Rings of Saturn* at frühsorge contemporary drawings in Berlin in 2012. This installation explores the imaginative connection between encyclopedias and labyrinths and uses a very thin type of paper known colloquially in English as 'bible paper.' This paper is normally used for printing very large volumes such as bibles and encyclopedias. A volume of a 1960's edition of the Encyclopedia Britannica titled, From Sarsaparilla to Sorcery is also included in the installation and gives the work its title. Herein lies the clue or 'golden thread' to the thematic content of the entire exhibition — Saturn, shellac, shipping, silkworms...

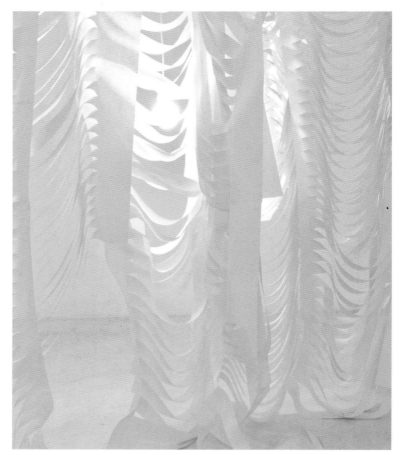

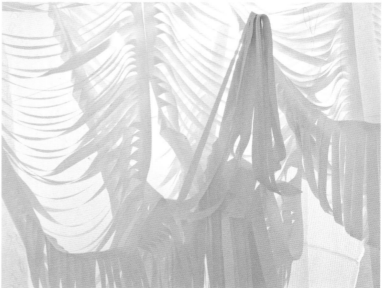

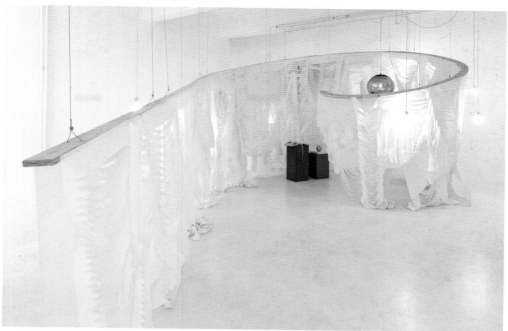

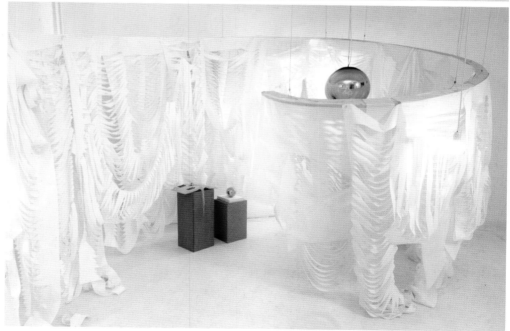

Projectile Heaven

Projectile Heaven is a personal reflection on the relationship between religion and the term spirituality. Raised in a strict Catholic family, this cut paper installation was a chance for Antonius Bui to question the black and white laws of his faith. Religion is a very sensitive issue that tends to lead to argument and frustration. This piece hopes to bring peace and unity to followers of every religious denomination by making viewers appreciate the delicate beauty of each faith through a material that is equally fragile, paper. Instead of focusing on the differences in humanity, Antonius believes that we should develop a greater appreciation for our similar core values and desire to love. Most religions share a common goal of missionary work and spreading the 'good news' to every corner of the world. Starting from a corner, Projectile Heaven explodes, fully embracing the social changes of our generation (human sexuality, genetic manipulation, etc.). Arabic script found in the Quran was the main inspiration for this project. A star gazer projector was used to imprint a sense of time and space.

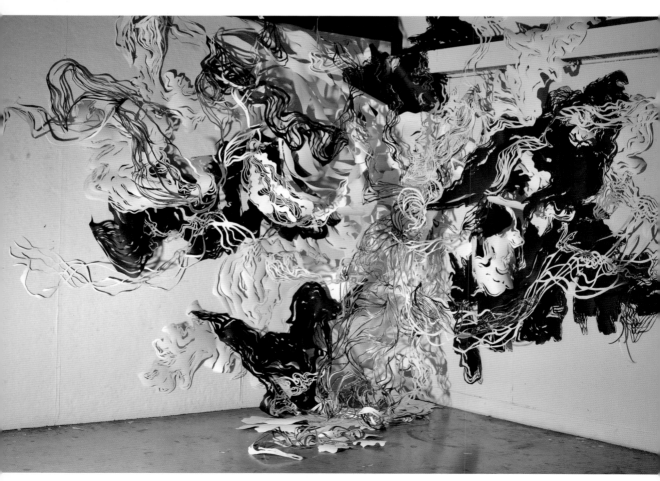

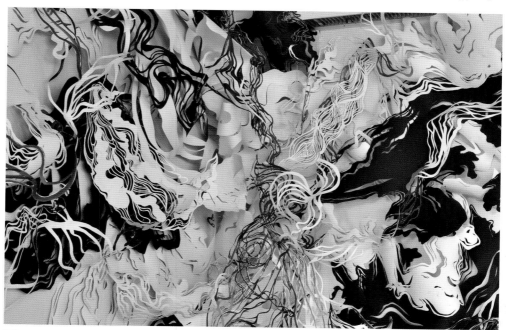

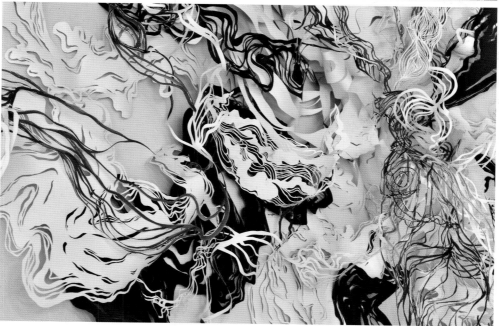

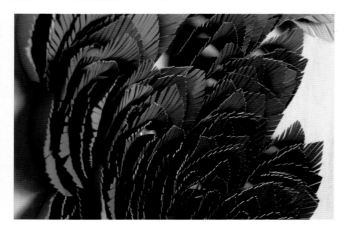

Un lugar imposible (An impossible place)

The focus of Pilar Mackenna's work is the elaboration of scenes that refer to natural landscape, the organic and the strange realm of the tactile. These scenes configured by volumes and drawings that transition between two-dimensional and three-dimensional, verge on both figuration and abstraction. Throughout Pilar's work, she seeks to create spatial constructions that will be inhabited by diverse elements that connect and coexist through their color and form. These scenarios are pieced together based on reflections regarding the observation of nature and the compilation of mental images. The results of this encounter are atmospheres, which may be defined as both strange and surreal. The use of paper and the medium of drawing lead these reflections towards a decisively subjective scale and multiple interpretations. In this way, the study of color, the process itself and the volumetric sketches merge to speculate upon the encounters between drawing, painting and volume.

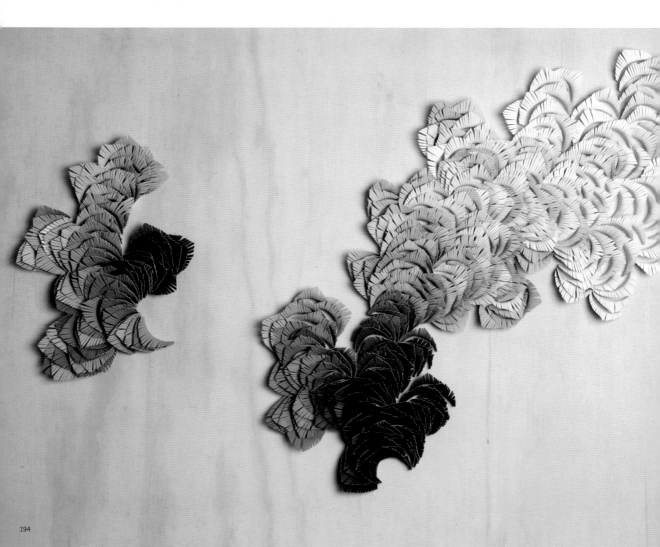

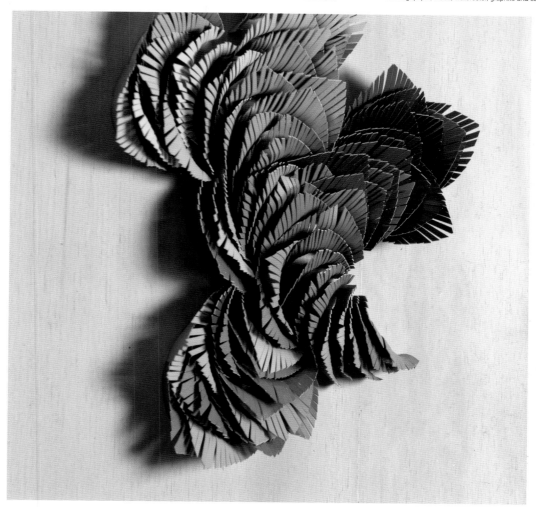

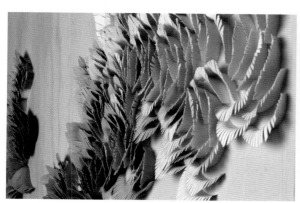

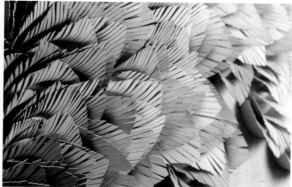

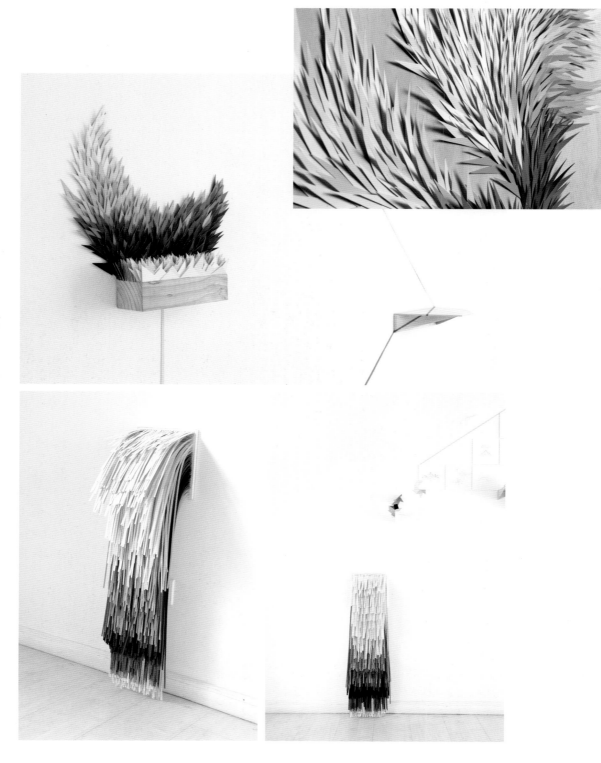

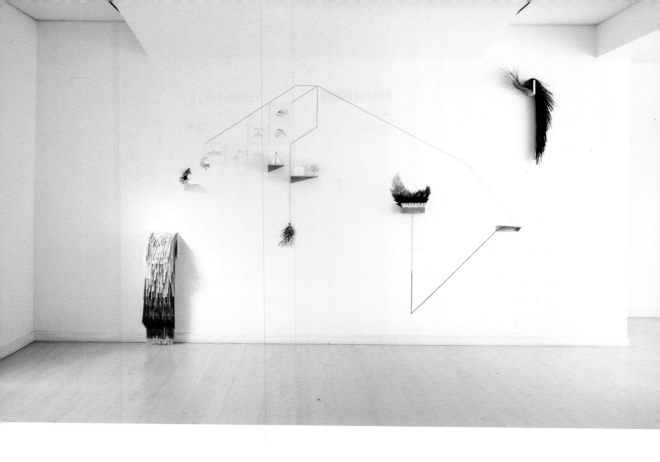

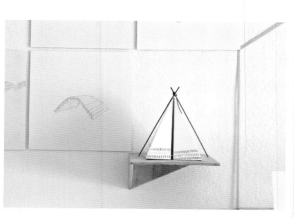

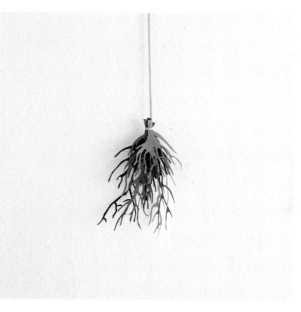

Matricielle 1

Matricielle 1 is an installation made of silk-screened, folded and assembled paper. Inspired by pixelated media imagery of explosion and construction games, the artist creates a space between representation and abstraction. The various folds and openings modify our perception of the printed surface. The printed paper becomes malleable, an interface offering unlimited possibilities of combinations. There is thus a dialogue between the ways we perceive, imagine and interact with our environment and the impact scientific and media imagery incur. How do tools, images and interfaces affect our relation to space and distances, to temporality?

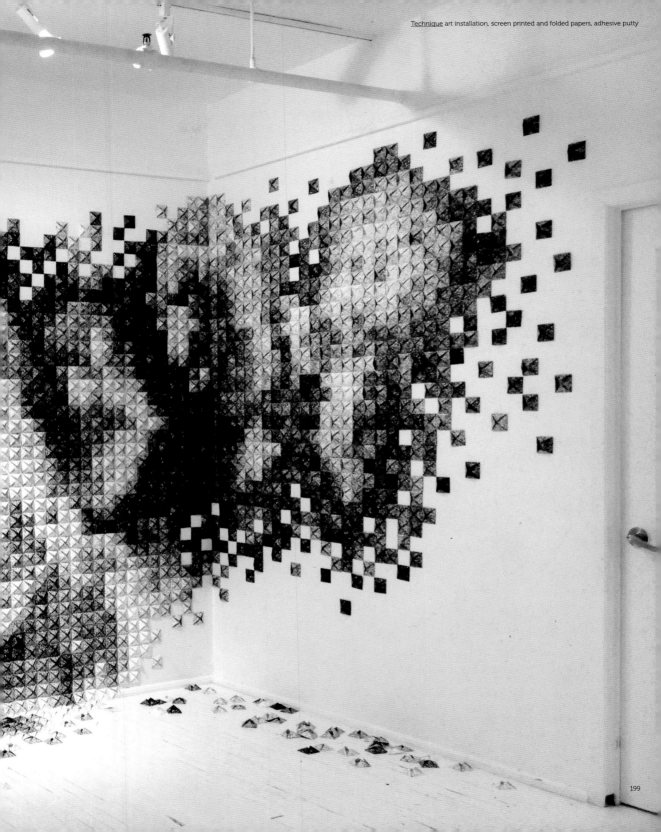

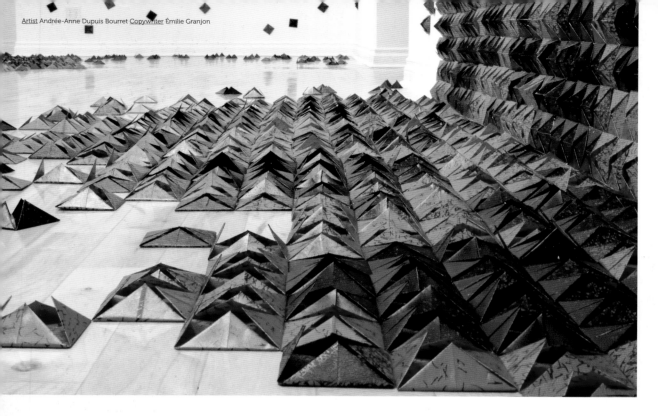

Artist Andrée-Anne Dupuis Bourret Copywriter Émilie Granjon

Matricielle 2

Matricielle 2, a work of patience and meticulousness, reveals an intriguing cartography composed of thousands of small, red and black paper units. The silk-screened papers that make up each of the elements are folded in the same way; fine black lines on a red background represent lineaments in dynamic and abstract shapes that are more or less dense. Cleverly assembled in space to resemble fractal images, these units also act as pixels of a digital image and the element that constitutes this basic component. Within this visual synecdochical interplay, the pixel-units build up, recomposing and reconfiguring the gallery's architecture, thus conceiving regions with a high modular density in some places and a lower density zone in others. The dynamic chromatic nuances of this cartography create formal rhymes and rhythms that accentuate the effect of the proliferation of these numeric cells.

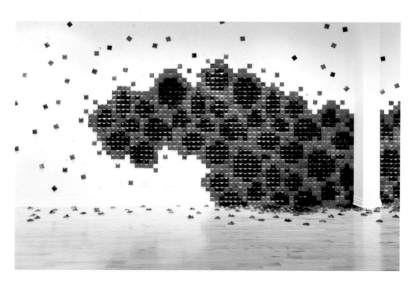

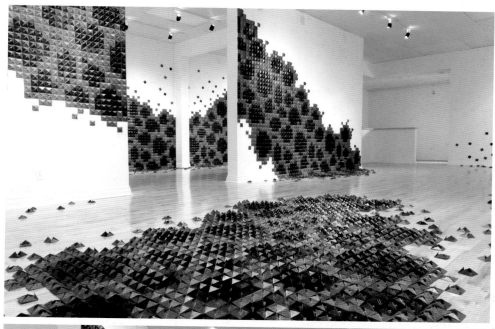

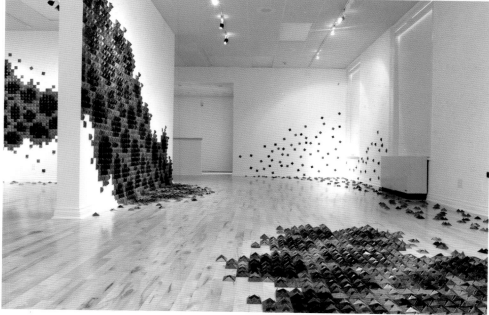

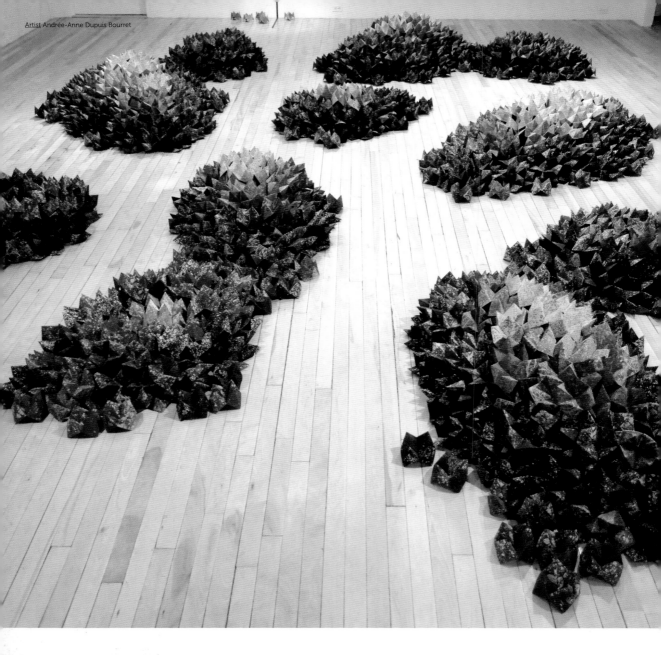

Terraformation

Terraformation is an installation made of silk-screened, folded and assembled paper. Inspired by masses of organic and industrial matter shaped by excavators, the artist explores modular constructions and their potential variations. She builds abstract and geometric forms that lie somewhere between image and object. The various folds and openings modify our perception of the printed surface and extend across the floor of the exhibition space. These structures, made up of 3,600 modules, are akin to computer-generated terrain modeling or proliferating landscape elements. Terraformation thereby challenges the ways in which we view and interact with the space around us.

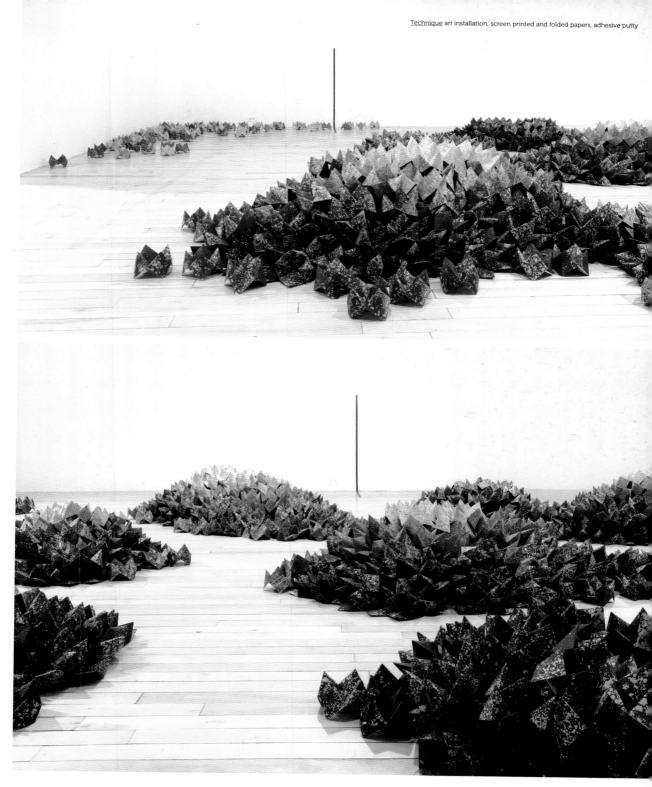

Eat Me

Hiroko Matsushita created
this piece while earning
her master's degree. She
was inspired by a Japanese
Christmas cake, which typically
has strawberries on top. In
the past, the term 'Christmas
cake' was used to allude to
unmarried women in Japan,
because 'no one wants them
after the 25th of December.'
Strawberries represent girls
who are 'identical' to one
another, in that they follow the
latest fashion. This work also
encompasses female issues
such as marriage, sexual
objectification and stereo-
typical imagery.

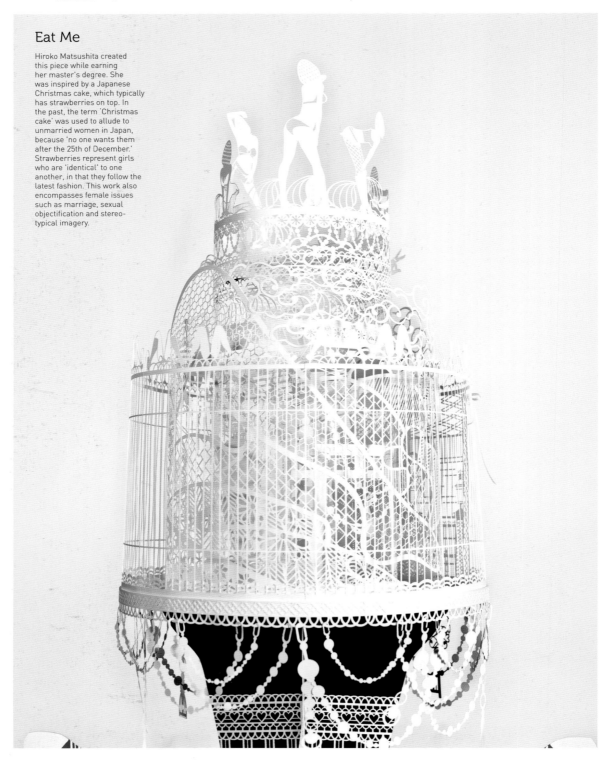

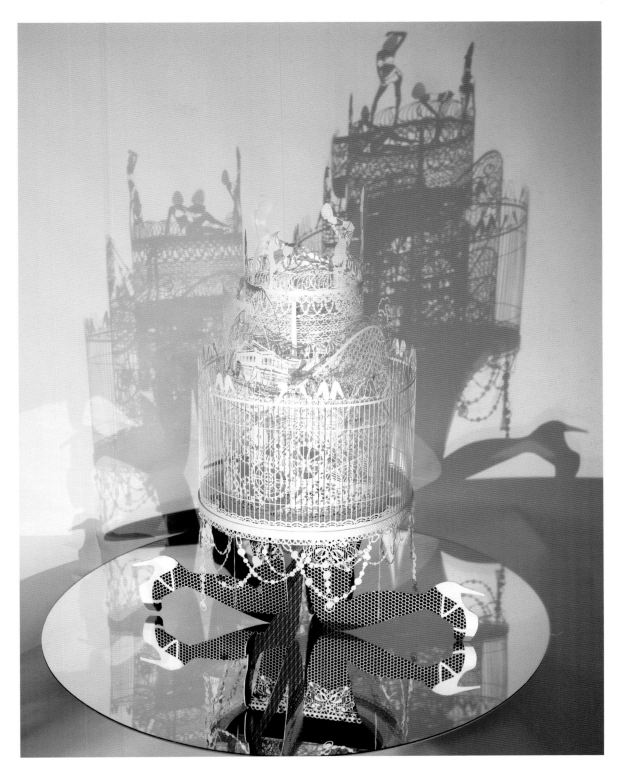

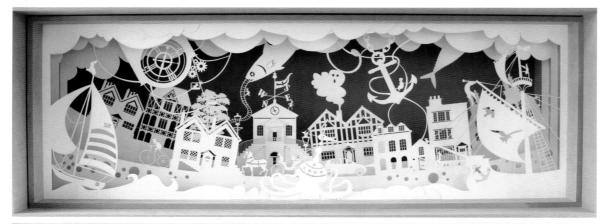

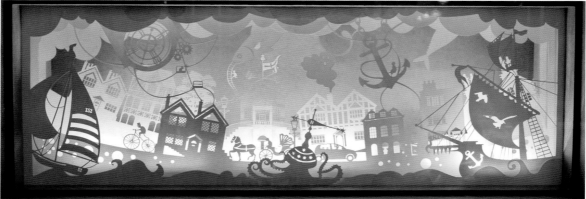

In-between

This project was part of 'Brilliance 2012' held in Pool, a port town in the southwest of England. All artists participating used lights within their artwork. Hiroko Matsushita was inspired by a beautiful old town and a historical museum in Pool and developed this whimsical small world, mixed with the past and the present. LED lights were set between paper cuts so that at night, the work takes on a different look.

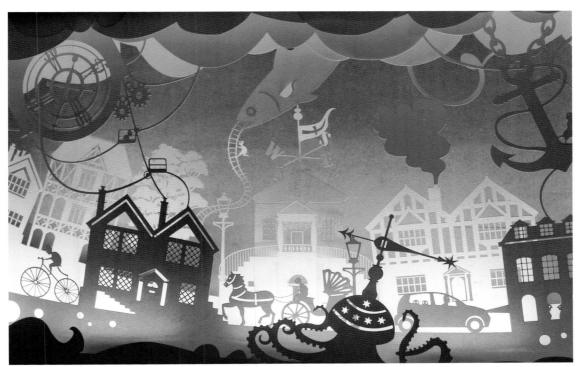

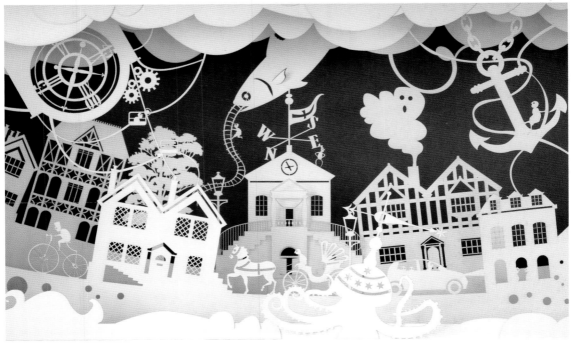

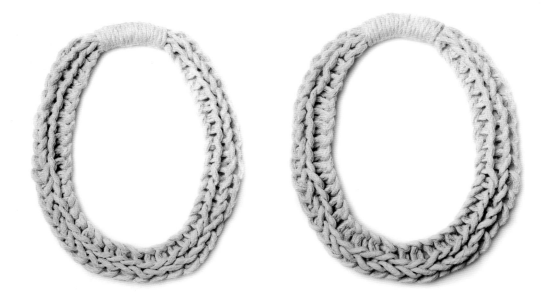

'Strands' collection

Sarah Kelly's inspiration for her 'Strands' collection came from an urge to create pieces with a beautiful simplicity and a return to dexterity. Each piece is made entirely by hand without the involvement of any machinery. They are a line of statement necklaces, which have an ombré effect finish and are designed to transform an outfit. It is a collection with an aim to be fashion focused and perfectly on-trend; making ready to wear necklaces that challenge the preconception that paper is not durable, with all materials sourced and made in the UK.

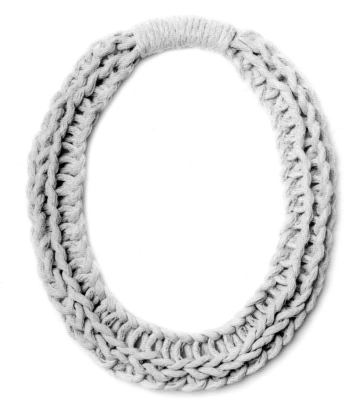

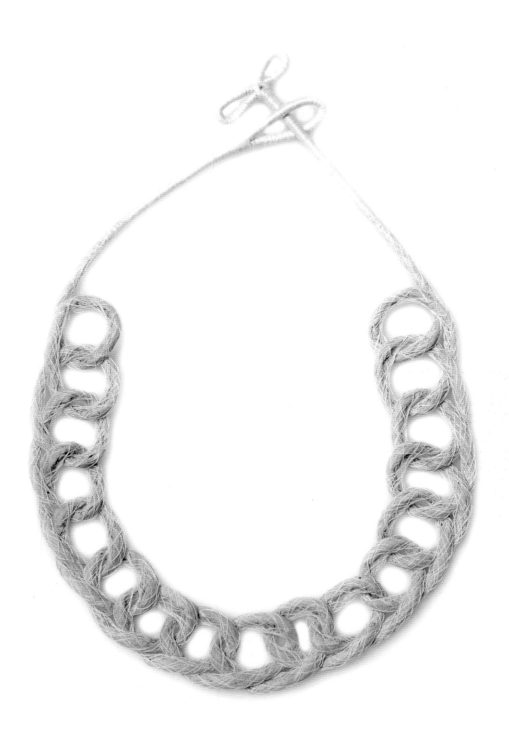

"Two-dimensional" Origami

Japanese artist Yuko Nishimura reworks single sheets of handmade paper into abstract, contoured works of art in her series labeled Relief. She employs the paper folding techniques used in origami to transform the special Japanese paper known as kyokushi into mesmerizing geometric patterns. She combines traditional methods with contemporary aesthetics across a monochromatic color scheme to make one visually interesting set of paper structures that echo the shape and visual pattern of mandalas.

Adding to their intriguing form is the fact that, unlike typical origami, they remain fairly two-dimensional. The grooves created through Yuko's expert execution of paper folding certainly adds some dimension to the paper, but it looks more like a flat, symmetrical piece of circular paper, that has been drawn on. It's hard to believe that the smooth creases are, in fact, folds. Light plays a crucial role in the way abstract designs and shadows are created as it hits the artist's creations, revealing the folds. Still, her ability to create such clean and curved lines is absolutely astounding. Yuko's work reflects her meticulous skill and patience.

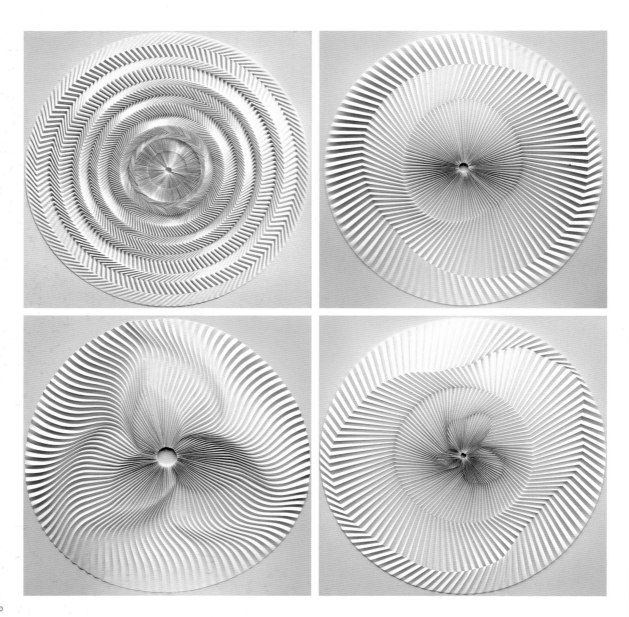

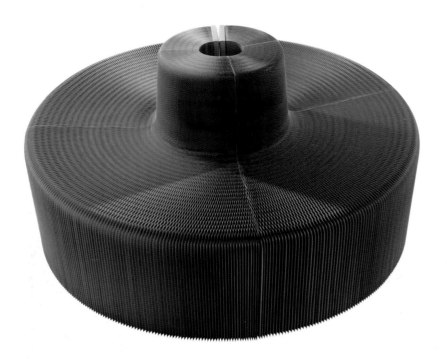

FlexibleLove® - A Living Piece

Back in 2005, FlexibleLove® was established with the idea of individuality and self-expression. Crafted out of simple wood and paper, FlexibleLove® is modest and humble, earthy and unpretentious and ready to evolve.

It grows and ages, accompanies one's intimate poetry gatherings and crowded rehearsal parties and provides hours of solitude. The imprints of the inspirations, and markings of the unforgettable, make FlexibleLove® into one's authentic and personal creation.

Like pointed shoes for a ballerina, or clay for a sculptor – necessary to one's creation, FlexibleLove® is an organic presence in the studio, dynamic and changing, without the sterility of leather and the aloofness of metal frames. It accommodates many visitors at once, or none at all. It can be folded and is recreated as one sees fit, like the magic of origami – it is a piece of art ready to perform.

Today, FlexibleLove® is on display in living rooms, studios and galleries across the world, each FlexibleLove® will continue to evolve. The imprint of each user who rests on these chairs is original. With time, FlexibleLove® will only become more authentic to its surrounding.

By then, you will be the creator of your FlexibleLove® – as you have reshaped it and given it life.

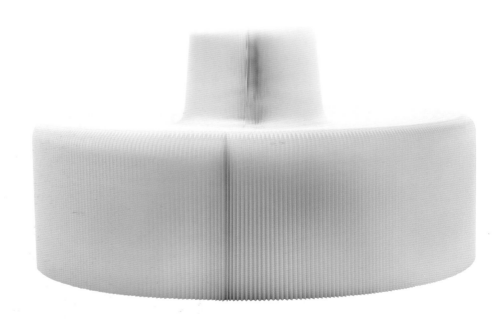

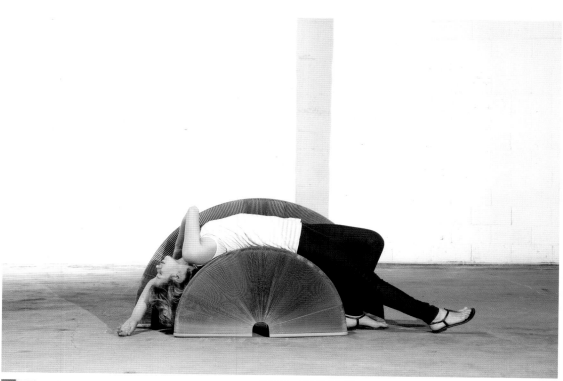

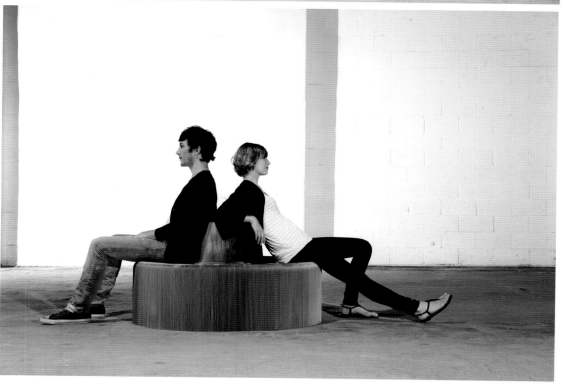

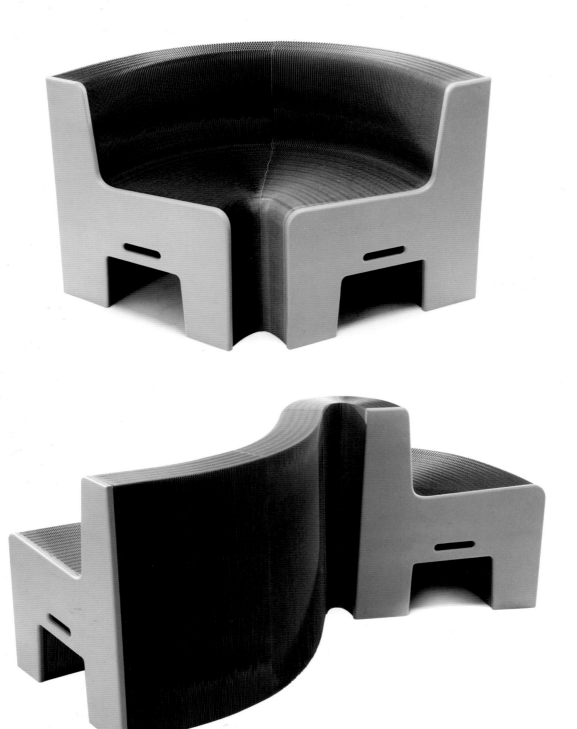

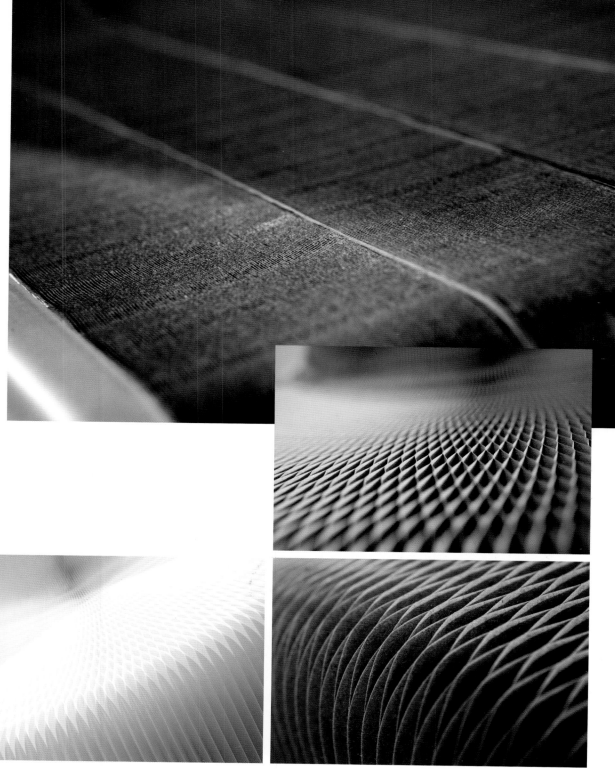

Artist Daniele Papuli Photographer Daniele Papuli

CARTODENDROMETRIA

The title of this work is derived from the words, CARTO (paper) and dendrometry (from the Greek words 'dendron' - tree and 'mètron' - measure). CARTODENDROMETRIA is the formation and classification of new morphological designs, meant for desks or stalls, and built as ring-section lamellar volumes, inlaid with various types of polychrome lightweight papers chosen for their peculiar characteristics. The desks were created out of newspapers and Corriere della Sera strips and formed using precise scientific calculations.

Each CARTODENDRO is handmade by the artist and is a numbered and signed single piece. Its uniqueness is due to the different types of paper chosen, the availability of raw materials, the shaping of the different volumes and the polychromatic modulation of the various ringed sections. Each CARTODENDRO is accompanied by a description card listing its dimensions, the piece number, the specifications of the selected papers, if possible, the date of achievement and the artist's signature.

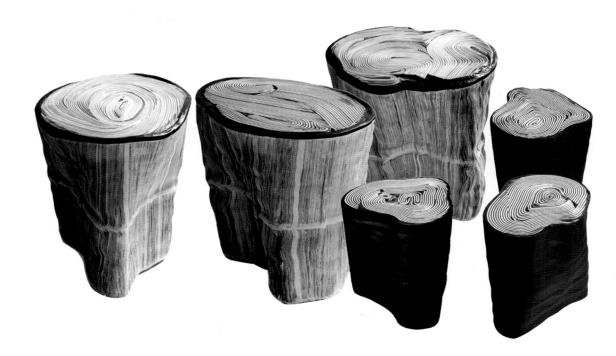

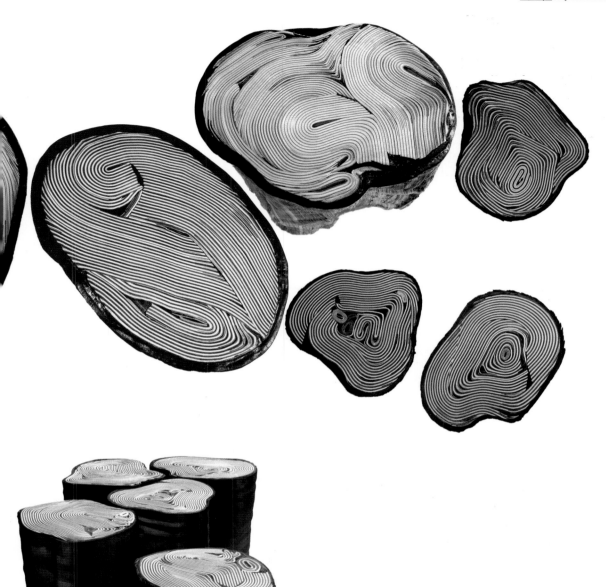

Artist Daniele Papuli Photographer Raul Zini, Leo Cabras, Enzo Pellitteri

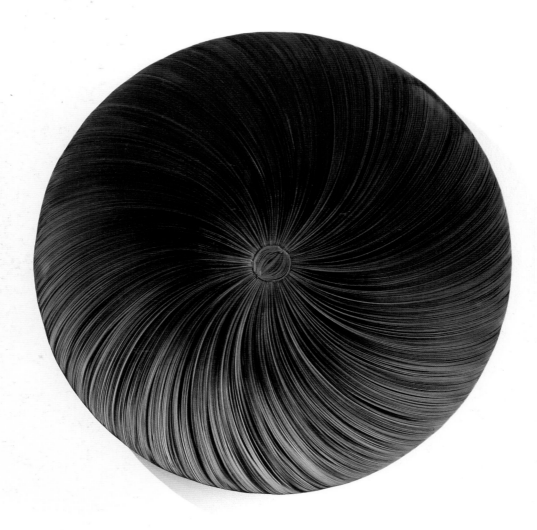

Panta rei/Aura Blu/Aura 1-M

Through a few crucial actions, such as cutting, decomposition and extrapolation of the pursued volumes, the sheet of paper becomes a surface on which Daniele Papuli can create. He carries on and develops his research throughout the construction of increasingly complex structures — founded on the repetition of different paper module. The volumes are lamellar compositions, made up of numerous patterns and realized through countless manual cuttings — a kind of 'fractal' obtained according to the ways of a plastic sculptor.

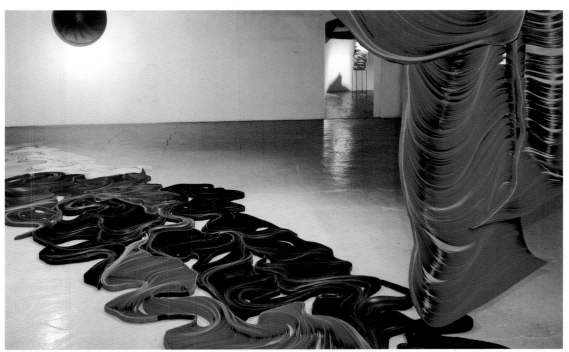

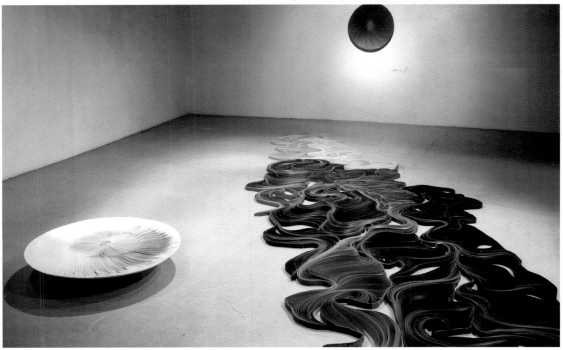

Artist Sarah Kate Burgess

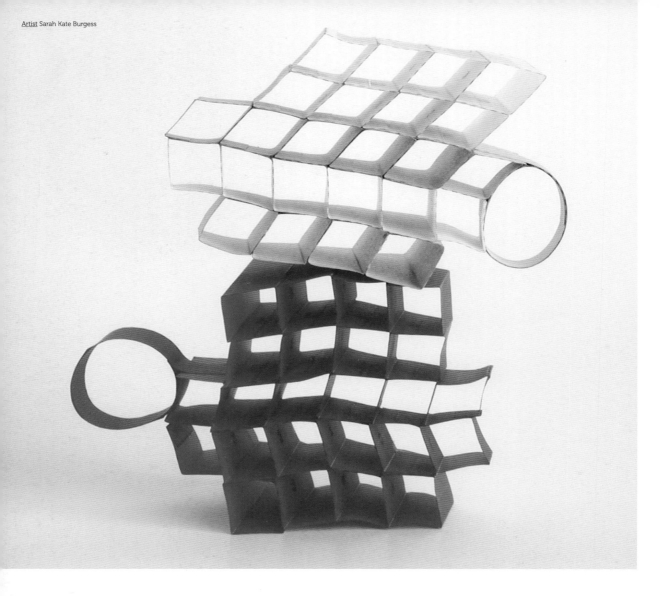

Do It Yourself –Rings

The 'Do It Yourself - Rings' series consciously activates and extends the collaboration between the wearer and the maker of jewelry. You are encouraged to download and print these patterns and construct the ring using scissors and glue. Unlike the jewelry industry, this situation does not require the viewer/maker to execute the design faithfully. Instead, improvisation is encouraged. In this way, the relationships between designer and fabricator, and designer and wearer, are examined.

Unlike traditional jewelry, material is not an indicator of value for the 'Do It Yourself - Rings.' Instead, value is indicated by the extent of the audience's participation. In this project, preciousness comes from the time spent constructing the ring by hand. The pattern (as a file on the Internet) has even less physical presence than an ephemeral paper ring and a latent potential dependent on human interaction.

To encourage this participation, the ring patterns draw on the language of do-it-yourself books or kits. The connection methods we use everyday — rubber tire patches, zippers, snaps, pins, twine, thread, tape and staples — are the devices that form the rings. The simplicity of the patterns disguise the complexities of contemporary issues of value, ownership and societal involvement.

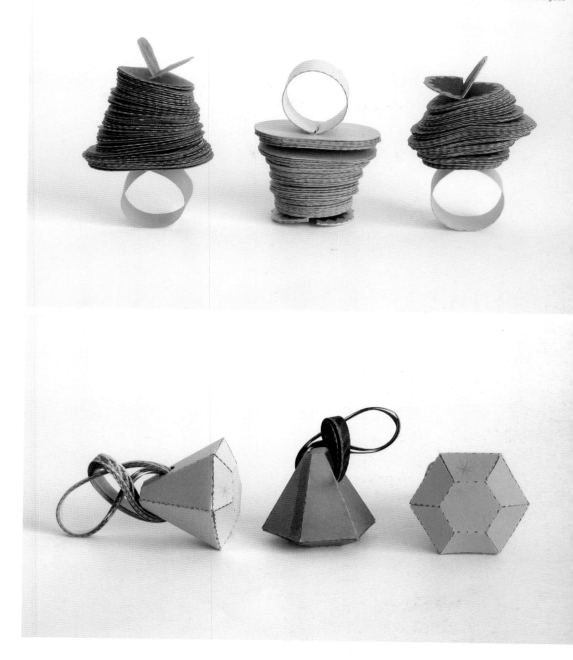

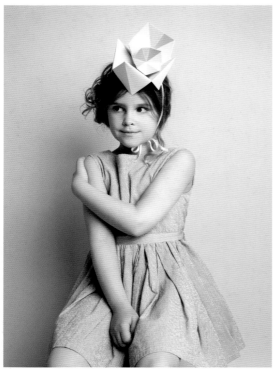

Papier Mache

Fideli Sundqvist has created all the paper props on this beautiful children's fashion editorial published in Papier Mache.

Designer Fideli Sundqvist Client Etienne PLAZA Photographer Olivia Jeczmyk Stylist Saša Antić

A three-course menu

A three-course meal constructed from paper.

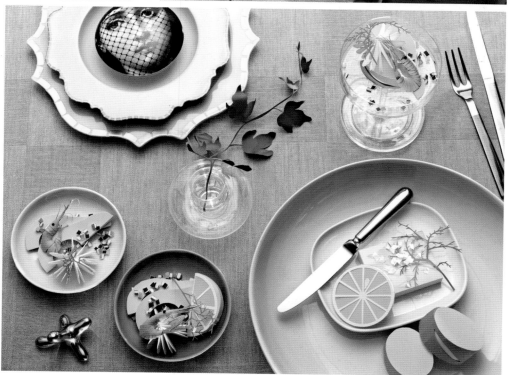

Designer Fideli Sundqvist Photographer Olivia Jeczmyk Stylist Joanna Lavén

Smaklöst

A still life series crafted in paper for an exhibition in Stockholm.

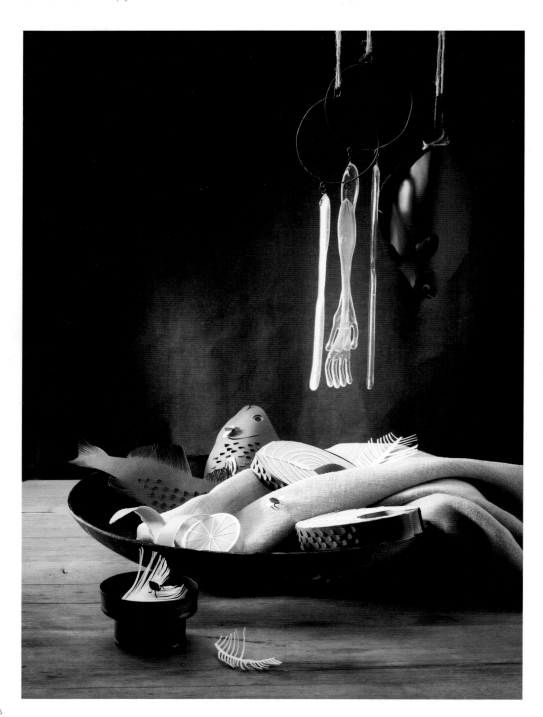

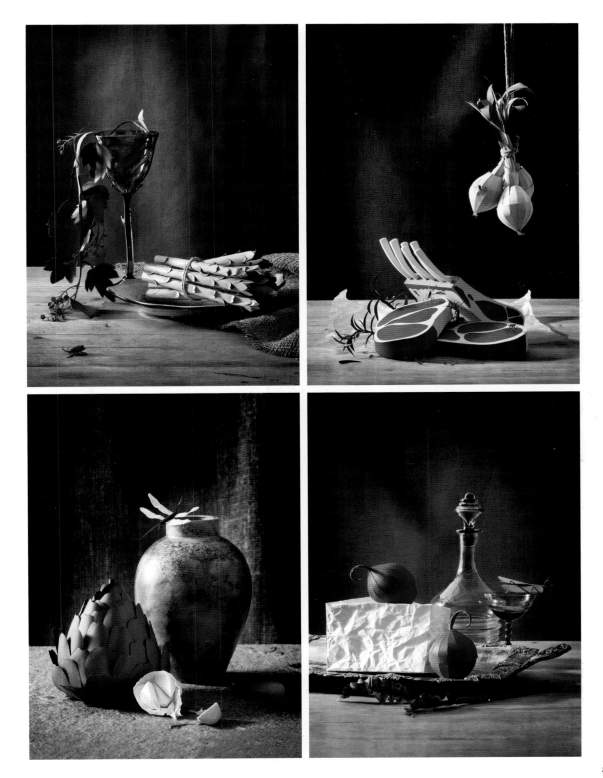

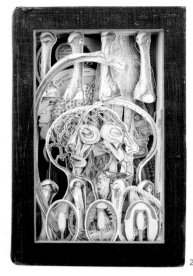
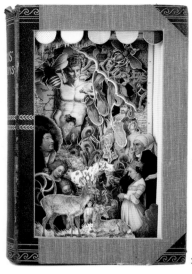

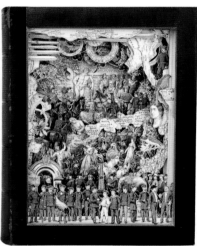
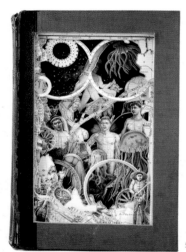

Cut Books

1 / Weltall und Menschheit Vol. 4, 1910
2 / Gray's Anatomy, 1910
3 / Brockhaus 9, 1907
4 / Noveau Larousse Illustre 4, 1906
5 / Meyers 13, 1906
6 / Meyers 9, 1897
7 / Larousse du XXe Siecle 4, 1928

Through Alexander's work in the tradition of collage he is pursuing a very personal obsession of creating narrative scenarios in small format. By using antiquarian books, the work is simultaneously an exploration and a deconstruction of nostalgia.

We create our own past from fragments of reality in a process that combines the willful aspects of remembering and forgetting with the coincidental and unconscious. On a general level, he aims to illustrate this process that forms our inner landscape. By using pre-existing media as a starting point, certain boundaries are set by the material, which he aims to transform through his process. Thus, an encyclopedia can become a window into an alternate world, much like lived reality becomes its alternate in remembered experience. These books, having been stripped of their utilitarian value by the passage of time, regain new purpose. They are no longer tools to learn about the world, but rather a means to gain insight about oneself. Alexander makes book sculptures, cuts books by working through a book, page by page, cutting around some of the illustrations while removing others. In this way, he builds his composition using only the images found in the book.

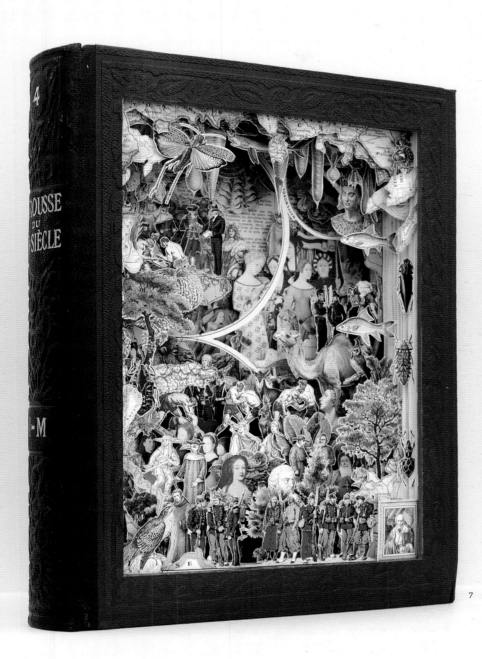

7

Gravity & Configuration

This is a three-dimensional installation and wall work made out of paper and glue. The pieces are initially perceived as a whole — a pulsating arrangement of regular shapes and volume — then as an assemblage of individual components that make up the entire sculpture and systems of patterns and motifs emerge from the collective. Painstakingly handcrafted piece by piece, Katsumi Hayakawa plays with the compositional idea of void versus solid in the careful presentation of the work. While examining the impression of architectural density, the pieces maintain the delicate nature of the material at hand.

In this exhibition, he attempted to reflect ideas about the relationship between gravity and configuration, as it is gravity that has an influence on the universe.

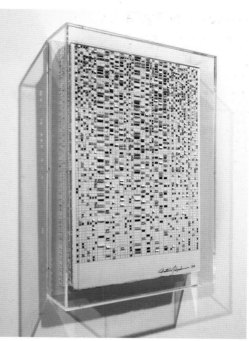

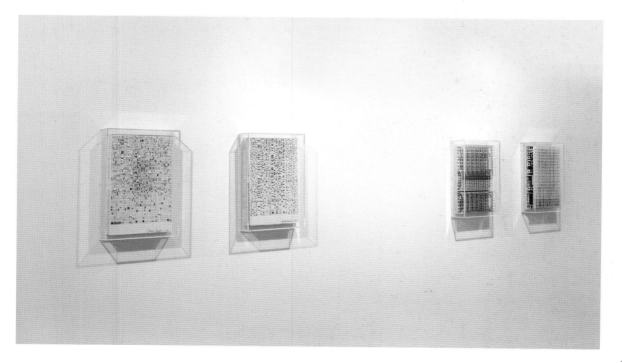

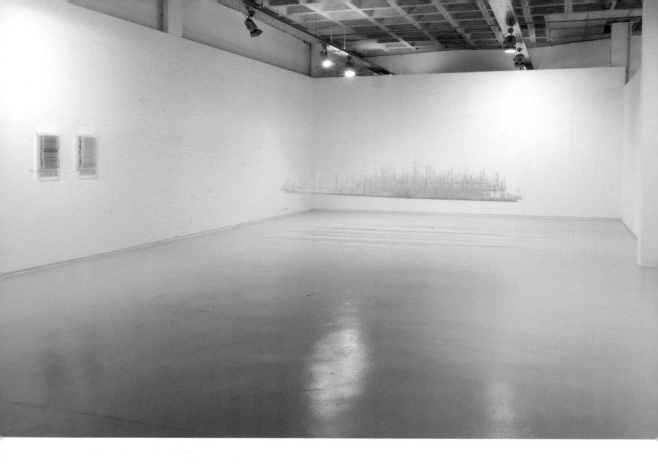

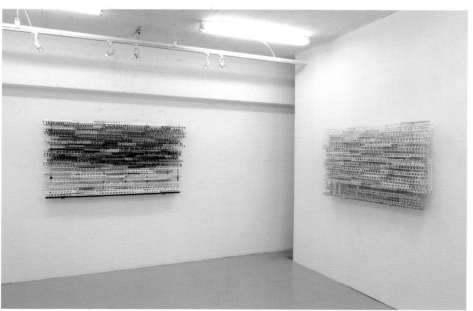

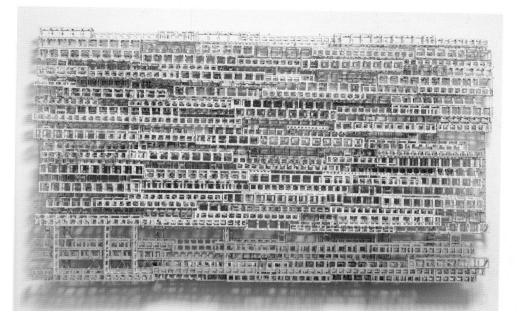

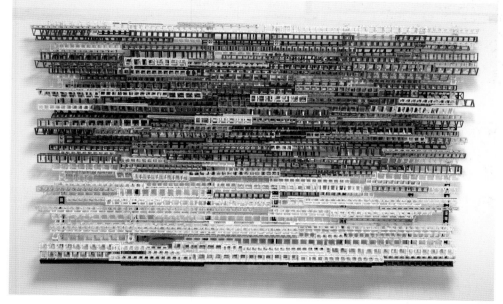

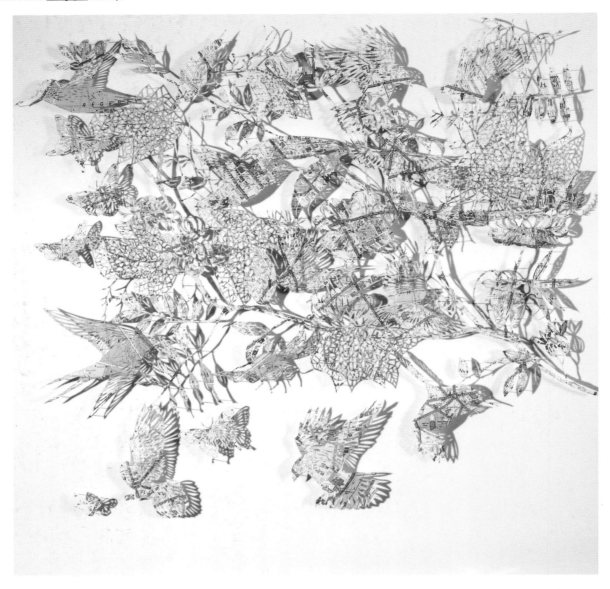

Paper in Three Dimensions

Claire Brewster's work is about retrieving the discarded, celebrating the unwanted and giving new life to the obsolete. She uses old and out-of-date maps and atlases as her fabric to create intricate, delicate and detailed sculptures. Nature is ever present, even in the most urban environments, taking over wherever we neglect, living in a separate yet parallel universe. Claire takes her inspiration from the natural environment, creating entomological installations of flora and fauna from imagined locations. Her birds, insects and flowers transcend borders and pass freely between countries with scant regard for rules of immigration or the effects of biodiversity.

The sculptures are either pinned directly onto the wall as a large scale installation or captured in box frames. The shadows created when light is shone on them creates a dynamic three-dimensional quality and a feeling of movement.

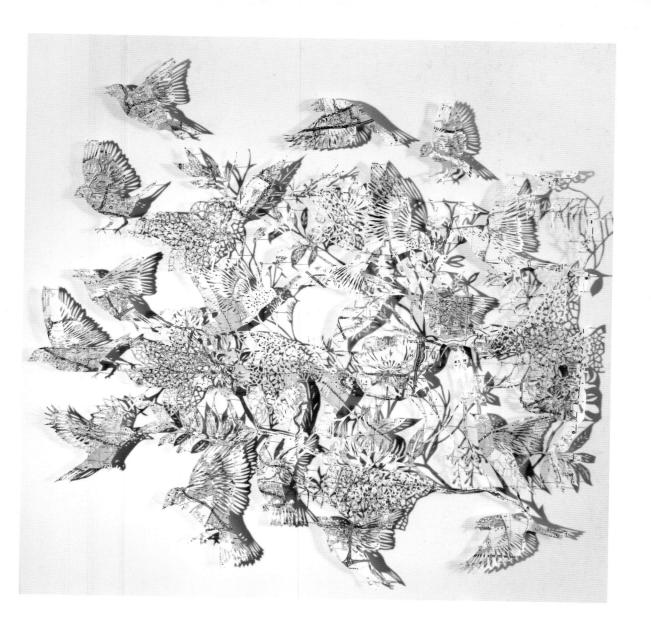

Design Agency KRONA & LION Designer Kristen Lim Tung, Fiona Lim Tung, Lisa Keophila, Jonathan Margono Photographer Saty + Pratha

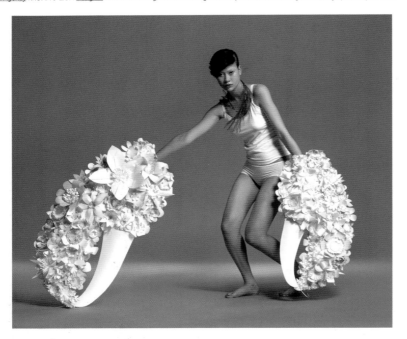

MENAGERIE

While it has been key in the transfer of knowledge for countless generations, paper seems to be meeting its demise during the current generation. Paper as a product is advanced and yet basic, natural and yet polluting, valuable yet commoditized. It is this complexity that the artists are exploring through their project, 'Menagerie.' They set out to create something magical out of this most 'common' of materials.

Collaborating with photographers Saty + Pratha, KRONA & LION developed a set of pieces that symbolize the evolution and possible extinction of paper as a medium. Each piece is made up of hundreds of hand-cut flowers — simple on their own, but fantastical when joined together.

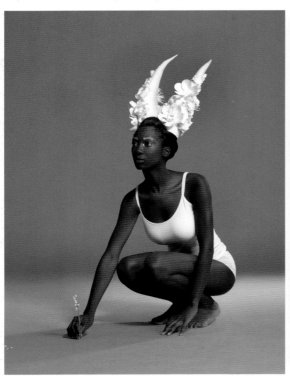

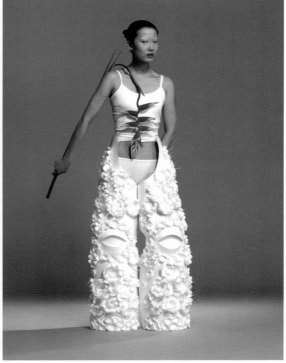

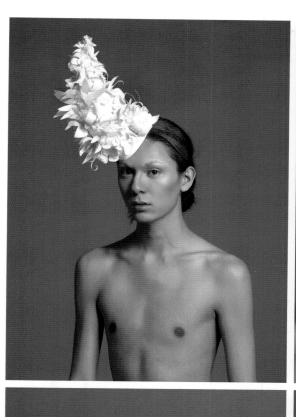
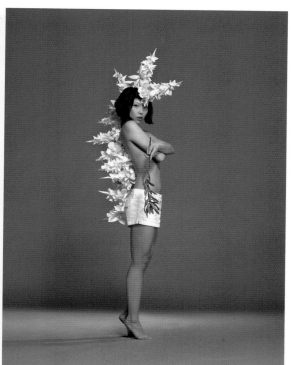
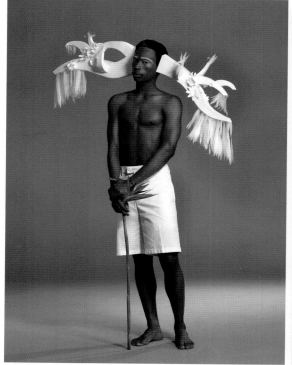
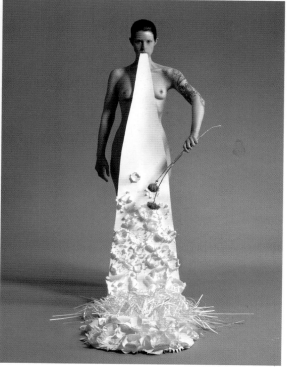

Cells

'Cells' is a mutable sculptural piece of approximately 300 letterpress printed, hand-cut paper cubes. The cubes can be rearranged in various ways to play with the idea of cells as both architectural and biological structures. Text printed on each cube reveals the malignant and benign objectives of various types of cells: grow, permeate, contain, mass, penetrate, invade, proliferate, encroach, dominate, creep, migrate, sprawl, accumulate, copy, multiply, colonize, crowd, reproduce, cluster, breed, spread, gather, overwhelm, infect, propagate and the phrase, "so much everywhere." 'Cells' was created during an artist residency at the Center for Book Arts, New York from 2012 - 2013.

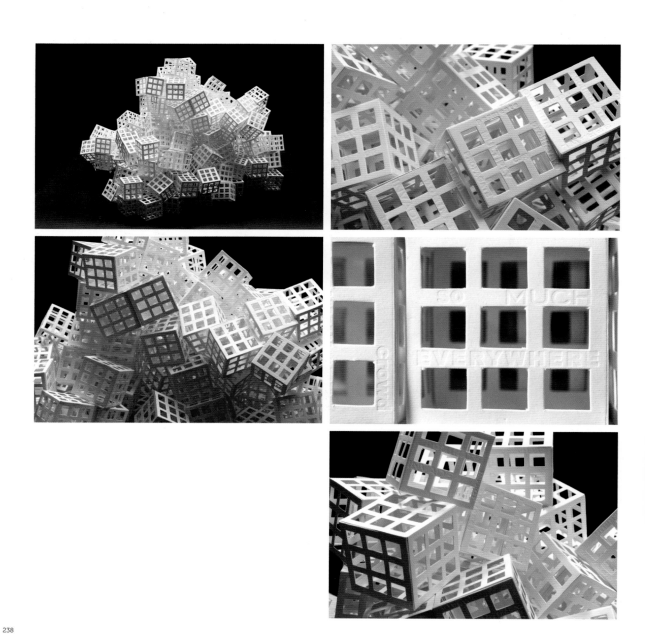

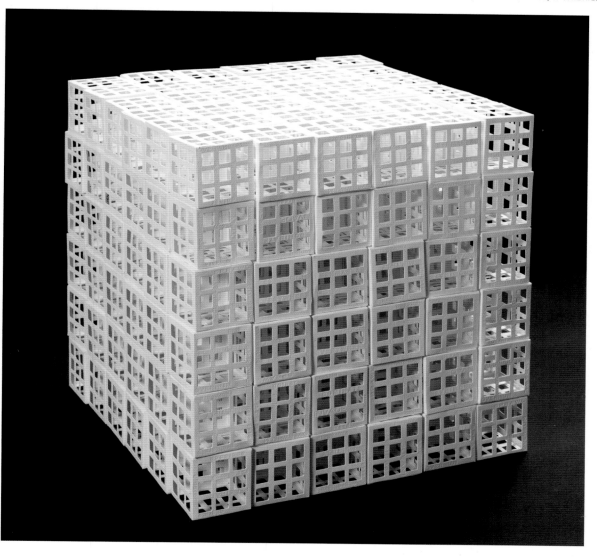

ONE

For the past several years, Mia Pearlman has made site-specific cut paper installations, ephemeral drawings in both two and three dimensions that blur the line between actual, illusionistic and imagined space. Sculptural, dynamic and often glowing with natural or artificial light, these imaginary weather systems appear frozen in an ambiguous moment, bursting through or hovering within a room.

Her most recent installation, ONE, deals with water as a subject and metaphor for the Taoist concept of Yin and Yang. This site-specific cut paper installation was composed of two sides, one extremely dark, heavy and flowing downward, the other light, buoyant and flowing upward. The viewer is caught between these two opposing and interdependent forces, which are connected only in the mind and memory of the viewer. ONE was also inspired by the Japanese Rinpa school painting "Waves at Matsushima" by Tawaraya Sōtatsu. Soon after she discovered the painting , the Japanese tsunami happened and the images of water and destruction were eerily similar. As in life, everything in ONE occurs simultaneously, from events like a tsunami that moves at lightning speed, to incredibly slow forming phenomena like stalactites.

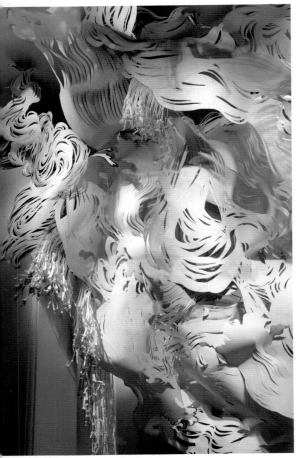

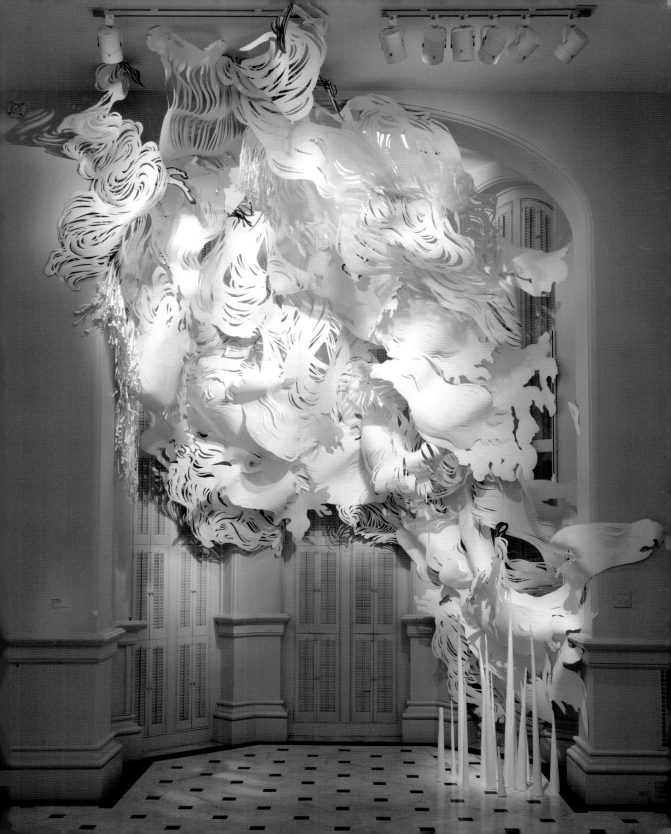

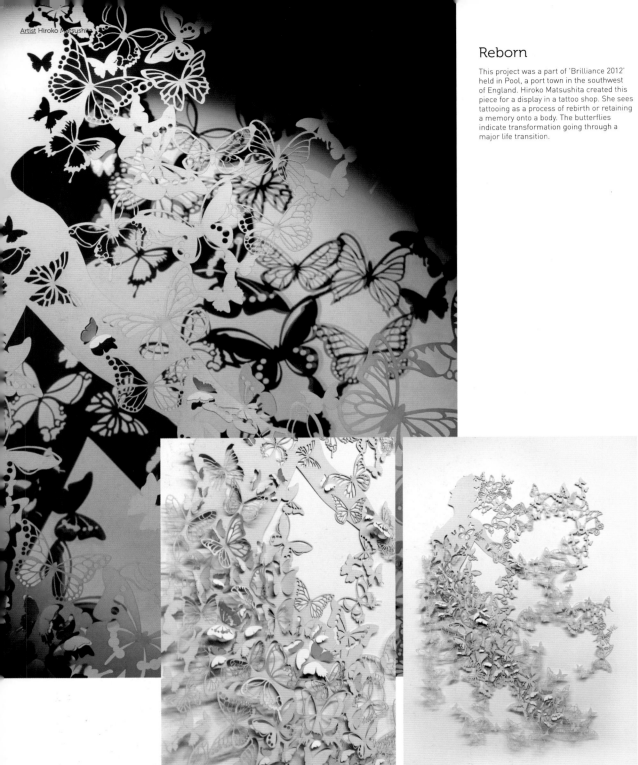

Reborn

This project was a part of 'Brilliance 2012' held in Pool, a port town in the southwest of England. Hiroko Matsushita created this piece for a display in a tattoo shop. She sees tattooing as a process of rebirth or retaining a memory onto a body. The butterflies indicate transformation going through a major life transition.

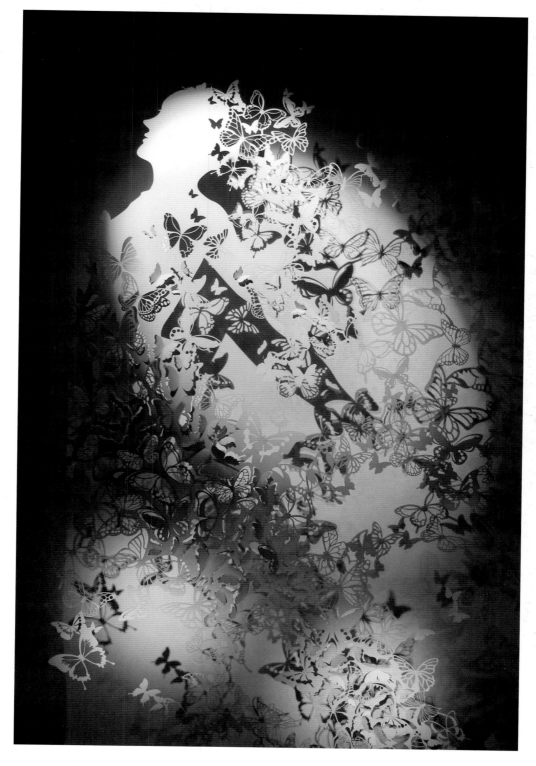

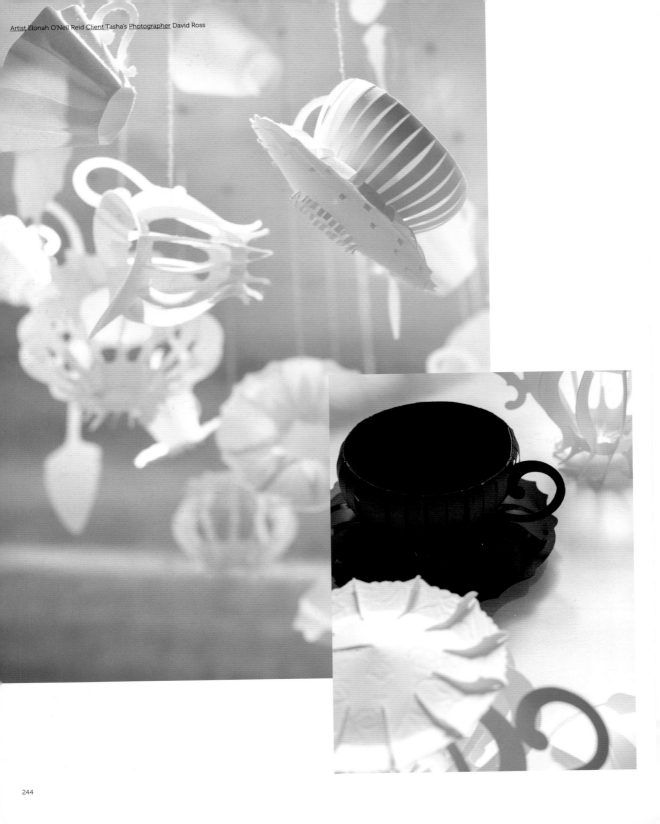

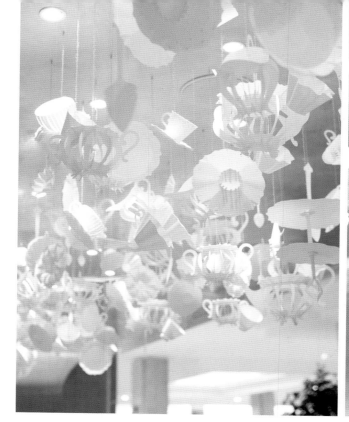
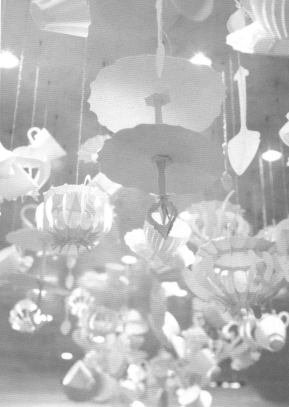

Tasha's Hyde Park — Paper Tea Cups

This delicate teacup installation was created as a signature piece for a flagship store. The artwork is inspired by the tradition of high tea and consists of 220 individually crafted pieces suspended over 8 meters. The intention was to create a piece that speaks to the intricacy and beauty expressed in craftsmanship, both in the artwork itself and the skill of the artisan bakery and patisserie.

The creative process utilized a variety of techniques. Each piece is generated and refined through a series of hand-made maquettes, before finally being unfolded and digitized. An extra layer of texture was introduced through blind embossing to slightly alter the opacity of the pieces, creating depth. The sheets were then dried before cutting and assembled by hand. No glue was used, only a series of friction locks. The cafe is a transient space where culinary innovation fuses with an outdoor terrace atmosphere. The installation is suspended from a curved ceiling, creating a sense of whimsy and momentary delight as they gently sway.

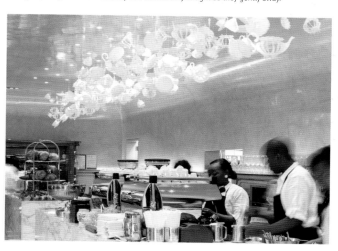

Spectrum-rainbow in the city

Mademoiselle Maurice develops and creates a mini play of countless colorful works with the fruits of rich influences and career lessons. Via origami, lace, embroidery, or other mixed media, she gave birth to works in tune with their daily lives. These materials are paper and thread and she loves to shape these natural materials in a complex manner.

Rising from the Paris gray, a work was born out of the urban monotony. These openly positive creations, vibrantly colorful and immediately demanding attention, emanates a carousel of emotions from everyone around.

Light in appearance, the work of Mademoiselle Maurice raises many questions about human nature and the interactions that sustain people and the environment. A breath of fresh air and true evolutionary thinking are in the artistic approach Mademoiselle Maurice opens, paving colorful dualities as attractive as a repulsive reality — wide spaces of abstractions in the city.

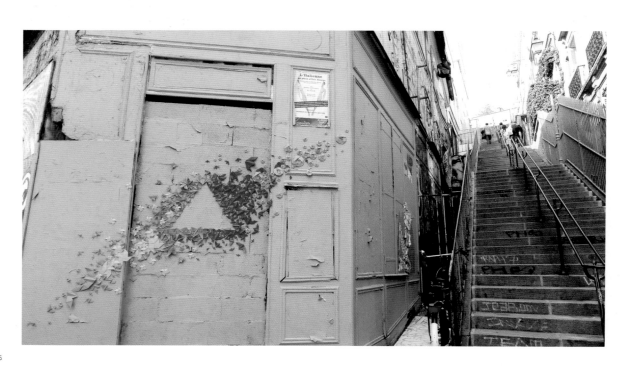

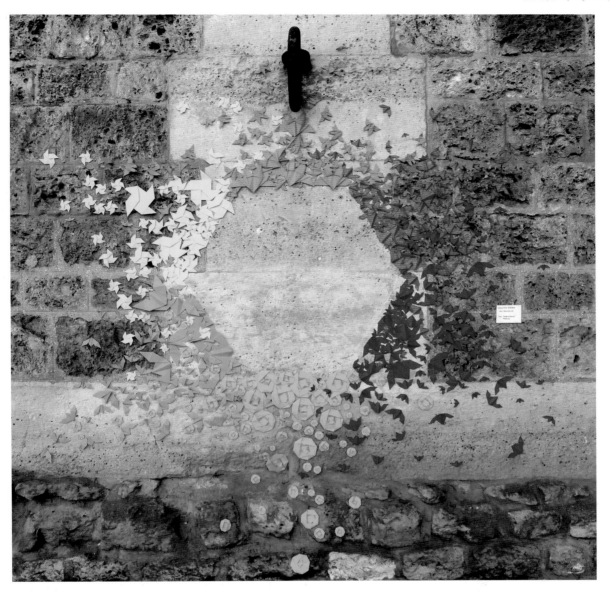

24° Studio

www.24d-studio.com

p.188-189

24° Studio is a multidisciplinary practice established in 2008 and founded by Fumio Hirakawa and Marina Topunova. We dedicate our investigation in working at the intersection of architecture, technology and environment. It is in our inherence to collaborate with our vast network of experts to deliver new solutions to our clients and audiences in realizing their aspirations. With ever changing global movements bringing us limitless inspirations, 24° Studio believes that the process of integrating multiple perspectives will lead to innovative results, thus redefining the connection between our body and our surroundings.

Adriane Colburn

Adrianecolburn.com

p.080-083

Adriane Colburn is an artist based in San Francisco, California and Athens, Georgia. She has exhibited her work throughout the United States and internationally. She has been an artist in residence at the Headlands Center for the Arts, the Macdowell Colony, the Kala Institute and the Blue Mountain Center. Adrianes's work consists of large-scale installations (comprised of layers of hand-cut paper, digital prints and projected light) that investigate the complex relationships between human infrastructure, earth systems, technology and the natural world.

Alexander Korzer-Robinson

www.alexanderkorzerrobinson.co.uk

p.228-229

"Through my work in the tradition of collage I am pursuing a very personal obsession of creating narrative scenarios in small format. By using antiquarian books, it simultaneously makes the work an exploration and a deconstruction of nostalgia.

We create our own past from fragments of reality in a process that combines the willful aspects of remembering and forgetting with the coincidental and unconscious. On a general level, I aim to illustrate this process that forms our inner landscape.

By using pre-existing media as a starting point, certain boundaries are set by the material, which I aim to transform through my process. Thus, an encyclopedia can become a window into an alternate world, much like lived reality becomes its alternate in remembered experience. These books, having been stripped of their utilitarian value by the passage of time, regain new purpose. They are no longer tools to learn about the world, but rather a means to gain insight about oneself.

I make book sculptures / cut books by working through a book, page by page, cutting around some of the illustrations while removing others. In this way, I build my composition using only the images found in the book."

Alice von Maltzahn

www.alicevonmaltzahn.co.uk

p.116-117

Alice von Maltzahn was born in 1983 in Oxford, England and now lives and works in London. She graduated with a Bachelor of Fine Arts from The Ruskin School of Drawing at the University of Oxford in 2006. The artist currently exhibits with the Wendt+Friedmann Gallerie in Berlin.

Andrée-Anne Dupuis Bourret

www.aadb-art.com

p.198-203

Andrée-Anne Dupuis Bourret approaches creation from the standpoint of a reflection on perception and occupying a space. Her projects assume a number of different forms: installations, sculptures, fixed and animated images and artist books. Her works have been presented in a number of individual and collective exhibitions in Canada, the United States, Israel and Australia. The artist, recipient of a Governor General's gold medal for her masters in 2011, is currently working on her doctorate at the University of Quebec in Montreal on the subject of modular printed installation. She has also written two research blogs: Le cahier virtuel and Le territoire des sens.

Andy Singleton

andysingleton.co.uk

p.164-165

Andy Singleton is a paper artist and illustrator based in Wakefield, England. He studied Animation with Illustration at Manchester Metropolitan University. His work is an exploration of the natural and manmade world through intricate paper cuttings, paper sculpture, hand-drawn illustrations and large-scale installations. Andy has produced work for a variety of clients, including the Crafts Council, Liberty, Hermés, Kensington Palace, Manchester Art Gallery, DDB Australia, The Hepworth Wakefield, The Beautiful Meme and The Outnet.

Anne ten Donkelaar

www.anneten.nl

p.064-065

Anne graduated in 2007 from the 'Utrecht school of The Art' (NL) Her direction is "3D Product Design."A damaged butterfly, a broken twig, a bumblebee, some strangely grown weeds: she finds all these unique discoveries in her path and then takes them home to the studio. There, she takes her time to explore the objects and tries to work out how she can show each one to its best advantage. Her findings inspire her. While looking at them she can invent her own stories about their existence and their lives. By protecting these precious pieces under glass, she gives the objects a second life and hopes to inspire people to make up their own stories about them.

Antonius Bui

www.behance.net/AntoniusBui

p.192-193

"My name is Antonius Bui and I am a second year student at the Maryland Institute College of Art (MICA) who hopes to eventually become an inspiring teacher for the youth of the world. Before deciding to pursue art, I was studying to become a doctor at a public university in Texas. Anything outside the engineering or medical field was unheard of in my traditional Asian family. Therefore, I am beyond grateful for the opportunity to be at MICA and am extremely fortunate to have parents who support my undying passion for art. Most of my work is concerned with perceptions of spirituality, human sexuality and psychological states of mind."

Art des Hauses

www.art-des-hauses.com

p.012-013

Art des Hauses is an independent, owner-operated design agency situated in Dortmund, Germany. They advise companies and institutions and develop and optimize successful appearances on a conceptual basis, with brands and communication tools that provide a market advantage and expertise. Creative processes, an intensive exchange with the customer and the search for subtle solutions and implementations, lead to individually tailored concepts with a high-quality design and a high standard.

Asya Kozina

asyakozina.com

p.096-097, 154-155

Asya Kozina is a paper artist. She was born in 1984 in the Dnepropetrovsk region, Ukraine. She was fascinated with paper since childhood and her first creations were made in paper cut techniques.

Asya's first exhibition "the delight of white," took place in 2007. The artist presented a series of paper sculptures devoted to historic costume. Her works are distinguished by a combination of jewelry, elaboration of details, plastique and wholeness. Despite of the sensation of monumentality, the sculptures are not large, only 30 to 60 centimeters. Besides sculptures, Asya created a series made from paper cut techniques. She constantly experiments with paper, creates installations, different objects, pieces of fashion, illustrations and other media. In her motherland, she is called "a fairy of paper." In 2013, Asya presented a new series, "from scratch." She currently lives and works in St. Petersburg, Russia.

Bea Szenfeld

www.szenfeld.com

p.118-119

Bea Szenfeld is a talented Swedish fashion designer/artist with the courage and determination to think and work innovatively with warmth and humor. Bea has worked with legends such as Stella McCartney, Björk and Swarovski and is known for her theatrical and inspiring fashion shows and innovative design. Bea creates her works all by hand and with heart.

Bovey Lee

www.boveylee.com

p.030

Bovey Lee is a cut paper artist known for her highly intricate works hand-cut on Chinese rice paper (xuan). She was born in Hong Kong and is currently based in Pittsburgh, Pennsylvania. Since 2005, Bovey has been creating cut paper works that explore power and survival in the context of urbanism and its impact on the environment. Bovey has exhibited at museums, galleries, and art fairs around the world. Her works are represented in the permanent collection of the Ashmolean Museum of Art at Oxford University, Pacific Asia Museum in Los Angeles, Hong Kong Museum of Art and corporations including BNY Mellon, Christian Dior, Fidelity and Progressive, among others. Bovey's international commissions include: The New York Times Magazine, F.P. Journe, Hugo Boss, Panasonic and others.

Cara Barer

www.carabarer.com

p.122-123

Cara Barer was born in 1956 and lives and works in Houston, Texas. She has been represented in numerous group exhibitions across the United States, with solo exhibitions in Galveston, Houston, Toronto, San Francisco, Seattle, New York and Paris. Her work has appeared in New York Magazine (2006), PhotoNews (2008) and The Houston Press (2006), among others. More recently, she has been featured in Art Made From Books: Altered,

Sculpted, Carved, Transformed (Chronicle Books, 2013). Barer's photographs can be found in many private and public collections including the Museum of Fine Arts Houston, Trump Hollywood, VISA, UCLA Special Collections, the private collection of Danielle Steel, Bloomingdale's, Lehigh University, Nordstrom's Nationwide and Wells Fargo Bank.

Caroline Jane Harris

www.carolinejaneharris.com

p.110-111

Born in 1987, British artist Caroline Jane Harris lives and works in London, UK. Having graduated from Camberwell College of Art in 2006 and receiving a Fine Art Printmaking degree at the University of Brighton in 2009, Harris has achieved significant exposure and recognition for such a young artist. Harris has exhibited in the UK and internationally including India and Singapore. In 2013 she was selected as a finalist for the Aesthetica Art Prize and won the Chelsea Arts Club Trust Stan Smith Award for Research and Materials. Harris also received the Judge's Choice Award at the British Women Artists Competition and an honorable mention for the Beers Lambert Award for Emerging Art. Harris' practice explores the dichotomy in science and art, traditional processes and contemporary practices through the medium of hand-cut paper.

Cecilia Levy

www.cecilialevy.com

p.085, 098-099

Cecilia Levy is an artist based in Sigtuna, Sweden. She has a background in graphic design, bookbinding and illustration. In 2009 she started experimenting with paper, building three-dimensional forms out of book pages and glue. Her work has been exhibited regionally, nationally and internationally in solo and group shows. She is a member of the arts and crafts cooperative Kaleido Konsthantverk in Uppsala, Sweden.

Charles Clary

www.percusiveart.blogspot.com

p.078-079

Charles Clary was born in 1980 in Morristown, Tennessee. He received his Bachelor of Fine Arts in Painting with honors from Middle Tennessee State University and his Master of Fine Arts in Painting from the Savannah College of Art and Design. As an artist, Charles has exhibited regionally, nationally and internationally in numerous solo and group shows. In 2011, Charles was featured in several print and Internet interviews. He is also represented by The Diana Lowenstein Gallery in Miami, Florida and is currently living and working in Murfreesboro, Tennessee.

Charlotte McGowan-Griffin

www.mcgowan-griffin.net

p.022-023, 031, 042-043, 190-191

Charlotte McGowan-Griffin was born in London and graduated from the Fine Art course at London's Goldsmiths College in 1997. Since then, paper cutting has been her primary medium. During a residency in Japan in 2004, she began to combine the technique with light, shadow and projection to create large-scale installations. Whereas her two-dimensional cut-paper works might borrow from traditional paper-cutting practices, her installation projects tend to be site-specific and are increasingly oriented towards experimental modes of working.

Chishen Chiu

www.flexiblelove.com

p.212-215

Chishen Chiu finds inspiration from a wide range of hobbies and his work reflects his adventurous spirit and a never-ending curiosity for new materials and ideas. He is a graduate of the National Taiwan University of Science and Technology's prestigious School of Industrial Design. At its introduction during the annual Young Designers' Exhibition (YODEX), the world's largest design exhibition for young talent, FlexibleLove was an immediate hit and the highlight of the show. Since then, FlexibleLove has attracted the attention of media around the world and continued to capture people's imagination year-after-year.

Christine Kim, Marcin Kedzior

www.christinekim.ca

p.016-017

Christine Kim lives and works as an artist and educator in Toronto, Ontario. Working primarily in mixed media, Christine creates intricate cut paper; carving away the boundaries between illustration, sculpture, collage and installation.

Marcin Kedzior explores collaborative art and architecture projects situated between pedagogy and practice. He currently teaches in the Master of Visual Studies program and the Bachelor of Art in Architectural Studies program at the University of Toronto and in the Bachelor of Interior Design program at Humber ITAL.

Claire Brewster

clairebrewster.com

p.234-235

Claire has been living and working in London for over 20 years, but started life in the semi-rural county of Lincolnshire. Using old maps, atlases and other found paper, she creates beautiful, delicate and intricate paper cuts of flowers, birds and insects. Her inspiration comes from nature and the urban environment in which she lives and a desire to reuse the discarded, unwanted and obsolete. She exhibits her work nationally and internationally, showing regularly in London, other parts of the United Kingdom, the United States, France, Germany and Italy. Her work has been published in many magazines including: Vogue (UK and Greece), World of Interiors, Inside Out (Australia) and was featured in the book "Paper: Tear, Fold, Rip, Crease, Cut" (Blackdog Publishing, 2009). She was commissioned to make a large-scale work for the Corinthia Hotel in London in 2011. Most recently she showed at the London Transport Museum (part of Cultural Olympiad 2012 and Manchester City Art Gallery).

Clare Pentlow

Cjpdesigns.co.uk

p.168-169

While studying Surface Pattern Design at University, Clare became fascinated by paper and started upon an exploration of the material, working with the transformation of paper from a flat, basic material, to a folded, cut and sculpted piece of art. This exploration is still continuing and she is finding many new and exciting ways of changing the surface dynamics of an ordinary material and challenging people's perceptions of this everyday material.

Cybèle Young

www.cybeleyoung.ca

p.058-059

Cybèle Young creates sculptural works from Japanese papers and incorporates print media and film in her practice. Since her studies at Ontario College of Art & Design (OCAD), she has been awarded over twenty grants and awards and has received critical acclaim in such publications as Art in America and the New York Times. Young has mounted over twenty solo exhibitions and thirty group shows and is included in numerous annual art fairs. Her work resides in major collections around the world.

She is the author and illustrator of several children's books and won the Governor General's Award for illustration in 2011 for her book 'Ten Birds.' In 2011, she received a Canada Council four-month residency in Paris. Cybèle lives with her husband and two children in Toronto.

She is represented by Forum Gallery in New York.

Dagna Napierala

dagnana.com

p.120-121

Dagna was always fascinated by worlds where reality is mixed with the extraordinary, fantastic, magical or weird. She loves the mood and atmosphere created by Gabriel García Márquez in "One Hundred Years of Solitude." She also finds inspiration in Caravaggio's paintings, where characters emerge from the darkness – from the black background they are sharply illuminated. When Dagna began to rediscover paper she was impressed by what artists like Chris Natrop and Richard Sweeney were doing with this material. She loves Mexican Alebrijes, but her biggest inspiration is people. She is fascinated by the human psyche, the complexity of thought and imagination and the way we can develop and break through our limits and, on the other hand, how much we limit ourselves. "I think that's my path — both as a person and as an artist — to try to understand myself and other people."

Daniele Papuli

www.danielepapuli.net

p.216-219

Daniele Papuli was born in 1971 in Maglie, Puglia. His first attempt at sculpture dates back to 1991 when he created stone, wood and plaster artifacts. In 1993, at an international workshop in Berlin, he learned methods for manufacturing sheet paper. It was a crucial experience that in 1995 brought him to choose paper as the most suitable material for his research and his own language. He then experimented with the production of handmade paper and in 1997 made his first sculptures with different types of paper material. He proceeds more like an explorer than like a designer, transferring and amplifying images and suggestions of a design path undertaken on paper. His continuous investigation into matter and his experimentation with new materials similar to paper – proposed for their structural and tactile potential – lead him to continuous interconnections from sculpture to design and to site specific installations.

Elonah O'Neil Reid

www.elonahoneil.co.za

p.244-245

As a paper architect, Elonah develops form through making. It is through this process of experimentation and observation that she comes to a new understanding. Paper is an expressive medium. The beauty lies in the process of folding that is both systematic and delightfully unpredictable. Folding is a metamorphic process. It is nimble and intuitive. Manipulation through folding

changes the memory of paper that leads to the discovery of a multitude of forms. Unfolding reveals a map of the decision making process that allows one to dissect and thereby strengthen, modify and adapt new methodologies. The final outcome is revealed through a sequence of small decisions and the freedom of making mistakes. Hence, Art through emotional sequence.

Elsa Mora

www.AllAboutPapercutting.com

p.156-159

Elsa Mora is a multimedia artist living and working as a freelancer in Los Angeles, California.

Fideli Sundqvist

www.fidelisundqvist.com

p.046-047, 222-227

Paper artist, illustrator and graphic designer Fideli Sundqvist grew up in a creative environment in Uppsala, Sweden. Her mother is a potter and her father a religious historian. The family had a small printing space in the kitchen where Fideli would hang her pictures to dry on a clothesline. The artistic climate of her childhood and her great interest in music were the foundations for her career choice. Fideli is inspired by everyday existence. "I think you have to give yourself a varied life, expose yourself to different types of impressions. Mostly, I think it is the work itself that gives birth to new ideas. Desire drives the work forward, as I heard someone say on the radio, and that is so true."

Flora Vagi

www.floravagi.net

p.100-101

There are things we can think of, things we can name. Like 'bread,' 'pane,' 'kenyer,' 'chlieb' and so on. But there are also things we have no words for. Search, discover, transform, surprise; all aspects of the process Flora applies to her work. The materials get a 'return ticket' from her and with their 'newly dressed souls' she sends them back to the world where they came from.

Flora makes objects that are intimate and meaningful to their owners. Jewelry not only adorns but 'talks' or sometimes 'whispers.' She works in a language that is understood without words and the verbal explanation becomes secondary.

Géraldine Gonzalez

www.geraldinegonzalez.com

p.024-025

A graduate of the Duperre School of Applied Arts, Paris (textile section), Géraldine Gonzalez started her career as a shoe designer before becoming a sculptor. In the past, her work was used as illustrations in advertising press and children's books and shown in both personal and group exhibitions in several Paris museums including: Grand Palais, Menagerie de Verre, Halle Saint-Pierre and the Georges-Pompidou. Today her focus is on home and storefront decoration. Géraldine Gonzalez enjoys working with some materials more than others, but papier-mâché, cloth, crushed glass and pearls have gradually made way for the prince, crystal paper, a material with a lovely name that allows her to delicately play with transparency and light.

Harikrishnan Panicker

www.thumbdemon.com

p.182-183

Harikrishnan Panicker is a Denver-based graphic designer / illustrator. He has a Masters degree in Design from the Industrial Design Center, IIT Bombay and then worked with MTV India where he was the Senior Designer and created designs for channels like MTV, Vh1 and NICK. He moved to Denver in 2010 and now spends his time experimenting with paper cutting, printmaking & screen printing. Paper is his passion, He believes that "Paper is brutal in its simplicity as a medium. It demands the attention of the artist while it provides the softness they need to mould it in to something beautiful.It is playful, light, colorless and colorful. It is minimal and intricate.It reflects light, creates depth and illusions in a way that it takes the artist through a journey with limitless possibilities." He is a traveler and an explorer and enjoys the outdoor life in Colorado amongst the mountains and enjoys camping. His inspirations are from nature and story telling techniques like the kaavad and shadow puppets of bali. He along with his wife Deepti Nair have developed a series of art pieces that play off the concept of light and paper with handcut paper illustration light boxes and have hosted 5 shows in various art galleries.

Haruhiko Tanaka

www.haruhikotanaka.com

p.124-125

Haruhiko Tanaka graduated from Tama Art University in 2003. He has started a paper cutting from 2011. He once received "2013 International Kirie Art Competition In Minobu, Japan" Award.

Hattie Newman

www.hattienewman.co.uk

p.132-133

Originally from the quiet countryside of Devon, England, Hattie studied illustration in Bristol, graduating with a First Class Bachelor of Arts (Hons) before moving to London to work as a freelance illustrator and set designer. Her colorful and optimistic style, alongside a passion for paper, has led her to work on a breadth of projects including children's books, animation, set design and window displays.

Hiroko Matsushita

www.hirokomatsushita.com

www.nomena.co.jp

p.204-207, 242-243

Hiroko Matsushita works in several realms: design, illustration and art. After receiving a Masters in Illustration from The Art University Bournemouth in 2012, she moved her base to Tokyo and works as part of Nomena Inc., collaborating with engineers and other designers. In a commercial area her creations have been widely shown in magazines, advertisements and window displays. On the other hand, as an artist, she has been pursuing expansive notions of illustration and developing light/shadow installation using paper.

Jeff Nishinaka

www.jeffnishinaka.com

p.044-045, 048-049

"I began experimenting with paper sculpture as part of a project during my student days at The Art Center College of Design in Pasadena, California. We could choose any type of medium, like matchsticks, nails or clay. I chose paper and made a fish sculpture - it was an 'ah-ha!' moment for me. After that I quickly developed a feel for working with paper. I began experimenting with different types of papers, finding ways to shape, bend and round edges on it. I knew I was destined to make paper sculptures. I feel that paper is a living thing with energy of its own. All I try to do is redirect that energy. Though they look 3D, they're actually 2D. The illusion is achieved by layering and lighting."

Jun Mitani

mitani.cs.tsukuba.ac.jp

p.020-021

Jun Mitani was born in 1975. He received his PhD in Engineering from the University of Tokyo in 2004. He has been on the faculty at the University of Tsukuba since 2005. His research interests center in geometric modeling in computer graphics including human computer interaction, computational origami design and so on.

Karen Margolis

www.karenmargolisart.com

p.026-027

Karen Margolis received her Bachelor of Science from Colorado State University in Psychology. She also studied at the Art Student's League, Parsons School of Design, the School of Visual Arts and the New York Microscopical Society. It was during her studies in Microscopy that Margolis was inspired to diverge from her traditional studies in figurative art to create work exploring the universality of macro/micro patterns.

Katsumi Hayakawa

www.katsumihayakawa.com

p.230-233

Born in Tochigi Prefecture, Japan and educated in Tokyo and New York City, Katsumi Hayakawa has held many solo and group exhibitions and won a number of awards.

Kelli Anderson

kellianderson.com

p.072-073

Kelli Anderson designed and illustrated Tinybop's The Human Body. As a designer and tinkerer, she tries to find extraordinary possibilities for ordinary things. In 2008, she worked with the Yes Men to create and distribute a meticulously recreated copy of The New York Times – filled with articles from a progressive Utopian future – for which they won the Ars Electronica Prix Award of Distinction. In 2011, she created a paper record player that garnered major attention from numerous media outlets including Mashable, Kottke, Slashdot, Make, The Atlantic, Swiss Miss, Wired, the Toronto Star and NPR. In 2012, she designed and art-directed a newspaper that was on view as part of Martha Rosler's Meta-Monumental Garage Sale at the Museum of Modern Art. Her work has been profiled, praised or featured in print by Wired UK, New York Magazine, Gestalten, Rockport Publishing, iDN, How Design Magazine and Victionary and has been on view at ApexArt, Jen Bekman Gallery, the New York Public Library

and MoMA. She has given talks at Webstock, Creative Mornings, TYPO and TEDx and sometimes teaches art history as part of Pratt's Pre-College program.

Kerry Miller

www.kerrymiller.co.uk

Kerry Miller is a book artist, based in South Oxfordshire, England. She comes from a background of collage and mixed media, which ultimately led to her experimentation with discarded vintage books.

KRONA & LION

www.kronalion.com

KRONA & LION consists of Kristen Lim Tung, Fiona Lim Tung, Lisa Keophila and Jonathan Margono. They are a multi-disciplinary design collective with experience in architecture, graphic design, ceramics and textiles. KRONA& LION are fully skilled in both low and high-tech contemporary craft techniques. They share a common goal of creating beautiful and cutting-edge pieces, with a strong conceptual base. KRONA & LION's work imparts beauty into unexpected spaces with unexpected materials, lending a sense of fun, exuberance and cheekiness. KRONA & LION have created installations and sets for private collections and editorial shoots and have exhibited extensively. In addition, they have developed their signature flower design for retail mass production. KRONA & LION have worked with an extensive list of clients, artists and designers and welcome future collaborations.

Kuin Heuff

www.kuinheuff.nl

Kuin Heuff was born in Dordrecht, the Netherlands in 1969. She paints portraits on paper and then cuts the portraits into lace-like structures of paperwork. Heuff started painting portraits in 1993 and began with the paper cuttings in 2007. She currently lives and works in Rotterdam, the Netherlands.

Laura Garcia Serventi

www.lauragarciaserventi.tumblr.com

Laura Garcia Serventi was born in Buenos Aires, Argentina. She has a Bachelor's Degree in Photography and a Master's Degree in Painting. When she moved to New York in 2007 she began creating sets almost exclusively out of paper for fashion editorial stories. She also started working in illustration and video, using collage and stop motion respectively. With a background in the arts, and her personal artwork based on the ambiguity of reality, the building of parallel words came to her as a natural transition and paper became her favorite material due to its ductility and malleability.

Lauren Kussro

www.laurenkussro.wordpress.com

Lauren Kussro is an artist and teacher currently employed as both faculty and printmaking technician at the Herron School of Art and Design in Indianapolis. In this role she teaches various university level courses in printmaking and drawing and maintains the printmaking studio area.

She attended Herron School of Art & Design in Indianapolis for her undergraduate education, earning a Bachelor of Find Arts with a concentration in painting and printmaking in 2003. She attended the University of Tennessee in Knoxville for graduate school and received her Master of Fine Arts with a concentration in printmaking in 2006.

In 2012, she was one of two residency recipients for the yearlong Indianapolis Stutz Studio Residency. Recent exhibitions include participation in the Arts at the Airport program at Nashville International Airport in Tennessee and a solo exhibition at Twist Gallery also in Nashville.

Lee Huey Ming

www.mingsrealm.com

Ming is a paper artist and graphic designer based in Auckland, New Zealand. She holds a Master of Art and Design from Auckland University of Technology. Her works have been exhibited in various galleries in Auckland. Ming loves spending her time observing the intricacies of nature. Her love for tactility, curiosity to explore, observe handmade craftsmanship and physically built objects is expressed in her intricate paper cuttings and paper sculptures. Her works investigate the structure of nature and is inspired by Ernst Haeckel.

Liz Shreeve

www.stelladownerfineart.com.au

Liz Shreeve is a Sydney based artist with a background in science. She completed a Bachelor of Science (Hons) at the University New South Wales and a Bachelor of Fine Arts (Hons) at NAS.

Recognized throughout Australia as an artist working on paper, Shreeve has been a finalist in major works on paper prizes. In 2012 she was invited to exhibit at Paper Now in Willoughby, Sydney. She has also featured in Radio National's The story of Paper, 2013.

Shreeve has been awarded grants from NAVA, Arts NSW, Marrickville Council and Bathurst Regional Council. She has exhibited widely in Australia and overseas including: Miami, Grenoble, Paris and Vienna. Her work is held by Kempsey Shire Council and St Vincents Hospital and is featured in corporate and private collections in Australia, Indonesia, the United States and France.

Lucie Houdková

www.luciehoudkova.com

Lucie Houdková was born in Brno, Czech Republic in 1984 and now she lives and works in Prague. She graduated from Academy of Arts Architecture and Design in 2010 and joined the Association Unosto in 2011. Her work has been collected by The Museum of Decorative Arts in Prague. She has held a number of solo and group exhibitions, including "4D Schmuck," "Identity" and exhibited at the Beijing International Jewelry Art Biennial in 2013.

Lydia Hirte

www.LydiaHirte.de

Lydia Hirte studied Jewelry Design at the Pforzheim University (FHG) under supervision of Rüdiger Lorenzen and Johanna Dahm from1987-1992. She worked as an artist in Ingolstadt and has worked in Dresden, Germany since 2004. She has been a participant in many exhibitions and a contributor in many books. Selected exhibitions: 2014 Asia-Europe II: A large vision of Fiber Art. Deutsches Textilmuseum Krefeld, DE, Jean Lurcat Museum Angers,

FR | 2013 CODA-Paper Art, CODA Museum Appeldoorn, NL | 2012 Santorini Biennale of Arts, Santorini GR | 2011 Open Mind, Sungkok Art Museum Seoul, KR | 2010 Holland Paper Biennale, Rijswijk, NL | 2009 Goiella di Carta, Triennale Design Museum Milano, IT | 2008 SOFA New York and SOFA Chicago.

Madeline Silcock

www.behance.net/madelinesilcock

Madeline Silcock is a graphic designer from Wellington, New Zealand. She recently completed a Bachelor of Design, majoring in Visual Communication Design at Massey University. Her work tends to focus on typography, print design and handcrafted objects.

Mademoiselle Maurice

www.mademoisellemaurice.com

Born and raised in the high mountains of Savoy, Mademoiselle Maurice is a 29-year-old French artist. After studying Architecture in Lyon and working in Geneva and Marseille, she spent a year in Japan in 2011. During her time in Japan, she experienced the tragic events (earthquakes, tsunami and nuclear power plant explosion in Fukushima) and decided to start creating urban works in connection with these experiences. They are based on the legend of 1,000 cranes and Sadako's story of a little girl who lived through the tragedy of Hiroshima. Now based in Paris, Mademoiselle Maurice develops and creates countless colorful works with the fruits of rich influences and career lessons. Via origami, lace, embroidery or other mixed media, she gave birth to works in tune with their daily lives.

Marine Coutroutsios

marine-coutroutsios.com

Marine is a French artist based in Sydney, Australia. She has a Bachelor of Visual Arts and studied interior design at Ecole Boulle in Paris. She worked as a sculptor and an interior designer before she started cutting paper. Her personal work is inspired by her surroundings and nature and she works on commissions for illustrations and paper installations. Marine is interested in creating visual emotions to engage and inspire the viewer.

Mathilde Nivet

mathildenivet.com

Mathilde Nivet was born in 1983 in Bourges, France. She currently lives and works in Paris. She graduated from Superior School of Applied Art Duperré, Paris in textile design.

Mathilde Roussel

www.mathilderoussel.com

Mathilde Roussel was born in 1983 and currently lives and works in Paris.

Roussel's work is a sensible and symbolic research about the nature of physical life. She is interested in the cyclic metamorphoses that transform organic matter, whether vegetable, animal or human. Through her sculptures, installations and drawings, Roussel integrates the ways in which time weighs on our body, leaving its traces as an imprint and thus creating an invisible archive of our

emotions, a mute history of our existence. Skin becomes paper while our cells transform into graphite particles and our muscular tissues turn into a thin membrane of flayed rubber. Her work becomes a mapping of the body, an anatomy of our fragile presence in the world.

Matthew Picton

www.matthewpicton.com

p.038-041

Matthew studied Politics at The London School of Economics. He has been exhibiting as an artist since 1998, with solo shows in San Francisco, Los Angeles, Seattle, Portland and solo shows in New York and recently London. His works are held in the collections of the De Young Museum, San Francisco, The Herbert Museum of Art in Coventry, England and The Dresden Museum, Germany. He has had reviews and articles in publications such as: Art Forum, Art News, Art Ltd, ARTillery and Artweek, The San Francisco Chronicle, The Los Angeles Times, Der Stern Magazine, Blueprint magazine, The Independent and others. He is currently represented by Summaria Lunn gallery in London and Toomey Tourell in San Francisco.

Maud Vantours

www.maudvantours.com

p.076-077

Maud Vantours is a young French designer. Her creations between art and design are original graphics of multicolored and dreamlike landscapes. She likes to start with a simple drawing that she divides into layers and develops into three dimensions. Color, material and patterns have an important place in her work, like paper, which became her favorite material. She folds it, cuts it and tears it to create inspired patterns in volume. Maud collaborates with luxury brands and her works have been shown both in France and internationally.

Mia Pearlman

www.miapearlman.com

p.240-241

Since receiving a Bachelor of Fine Arts from Cornell University in 1996, Mia Pearlman has exhibited internationally in numerous galleries, non-profit spaces and museums, including the Museum of Arts and Design, New York, Plaatsmaken, the Netherlands and Roebling Hall Gallery, New York. Her work has been featured in over a dozen books on contemporary art and in both international and domestic press. Pearlman has also participated in many residency programs, such as Proyecto' Ace (Buenos Aires) and the Vermont Studio Center. In 2012 she will be a Fellow at the Liguria Study Center in Bogliasco, Italy. Currently, Pearlman lives and works in Brooklyn, New York.

Mia Wen-Hsuan Liu

www.itpark.com.tw/artist/index/647

p.146-153

Mia Wen-Hsuan Liu graduated from the San Francisco Art Institute in 2007 and in the same year, enrolled in CUNY Hunter College's Graduate School of Art. She likes to draw freely and is particularly mesmerized by the unique textures created by drawing on different papers; therefore, she loves to discover different papers from her everyday life to use as her creative medium and the medium itself also leads to the inspiration for her installation works. The process also goes on to form the clear emergence of her creative theme. By working with flat and three-dimensional structures, Liu has produced a series of drawings that have superseded two-dimension, which she calls "installation drawings."

Michael Velliquette

www.velliquette.com

p.074-075

Michael Velliquette was born in 1971 in America and is a mixed media artist known for his densely detailed and dimensionally complex paper sculpture. He recently held exhibitions at DCKT Contemporary New York, Morgan Lehman Gallery, New York, the David Shelton Gallery, Houston and Tory Folliard Gallery, Milwaukee. His work is in the collections of The Progressive Corporation, the Museum of Wisconsin Art, Western Bridge, Seattle, The John Michael Kohler Art Center, The State of Wisconsin, Boston Children's Hospital, the San Antonio Museum of Art, and the Racine Art Museum. He is a Faculty Associate at the University of Wisconsin-Madison.

Michelle Muzyka

michimuzyka.com

p.114-115

Michelle Muzyka is a cut paper installation artist who resides in the greater New York area. She works closely with digital technologies as she constructs intricate patterns of paper fungus growth. Her primary interest arose while looking back on a childhood of nightmares regarding creeping mold slowly taking over her room as her environmentalist father told her horror stories of the dangers of pollen and mold lurking in the walls. Her work references the dichotomy of nature and technology, the organic versus the synthetic and the digital versus the analog.

Michelle studied Digital Imaging at Pratt Institute where she received her MFA. She has shown her paper sculptures at multiple galleries in Lithuania and New York. She had a solo exhibition at the Slingluff Gallery in Philadelphia and past exhibitions at the Museum of Computer Arts, b.j.spoke gallery and Schaefler Gallery in New York. She continues to construct paper forms and has started incorporating natural environments and abandoned spaces as the backdrop of her installations.

Nathalie Boutté

www.nathalieboutte.com

p.034-037

Nathalie Boutté was born in 1967 and she currently lives and works in Montreuil, near Paris, France.

Nathalie is neither a photographer nor a sculptor, nor painter, but her collages are all of these things. Her creations are derived from her knowledge of paper and volumes. She cuts long narrow strips of paper that she patiently assembles, one-by-one, thus creating a feather effect, which constantly evolves. Nathalie is self-taught. She does not have a specialist degree or training; what she knows she has taught herself through her passion. She is not opposed to formal training, but she believes that the key to knowledge has always resided in the practical side of experimenting with materials. Her creations are always the beginning of something new, her technique is forever being enriched and improved. There is no certainty with her, no one truth, but there is always another experience, another achievement.

Noa Haim

www.collectivepaperaesthetics.com

p.094-095

Noa Haim hails for Jerusalem and was born in 1975. She is a master of architecture, designer, journalist and contributing editor, based in Rotterdam, where she graduated from The Berlage Institute in 2004. In her work at international architectural firms she specialized in the field of Mixed-use developments and urban strategies.

Since January 2009, Noa is running her independent multidisciplinary studio working on open-design installations, product design and architecture. Her first design project 'Collective Paper Aesthetics' was awarded by dezeen.com and tdwa.com to participate in the Environmental container exhibition 2010, Tokyo and was selected for Shenzhen, Hong Kong Bi-city Biennale of Urbanism\ Architecture 2011. Her Second design project 'Spaceship HEART' was nominated for FRAME moooi design award 2013 and short listed for ISG Retail Week Interiors Awards 2013.

Ohashi Shinobu

shinobu.xxxxxxxx.jp

p.068

Ohashi Shinobu was born in 1989 in Fukushima prefecture, Japan. She has been working as a paper cut artist since graduating from college with an art and design degree. For her, the most prized aspect of producing paper works is the vibrancy of fancy words and the live sound she hears on a moment-to-moment basis. Ohashi Shinobu also loves plant and animal motifs.

Oksana Valentelis

www.oksanavalentelis.com

p.112-113

Oksana Valentelis is an art director and fine artist. She was raised in the post-Soviet climate of Eastern Europe where she received her first taste of art in a regimented and strict environment of Soviet art at art school. She moved to London at the age of 16 and lived there for 13 years before moving to Sydney. She studied graphic design at Central St Martins and now works in advertising.

Pablo Lehmann

www.pablolehmann.com.ar

p.052-053

Pablo is an Argentinean artist born in 1974. He graduated as Licentiate from the National School of Arts (IUNA), where he later became a professor in 2000. He has held many solo exhibitions including: Black Square Gallery, Miami (2012 & 2011); Carla Rey Arte Contemporáneo, Buenos Aires (2010) and Collective exhibitions such as Philips & de Pury – Auction, London (2011); Sívori Museum, Bicentennial edition auction, Argentina (2010). His wonderful works have also won numerous awards such as, Salón Nacional/Textil (First ward, 2008), Salón Nacional/Textil (Second award, 2007).

Paige Smith

acommonname.com

p.186-187

Paige Smith is a designer turned artist. As a designer, she is truly multi-media, creating many of her graphics physically from paper and other materials. Smith eventually started experimenting with her own fine art works in late 2011.

Her art comes from the street, inspired by the cracks in the surface of Downtown Los Angeles. She first drew attention with her unique three-dimensional "urban geode" installations and has since created large-scale installations in galleries, hotels and the street.

Paper-Cut-Project

www.paper-cut-project.com

p.108-109

Founded in October of 2009, Paper-Cut-Project is an installation design element using expressive paper sculpture. A collaboration between Amy Flurry and Nikki Nye, the Atlanta-based studio makes delicate paper cuts as an antidote to the ubiquity of mass-production, a return to something hands-on. Nye has long nurtured affection for the material through her own paper art. Flurry is a veteran writer and stylist. Together, they plotted a new way to channel their love of fantasy in storytelling as it plays out in campaigns, runway productions and fashion spreads.

Pascale Malilo

www.pinterest.com/pascalemalilo

p.032-033

Pascale Malilo, born in 1962, lives and works in Brussels. After studying interior design at CAD she worked at various architectural firms. After a stint at La Cambre, she worked for nearly 20 years in the world of graphics.

Pilar Mackenna

www.pilarmackenna.com

p.060-063, 194-197

Pilar Mackenna (Santiago, Chile, 1985) obtained a Bachelor Degree in Visual Arts, from The Finis Terrae University. She attended The School of Visual Arts and the Parsons School of Design (New York, USA), where she studied Drawing and Illustration. Mackenna has participated in shows in Chile and abroad. Some of her most relevant solo shows are: Un Lugar Imposible (An Impossible Place), XS Gallery, Santiago, Chile, 2013 and Mary Bell, MORO Gallery, Santiago, Chile, 2010. Some of the most relevant group shows she has participated in include: Medidas Variables (Variable Measures), Museum of Contemporary Art (MAC), Valdivia, Chile and The Annual Contemporary Art Fair in Buenos Aires, Argentina. She was selected for the 2010 version of the National Award for Young Artists Exhibition, Cabeza de Ratón, at the Museum of Visual Arts (MAVI) and for the 2012 version of The Olympic Fine Arts exhibition at The Barbican Center, London, England. Mackenna's work is part of the Karen and Robert Duncan Collection, Nebraska. She is currently studying for a postgraduate degree in Illustration, while working as a freelance Illustrator.

Rachael Ashe

portfolio.rachaelashe.com

p.092-093

A multidisciplinary artist, Rachael began her career as a graduate of the Creative Photography program at Humber College, specializing in portraiture and toy cameras. Over the past five years, her focus has evolved from photography to paper-based work, notably altered book sculpture, paper cutting and paper engineering. Rachael is process driven, with a belief in learning by doing and is constantly experimenting to push the boundaries of her work as an artist.

Rachel Thomas

www.rachelthomasstudio.com

p.160-161

Rachel Thomas is virtually peerless for the unique position she occupies in the creative landscape. She sits somewhere between an art director and set-designer and her work spans many media, from print to installation. She has worked with a diverse range of clients in fashion (Mulberry, Hermes, Acne Jeans, Giles Deacon and Topshop) editorial (Another Magazine, NOWNESS, Acne, Paper, PIN-UP Magazine and British Vogue) and the wider commercial world (Orange, John Lewis, Nike and London Underground). Rachel's background is in fine art (which she studied at Goldsmiths), film-making (her early work includes several pop promos and self-initiated films) and photography and has led to her unique aesthetic and three-dimensional approach.

Rogan Brown

roganbrown.com

p.050-051

Born in England in 1966, Rogan Brown has a Master's Degree in Literature and Philosophy and has spent his life traveling, teaching and making art. He only recently decided to make his work public and since then has taken part in a number of group exhibitions.

Sachin George Sebastian

27sachin.blogspot.com

p.128-129

Sachin George Sebastian is an alumni of the National Institute of Design, INDIA. He is a self-taught paper engineer. His works spread over different areas of interest within art and design, exploring both the structural and visual possibilities of paper. The gallery, Exhibit 320 in New Delhi, India, represents his artworks.

Sarah Dennis

www.sarah-dennis.co.uk

p.069

Sarah Dennis is a freelance illustrator and artist living in Bristol, England. Growing up in the heart of Sussex, she spent much of her childhood drawing and experimenting with art. Sarah took her first steps to becoming an aspiring artist by completing a foundation course in art and design at Brighton City College. Sarah has always been influenced by storytelling, drawing inspiration from her Grandfather's collection of old books and Japanese artwork. She possessed a strong desire to create a world of her own, fueled by nature, animation and personal experience.

Sarah completed a degree in Illustration in 2008 at the University of The West of England, where she developed her drawing and applied her skills to children's books, editorials, designs and animations.

Her work now combines traditional scherenschnitte (paper cutting) with collage. Sarah's work exemplifies the beauty of nature in fairy tales and whimsical childhood dreams, telling classic poems and folk tales through the medium of paper. Each piece is individually hand-cut using a craft knife to reveal exquisite, delicate detail within the illustration.

Sarah Kate Burgess

adorneveryday.com

p.220-221

Sarah Kate Burgess received a Masters of Fine Art Degree from Cranbrook Academy of Art in 2002 with a focus in Metalsmithing. In 2003, she participated in the Oregon College of Art and Crafts Artist in Residence Program. Burgess also lived in Berlin, Germany where she co-founded Takt Kunstprojektraum. She has taught metalsmithing at numerous places including full-time positions at Interlochen Arts Academy (Michigan), Wayne State University (Michigan), and Millersville University (Pennsylvania). In addition, she has held numerous workshops throughout the community on paper jewelry-making at the West Collection's MAKE Series, the Philadelphia Art Alliance and The John Michael Kohler Arts Center and given lectures on her work throughout the United States.

Her work has been included in Metalsmith Magazine and numerous national and international books and magazines. Burgess has exhibited her work both nationally and internationally, most recently at the Galleries at Moore College of Art, Philadelphia, Pennsylvania, the Museum of Public Fiction in Los Angeles, California, the Acquiro Civico, Milan, Italy, the Society for Contemporary Crafts, Pittsburgh, Pennsylvania and with the Opulence Project at SOFA New York.

Sarah Kelly

www.saloukee.com

p.208-209

For years Sarah Kelly created traditional metal jewelry models in paper as preparation for larger works. It was at this point that she realized she loved working with the malleable nature of modeling materials, much more than the metals that produced the final outcomes. Her unique use of materials enables her to create amazingly innovative and wearable statement jewelry, precious to each and every wearer, under her company name 'Saloukee.'

Sixstation

www.sixstation.com

p.126-127

Benny is one of the well-known young and creative designers in Hong Kong and specializes in web design, typography and illustration. His unique style of mixing traditional oriental culture with contemporary culture has gained him positive feedback from both clients and people who have been exposed to his works.

Benny has won a number of awards from both local and international competitions, including: Tokyo Type Directors Club Selected Awards in 2006, 2007 and 2008; Silver, Bronze and Excellent Awards by Hong Kong Designers Association from 2002 to 2005; and winner of the Favorite Website Award in 2003, which gave him great affirmation from the design field.

In 2008, moving to the position of an omnipotent designer, Benny established Sixstation Workshop and his own brand, Fayte.

Stephanie Beck

www.stephaniebeck.org

p.238-239

Stephanie Beck creates drawings, prints, cut-paper sculpture and stages public art interactions. Her work explores psychological responses to architecture, urban spaces and mapping. She has a Master of Fine Arts from the Pennsylvania Academy of the Fine Arts, a Post-Baccalaureate Certificate from the School of the Museum of Fine Arts, Boston and a Bachelor of Arts with Highest Distinction in Art History from the University of Virginia.

Stephanie received a Joan Mitchell Foundation MFA Grant in 2007, was nominated to apply for the Louis Comfort Tiffany Foundation Grant in 2009 and received an Emergency Grant through the Foundation for Contemporary Art in 2012. Stephanie lives and works in Brooklyn, New York.

SUPER NATURE

www.supernaturedesign.com

p.144-145

SUPER NATURE is a Shanghai based multi-disciplinary design company. They specialize in interactive design, visual communication and media technology. They take on challenges through experimentations in new media and physical computing. Seeking innovative solutions is SUPER NATURE's ultimate goal and they constantly commit to new research and development. The partnership with its research associate — Hyperthesis Visual Lab in New Zealand — was established to build a strong collaboration for finding new ideas with innovative and cohesive digital solutions. For SUPER NATURE, the definition of good design is 'Creating moments of engagement.'

Sushma Serigara

www.sushmaserigara.com

p.166-167

"Although born into an Indian household and brought up in the United Arab Emerites, my formative years were in Australia, where I completed my Bachelor in Architectural studies from the University of New South Wales in Sydney. Currently pursuing my career in the design industry, it is my hope to evolve into an established designer. I have always been an explorer of interestingly new and unusual things in art, architecture and design. I want to know why things work the way they Do or Don't! Even as a child, I was always too curious and nifty. I have an aptitude for innovation and a natural attraction to the bizarre. My hobbies are seeking knowledge, pondering over the mysteries of the Universe and designing, among less interesting ones like swimming, glass painting and writing poems. I am also a passionate traveller, wheather it is in or outside the UAE and my sense of adventure takes me to places that inspire me. Other things that fascinate me are life, nature, science and puristic designs. 'Being Creative,' to me is an amalgam of spontaneity, curiosity, playfulness, inventiveness, unpredictable, childlike and drive! I believe creative people are independent and do not play by the rules. And most importantly, they do not mind being a bit lost."

Takashi Kuribayashi

www.takashikuribayashi.com

p.009-011

Takashi Kuribayashi was born in 1968. After graduating the department of Japanese Painting at Musashino Art University, he completed a "Meisterschüler" degree at Kunstakademie Duesseldorf, Germany in 2002. Having his interests in boundaries drawn by border lines and the ambiguity of layers found in two-dimensional world such as Japanese painting as a departure point, Kuribayashi developed his work into three-dimensional space configuration and installations after returning from his studies in Europe. He has had solo exhibitions at museums such as Kolnisches Stadt Museum, Cologne, Germany (2003), National Museum of Singapore (2007) as well as participating in a number of international art fairs such as Singapore Biennale. Some of his work is now housed at Towada Art Center.

Terada Mokei

www.teradamokei.jp

p.134-135

Naoki Terada was born in 1967 and is a Japanese architect, designer, modeler and culinary specialist. Terada graduated from the architectural department School of Science & Technology, Meiji University in 1989. In 2003, he established Terada Design, a first-class architecture office and established TERADA MOKEI in 2011.

The Makerie Studio

www.themakeriestudio.com

p.054-055, 088-091, 176-181

The Makerie Studio consists of Julie Wilkinson and Joyanne Horscroft, friends from a Graphic Design degree at Bath Spa University who eventually decided that there is more to life than computers — namely ventures that seemed entirely plausible when they were five. At 25, after glitzy advertising jobs, design internships, photography courses, teaching expeditions and working away in other people's studios, they came back to their original childhood plans and joined forces to make lovely things. They now design and create bespoke paper sculptures using gorgeous papers and love every minute of it.

Tine De Ruysser

www.tinederuysser.com

p.172-173

Dr Tine De Ruysser trained as a jeweller at the Royal Academy of Fine Arts in Antwerp and the Royal College of Art in London, where she finished her PhD in 2010. Her work crosses the boundaries between art, jewelry, textiles and product design. She takes part in exhibitions worldwide and has won several awards. She also travels to teach and lecture, specializing in jewelery and the use of folding to create 3D shapes from sheet material.

TORAFU ARCHITECTS

www.torafu.com

p.066-067

Founded in 2004 by Koichi Suzuno and Shinya Kamuro, TORAFU ARCHITECTS employs a working approach based on architectural thinking. Works by the duo include a diverse range of products, from architectural design to interior design for shops, exhibition space design, product design, spatial installations and film making. They have received many prizes including the Design for Asia (DFA) Grand Award for the "TEMPLATE IN CLASKA" in 2005 and the Grand Prize of the Elita Design Awards 2011 with "Light Loom" (Milano Salone 2011). The airvase book and TORAFU ARCHITECTS Ideas + Process 2004-2011 was published in 2011.

Utopia & Utility

www.piadesign.eu

www.utopiaandutility.eu

p.174-175

"Utopia & Utility is where we combine the functional and the fantastical.

We believe that everything that deserves to be made, deserves to be made well. From the process to the finished objects, our motivation is to enrich life through beauty."

Founded in 2012 by siblings Pia and Moritz, the company focuses on handmade production, working with craftsmen all over the world. The brother-sister team work together to grow a business with integrity and good intentions, wishing to highlight the beauty of craft and the value in tacit skills.

Wendy Wallin Malinow

eyefun.squarespace.com

p.138-139

Wendy has lived her whole life in Portland, Oregon. She was raised in a family of artists, always surrounded by art and design. Her father was an architect and painter who frequently invited other architects and artists for dinners and parties at their home. Her first childhood encounters with art were with "love" beads and sketchbooks. She had a glamorous art historian/ librarian aunt who collected ivory, amber, and art glass beads created by many of her glass artist friends in the 60s and 70s Northwest Washington art scene. Add in a mother who was a calligrapher and could sew and design anything, Wendy's household was always knee deep in art projects. Wendy has contributed to many art and craft books, taught classes and exhibited in various galleries and museums. Combining media of varied value, lots of color and different emotional connections into a piece that resonates with the viewer is her goal. Using old and new, expensive and cheap, silly or dark she hopes to forms complex layers of meaning and value.

Wirin Chaowana

www.behance.net/wirinchaowana

p.018-019

Wirin Chaowana is a papercraft and graphic designer from Bangkok, Thailand and graduated from the art university, Silpakorn in the Visual Communication Design department. She is capable of creating cultural and creative papercraft and loves to design clean and neat works.

Yuko Nishimura

www.yukonishimura.com

p.210-211

At university, Yuko Nishimura majored in architecture. From that time on, she became interested in paper and started to create projects out of paper. After graduation, Nishimura envisioned a teahouse purely made out of paper. Considering the cultural background of folding, Nishimura started crafting origami from different perspectives.

Zim&Zou

www.zimandzou.fr

p.162-163

Lucie Thomas teamed up with Thibault Zimmermann to form Zim&Zou, a French studio based in Nancy that explores different fields including paper sculpture, installation, graphic design and illustration. Both aged 27, they studied graphic design for three years in art school. Rather than composing images on a computer, they prefer creating real objects with paper and taking photos of them. A number of intricate illustrations actually come from the three-dimensional installations made by Zim&Zou. Their choice of paper is due to the versatility and good quality of the material, especially when it is sculpted and photographed. Zim&Zou's strength is in being a complementary and polyvalent duo.

ACKNOWLEDGEMENTS

We would like to thank all the artists and designers for their kind permission to publish their works, as well as all the photographers who have generously granted us the rights to use their images. We are also very grateful to many other people whose names do not appear in the credits but who made specific contributions and provided support. Without them, we would not be able to share these beautiful artistic projects with readers around the world.